WHAT IT IS... WHAT IT WAS!

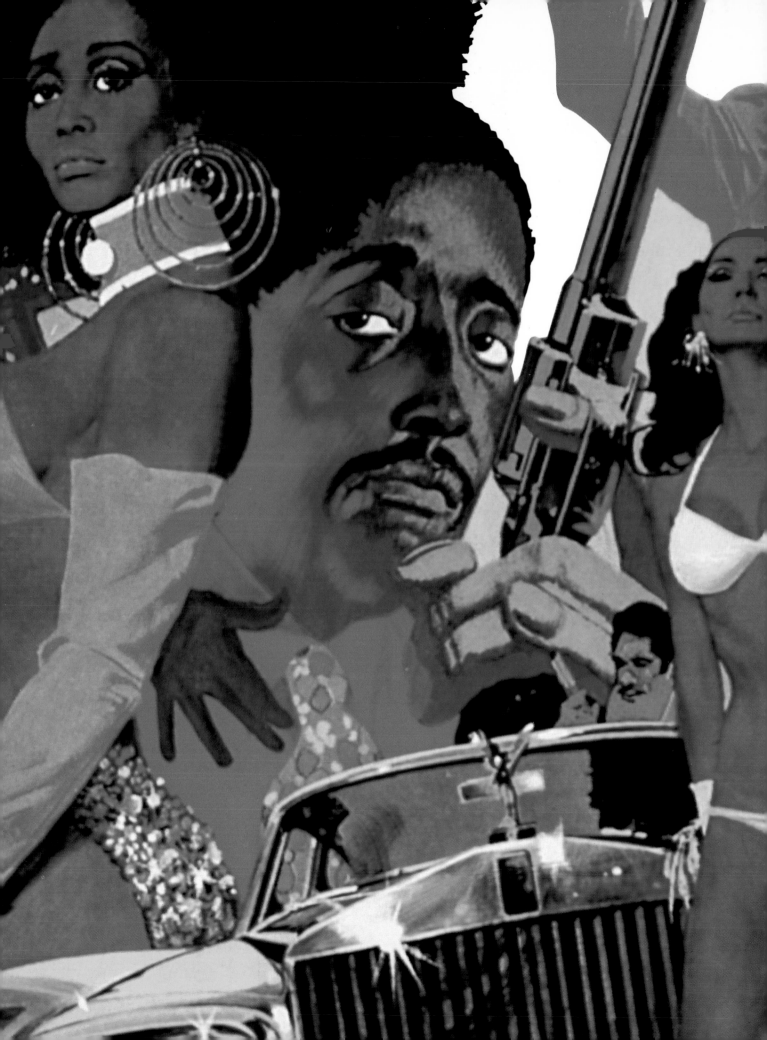

WHAT IT IS ... WHAT IT WAS!

THE BLACK FILM EXPLOSION OF THE '70s IN WORDS AND PICTURES

By GERALD MARTINEZ

DIANA MARTINEZ

ANDRES CHAVEZ

HYPERION

MIRAMAX BOOKS

Gerald Martinez is vice president and creative director for Rolling Thunder Pictures. Martinez has carried the RT mission to showcase films that are often overlooked. From a family of talented artists, he has produced art for Disney merchandising, worked as a toy designer, and a designer of movie posters. His graphic design work appears in *Pulp Fiction, Touch, From Dusk 'Til Dawn,* and *Jackie Brown.* Martinez is launching the Rolling Thunder Book Division with the book, *What It Is ... What It Was!*

Diana Martinez is an award-winning journalist. Martinez worked as an editor, producer, and news director before starting the communication company L.A. Media. An emphasis for L.A. Media is work that supports cultural understanding. Martinez produced the award-winning book *Covering L.A.'s Majority,* the first work to examine L.A.'s ethnic communities and media coverage. She produces *L.A. Stories* for KFWB CBS Newsradio.

Andres Chavez has worked as a producer and media manager for twenty-five years. Currently co-owner of L.A. Media, Chavez provides creative service to media and corporate clients. Prior to joining L.A. Media, Chavez was film director for KABC-TV in Los Angeles. He's an aficionado of world cinema. Chavez's other passions include his wife and son, martial arts, and science. He is a member of the Planetary Society.

Editors: Gerald Martinez, Diana Martinez, and Andres Chavez
Associate Editor: Jeri L. Love
Art Director/Designer: Gerald Martinez
Associate Designer: Mathieu Bitton

Cover illustration (*Cotton Comes to Harlem*) by: Robert E. McGinnis
Back cover illustration (*That Man Bolt*) by: John Solie

Copyright © 1998, Gerald Martinez, Diana Martinez, and Andres Chavez

The posters in this book are from the collection of Ron Finley.
Additional posters/ad material courtesy of: Mathieu Bitton
Photo Credits: Melvin Van Peebles - Chico De Luigi, Rimini, Italy; Cheryl Dunye - K. Brent Hill; Ice-T - Chris Cuffaro

ACKNOWLEDGMENTS
Bob Weinstein, Harvey Weinstein, Mark Gill, Julie McLean, Leith Adams, Brian Ashcraft, Darius James aka Dr. Snakeskin, Lydia Martinez, Alejandro M. Chavez, Josh Olson, Art Sims, Brian Quinn, Gabrielle Raumberger, Garo Nighossian, Frank and Kim, Hama/Cullen Design, Nagata Design, Creative Photo Services, A Band Apart, Toby Chi, Larry Zerner, Lee Stollman, Rebecca Saifer, Bumble Ward, Carlos Goodman, David Ring, Austin Stoker, Ron Witchko, John Kisch, Peter Saphier, Eric Caidin—Hollywood Book & Poster, Shannon McIntosh, Ray Bentley, Donny and the Goblin Market, Steve Mitchell, New York Society of Illustrators, Rick Reece

Martinez, Gerald.
 What it is, what it was! : the Black film explosion of the '70s in words and pictures / Gerald Martinez, Diana Martinez & Andres Chavez — 1st ed.
 p. cm.
 Filmography: p.
 ISBN 0-7868-8377-4
 1. Afro-Americans in motion pictures. 2. Afro-American motion picture producers and directors—Interviews. 3. Afro-American actors and actresses—Interviews. 4. Film posters, American.
I. Martinez, Diana. II. Chavez, Andres.
PN1995.9.N4M32 1998
791.43'75'08996073—dc21
 98–20517
 CIP

First Edition

10 9 8 7 6 6 5 4 3 2

This book is dedicated to
all the brothers and sisters out there who had enough of
The Man

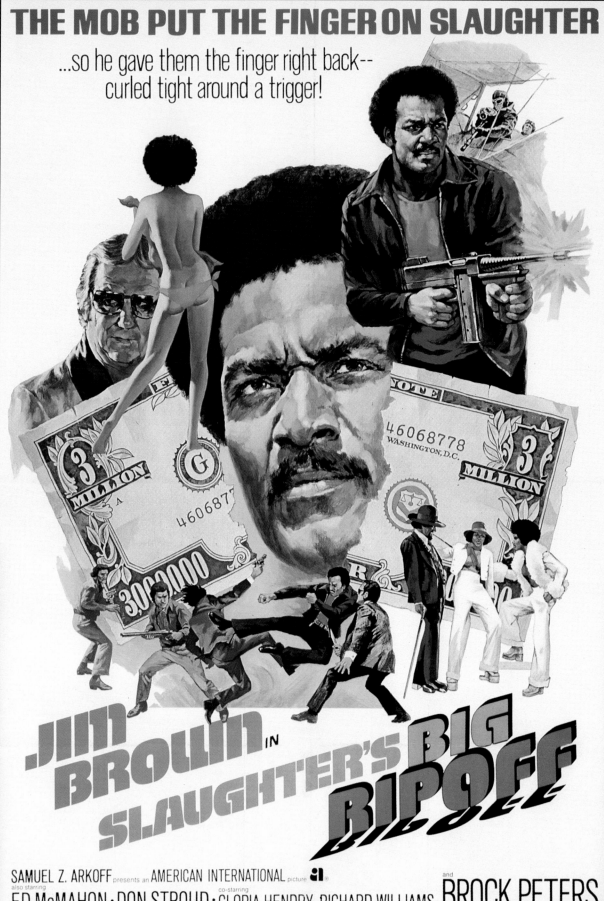

TABLE OF CONTENTS

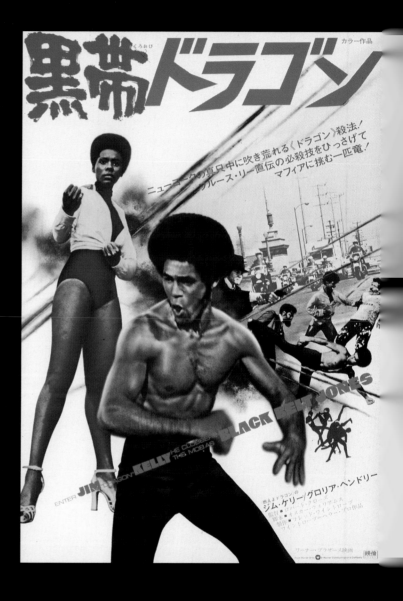

WHAT IT WAS...

What It Is . . . is a book of movie poster art from Black cinema of the '70s with reflections by some of those who made the movies, filmmakers and artists who were influenced by them, and people who simply loved the era.

This book grew out of Rolling Thunder Pictures's commitment to release films that have been overlooked. From Hong Kong New Wave to Black Cinema of the '70s, we provide an alternative to the fare inhabiting the local multiplex. On this path, we found that material on much of the cinema we were releasing was often limited. With our film release of *Detroit 9000,* we wanted to provide more. We want to be more than ticket agents, we want to be tour guides. Our books will help guide you on a journey not to just one film, but will introduce you to a whole genre that we hope you will explore and enjoy.

With this debut book we have the privilege of taking a look at two film phenomena. The Black Film explosion of the '70s and the art that helped define it.

The last golden age of movie poster illustration paralleled the demise of the Black film explosion of the '70s. Unknown to most, the movie poster was an art form where at times actors would pose for the artists. Through

The big three are on this case! They're the only ones who can save their race!

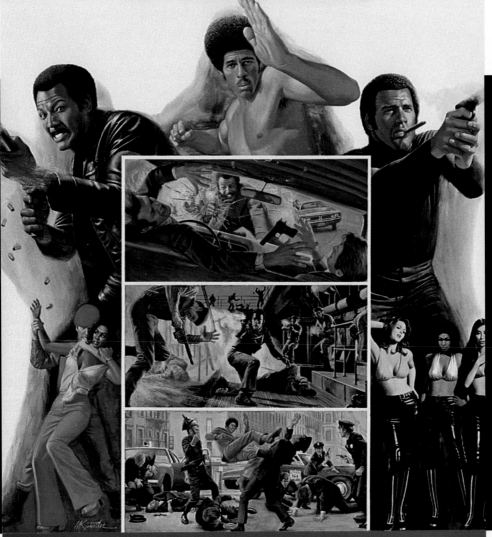

EMANUEL L. WOLF Presents

JIM BROWN
FRED WILLIAMSON
JIM KELLY

"THREE THE HARD WAY"

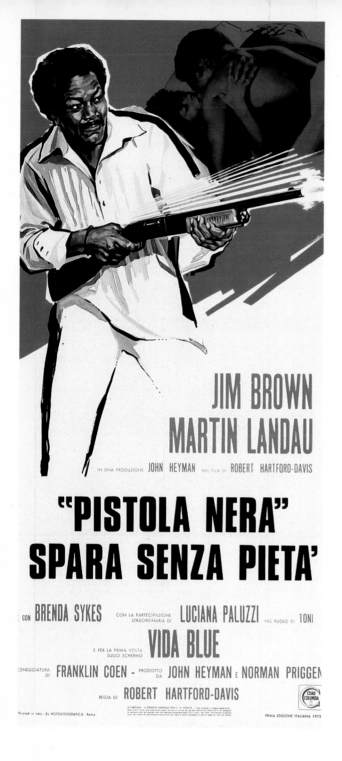

The art also reflected social change and the influence of civil rights and the Black Power Movement. As you may note, the poster for the '60s film *For The Love of Ivy* shows Sidney Poitier as a sophisticated, cultured man about town. It conveys an image of a strong, assimilated Black man. Many of the '70s posters illustrate strong Black men and women with a different strength and a more defiant attitude.

The 150-plus posters in the book recreate an era when things were *superflied* and *funkified*, that remind us of the fun part of the era. The people whose interviews make up the narrative of the book remind us that there was a very serious side as well.

The '70s were a time of important transition, socially and politically, with many successes and failures, and so too were the films. Without a doubt there were stereotypical images in some of the movies and there was a well-made argument that while a community was calling out to improve media images, who needed to see any image that could be viewed negatively? It's unfortunate that during this time the term "blaxploitation" was also coined and incorrectly painted the entire period with one large negative and controversial brush. The films were not that simple. If they were, the groundbreaking work of Melvin Van Peebles would not have caused such heated debate on college campuses. The performances of Fred Williamson and Pam Grier would not still be praised today. There would not be those film treasures born in the era like *Claudine, Cooley High, Corn Bread Earl and Me, The Spook Who Sat By the Door*. These films, as well as others, are classics.

Recognition for the Black-themed movies of the '70s has been slow in coming and a footnote at best. But, the truth is the films had an impact on all of cinema. The musical score for *Shaft* influenced countless film scores that followed. The use of the soundtrack to market the film completely altered marketing practices for all future soundtracks. The success of Melvin Van Peebles in producing and

creative imagination, innovative composition, and inspired design, the artist could elevate an ad into an art form. The poster art had an intrinsic value that was completely separate from the movie it was advertising. It's amusing to note those cases where the movie poster was better than the actual film. As you'll see in the pages that follow, the illustration could convey romance, power, excitement, and emotion. Unfortunately, today the illustrated movie poster has been replaced by movie posters created largely with photographs.

marketing *Sweet Sweetback's Baadasssss Song* showed the way for the independent filmmaker. The raw, gritting look of many urban action thrillers was first seen in the Black action film of the '70s.

It was a film explosion. Between 1970 and 1980, over two hundred films were released by independents and major studios with Black themes. They were powerful, funky, exuberant, hip, and just plain fun. The films ran the gamut from the thoughtful to the ridiculous. All genres and styles were represented. Family dramas, biopics, mysteries, horror, comedies, and, yes, plenty of action movies with lots of sex and violence. Neither before nor since has there been so much activity and so much work for African American actors. In addition, there were some new opportunities for writers, directors, composers, and support crew. Within the African American creative community, this was a time of celebration. There was a feeling that the door to Hollywood had finally swung open and they were about to walk through. But changes in distribution patterns, the return of the Hollywood blockbuster, political pressure from groups opposed to "blaxploitation," and a lack of fresh material ended the era of Black Cinema in the '70s. It would be ten years before we would begin to see African-American films again. As you will read, the period was a meaningful one for many present day filmmakers. This book is not intended to be a definitive work. It is a step in documenting this era.

To the people we interviewed, we are grateful for their reflections. We also understand and respect those that chose not to talk. Some were deeply hurt by the controversy and when the films stopped, they had difficulty finding work. There are many more stories to tell and we encourage new dialogue to preserve this period of cinema history.

Finally, we conclude the book with our own gift to the period: An illustrated movie poster painted by Gerald Martinez of the film *Jackie Brown*, to demonstrate our appreciation of . . . *What It Was!*

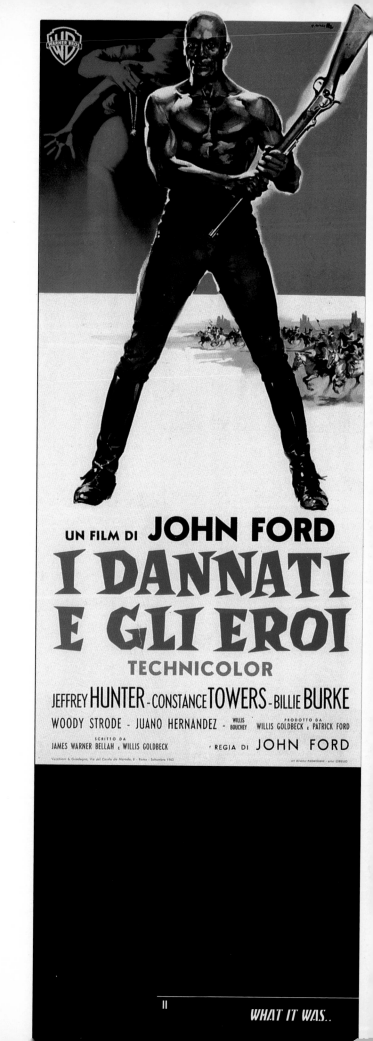

WHAT IT WAS..

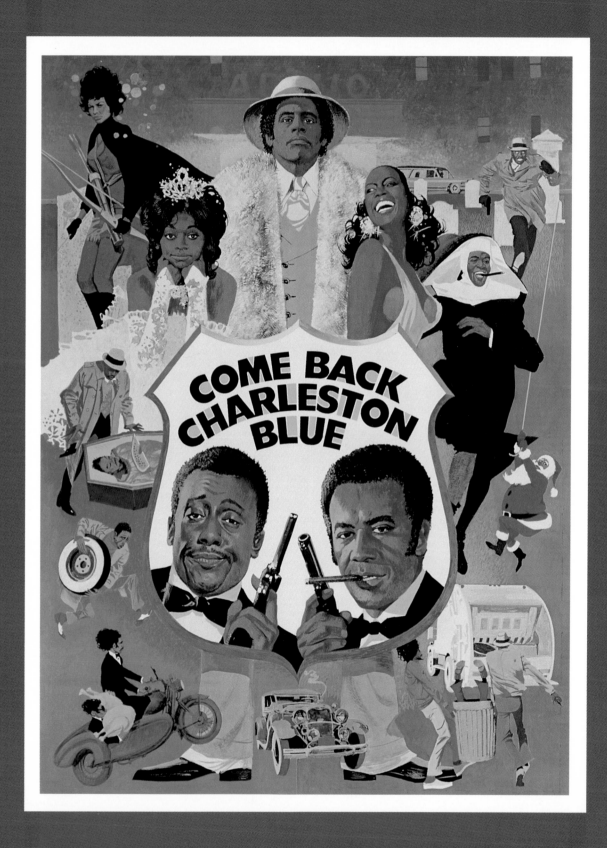

WHAT IT IS...

THE ART OF THE POSTER

WHAT IT WAS!

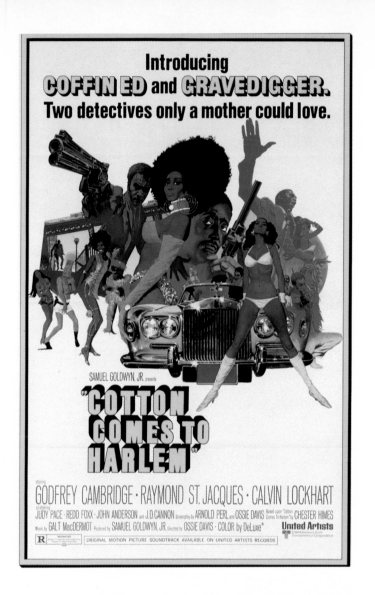

RON FINLEY

Ron Finley is an innovative fashion designer and owner of the L.A.-based DROPDEAD COLLEXION. He has designed clothing for a number of Hollywood celebrities. Interwoven with his passion for design is his fascination for his second endeavor—MIDNIGHT MATINEE—a collection of African-American movie posters and memorabilia. His collection of movie posters is featured in this book.

I began collecting Black movie posters and memorabilia because I was interested in the history of African Americans in film—their struggles and their many triumphs. I am devoted to salvaging and restoring items that held significance in the progress of the Black experience in cinema. I believe it's important to share these images with *all* people. Most don't even know this material exists.

WHAT IT IS...

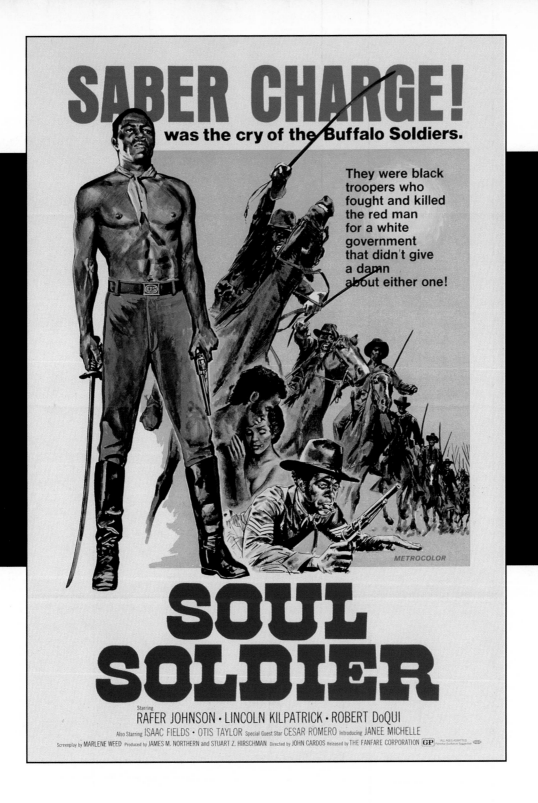

Actually it was never meant to be available to the public. The National Screen Service distributed all the movie posters and all media press kits within the industry. After the movies were shown, the theaters were supposed to return the posters and other promotional pieces, but many didn't. After the National Screen Service disbanded, the posters were disposed in various ways. Since not much value was given to them at the time, some posterrs were sold by the truckload. Many other posters were destroyed and thrown out. Some were even used as packaging material for bombs during the war years. It is because of this great disregard for their future value that only one or two posters of certain movie titles exist today.

WHAT IT WAS...

I get help in my search for more items for my collection by a network of acquaintances and fellow collectors who keep my wish lists and requests in mind when traveling around the world. They respect and admire the importance of what I'm trying to accomplish and in choosing to sell to me instead of a dealer, they understand that my motivation is not for financial gain, but a sincere love for the material and its importance for future generations. There have been times when I have had to choose between buying a certain item and eating. I feel like there are fewer and fewer opportunities to run into some very scarce material and when the chance to buy comes along, it is hard to pass it up.

You never know where a poster may turn up—yard sales, auctions, or flea markets. I like to take my kids with me on some excursions. They can now spot things for me—"Hey, Dad, there's a *Carmen Jones* soundtrack over there." That is kind of cool. It is definitely the kind of history lessons I'd like my boys to experience in learning about who they are and where they come from.

Collecting has opened up many more worlds of people than I would have come in contact with if it had not been for this common interest in posters. There is a small group of collectors who travel all over the world specifically looking for material. I received a call from someone in Paris the other day,

who had looked me up in the Yellow Pages on the internet. So the world is definitely shrinking. Some collectors are fanatical and are very public about what they are searching for while others hide behind purchasing agents.

Posters from the blaxploitation period—the 1970s—have become very hot items. Interest has grown for *Sweet*

Sweetback's BaadAsssss Song, *Shaft*, *Superfly*, *The Mack*, and Pam Grier's posters continue to be popular. A favorite of mine is the Italian poster version of *Coffy*. It is a big and glorious image of Pam in a perfect Afro and she is extremely sexy and provocative. The piece really captures the period and the essence of a strong Black woman.

I sometimes have a problem with the term blaxploitation. Even if it is true that most of these Black actors were only able to play very

shallow and stereotypical roles in these films, I feel they were compensated for their work and were able to call themselves actors through the making of these movies. Which in turn enabled them to live on Sunset Plaza Drive and buy expensive cars. These films were still a way to mark their place in the history of Black cinema. So for that reason alone, it is something to be proud of. So who's exploiting whom?

I am aware that some actors who apppeared in these movies feel ashamed. It is really

La Guerre contre la Mafia de la drogue fait rage dans Harlem !

Feu
à bout portant

20 Th. Century Fox
présente
Un film Palomar
PAUL WINFIELD
dans
Feu
à bout portant
Producteur exécutif
EDGARD J. SCHERICK
produit par
ROBERT L. SCHAFFEL
Réalisé par
OSSIE DAVIS
Écrit par
HOWARD FRIEDLANDER
& ED SPIELMAN
Couleur par TVC et De Luxe (R)
Distribué par Fox-Lira

ironic that the actors should be embarrassed about their work while the characters they created became larger-than-life heros and role models for the kids that grew up watching these films. But the shame was real. It is a lot like asking some African Americans about Stepin Fetchit. Although he is considered by many knowledgeable people in the film industry to be a "comedic genius," Stepin Fetchit is viewed by many African Americans as a negative stereotype, an Uncle Tom, a sell-out: "Oh, you old Stepin Fetchit Nigger" was a common insult. If Stepin Fetchit hadn't done what he did, your Black ass probably wouldn't have a job. He took the first steps in film for us and became one of the first

WHAT IT WAS...

SWEET JESUS PREACHER MAN

AMEN, BROTHER!

MGM Presents "SWEET JESUS PREACHER MAN"
Starring ROGER E. MOSLEY ✴ WILLIAM SMITH ✴ MICHAEL PATAKI
Written by STUART MADDEN ✴ JOHN CERULLO Produced by DANIEL CADY
Directed by HENNING SCHELLERUP

R RESTRICTED METROCOLOR MGM

Black millionaires. But only he knew how much pain he endured, how much humiliation he put up with, and how his heart bled. Most of what he did in white films he did in Black films also . . . and it was funny.

This is same kind of thing that happened to blaxploitation movies. They followed the same path as the white films at the time. The subject matter of Black films was as varied as its counterparts—gangster, horror, love stories, Westerns, etc. Who knew there would be a movie like *Blackenstein?*

I love to showcase my favorite pieces in my design studio and periodically switch the images for the enjoyment of my clients and myself. It's fun to see the reaction of many of my customers when they first visit my shop. It's often very unexpected and overwhelming to walk in and see so many images that they have grown up with and have fond memories of. One person was so impressed by what she saw she needed to step out and get some air. Others have literally asked to come back to see more. Some have totally forgotten that their appointnient was not about posters. One person said, "I've been looking for this all my life! Where did you find it?" That makes me feel good to see people appreciate what I have put together. I have had exhibits, but nothing where the collection can be viewed on a regular basis. I would love to have a gallery/archives/library/research center/museum where all could be viewed and stored.

Another aspect of interest to me about collecting is exploring the merchandising and marketing that went behind the images chosen for these posters. I love to analyze what images would be most successful in making me, as a movie-goer, reach into my pocket and pay to see a particular movie. Also it's quite fascinating to see the changes made in the poster art when the movies are marketed for certain groups—as in Blacks and whites. Some changes in the art are subtle while others, if you are paying attention, can be very blatant and insulting. For instance, guns and violence are enhanced and glorified for posters distributed in the inner cities, while they are downplayed for the predominately white neighborhoods. (You can see one example of how the same movie was marketed differently in Black and white neighborhoods below.)

I will continue to collect and preserve my collection for as long as I can. It has become quite competitive. Few out there are buying and selling for the love of the art. Most are motivated by the money and are making a nice living out of it.

I believe in collecting for *all* of our children's legacy. Every year more people are coming into consciousness of who they are and where they came from. A lot of the younger kids weren't around when these movies featured in this book were released. They're seeing them on video for the first time and they are spellbound by the fact that there are movies like *Foxy Brown, Trouble Man,* and *Cooley High.* Out of some of this new fascination will be born the future collectors and contributors to the history of Black film.

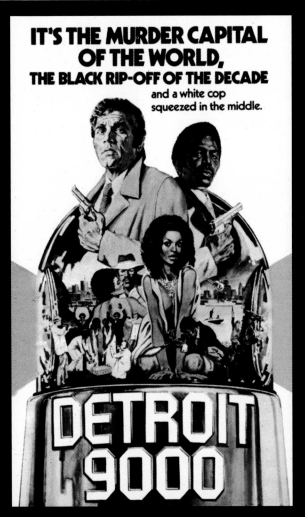

WHAT IT WAS...

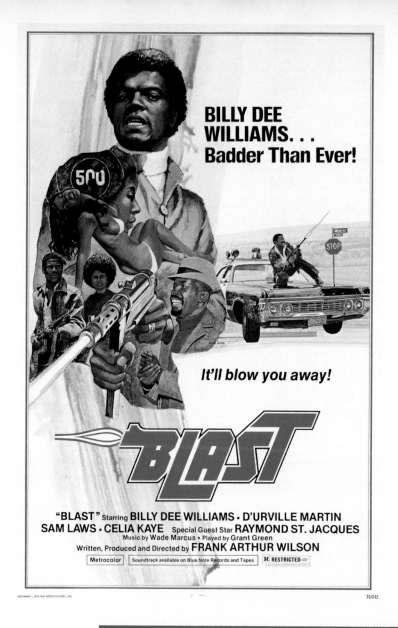

BILLY DEE
WILLIAMS. . .
Badder Than Ever!

It'll blow you away!

BLA-ST

"BLAST" Starring BILLY DEE WILLIAMS · D'URVILLE MARTIN
SAM LAWS · CELIA KAYE Special Guest Star RAYMOND ST. JACQUES
Music by Wade Marcus · Played by Grant Green
Written, Produced and Directed by FRANK ARTHUR WILSON
Metrocolor Soundtrack available on Blue Note Records and Tapes R RESTRICTED

JOHN SOLIE

An artist for over three decades, John Solie was one of the major movie poster illustrators during the '60s and '70s. Solie created over two hundred movie posters during this time, among which were Shaft's Big Score, Shaft in Africa, Darkdown Strutters, Blast, and TNT Jackson.

I had no interest in the movie industry, I didn't go to movies, and didn't care about movies, but I was freelancing and I heard they were looking for someone at Columbia. I went to Columbia Studios and met this guy, Lyle Wheeler, whom I had never heard of before. He was doing a movie called *Marooned*. This was in the early '60s. I showed him my portfolio and he said he didn't have any freelance work but he wanted me to work on this movie. God, I did not want

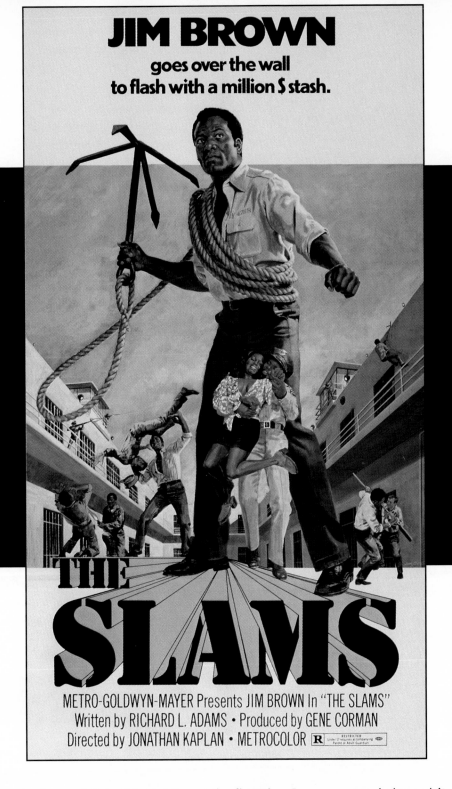

to work on that movie. I was at Columbia and it was the first time I was on a movie lot and it was a barn. It was ugly, and I thought, "I don't want to be here." He was a funny-looking guy with a bald head. I didn't know who he was. It turned out he had gotten an Academy Award for *Gone With the Wind* and he had been the head art director at 20th for years and he had twenty-five Academy Award nominations and five Academy Awards. I didn't know any of this. He said, "Would you like to work here?" and I said "No, I don't, but money turns my head." He said, "How about $250 a week," which was more than I thought the president made at the time. I said, "No, I need $300." He said, "Okay." Then I said, "I'm in the Society of Illustrators and we have meetings on Wednesdays so I'll probably have to go on Wednesdays." He said, "All right." I said, "Well, I'm freelancing, so I probably won't be able to get in on time

WHAT IT WAS...

in the morning, I'll probably come in late." He said, "Okay." I thought, "I can't not get this job. I don't want to work here." I went home so depressed my wife said, "What happened?" I said, "I have to work there!" God, I didn't want to work there. I didn't want to do movies, but I went in anyway because I couldn't turn down the money. It turned out to be the best job I ever had. I loved it and if I had any idea what it was like I would have begged for this job.

In the early days, I had total freedom. The freedom was phenomenal. I didn't know it wasn't going to last. I had a lot of years when it was just so much fun. I didn't have the same freedom at the major studios. When you were doing a poster, if you couldn't find the still photographs they would send you the stars and they would pose for us.

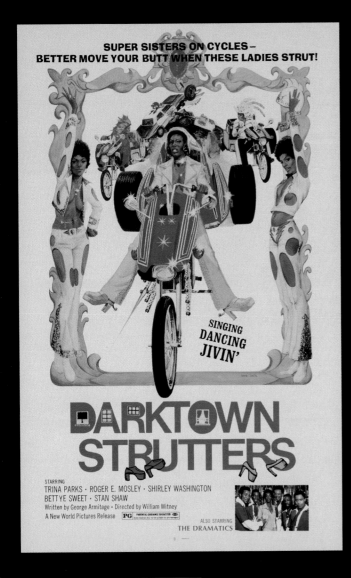

One of those stars was Jim Brown. I'm a football fan so that was pretty exciting to me. In the composition for the ad I was doing I had this rope looped around his left shoulder and crossing over to his right side. When he put it on he had it on his right shoulder going in the other direction. I said, "Excuse me, Jim, but the rope's got to go the other way." So he took it off, turned it around and put it back on the same way. I said, "No, no it still has to go the other way." Brown said, "Well, I changed it." I said, "I know but it's still going the wrong way." He said, "I changed it." I said, "Look Jim, don't piss me off because I can hurt you." I thought that was obviously a joke because I came up to his waist. But he gave me a look and I thought, "We'll leave it the way it is Jim." You don't want to mess with that man. He was big.

I did the poster for *Shaft in Africa* and there's a story with that. They wanted a montage of Richard Roundtree holding this big stick. They were going to run a contest that said, "Guess the length of Shaft's big stick." The prize was a free Shaft T-shirt. They decided maybe that was going a little far so they dropped that idea. Then they decided that for *Shaft in Africa* they wanted Richard Roundtree in this costume and a montage of scenes from Africa. They said, "Put the Eiffel Tower in there." I said, "I'm not all that great at geography, but I thought that was in France." "Yeah, yeah, yeah but we shot some stuff in Paris, we've got to get our production value. You gotta put the Eiffel Tower in there." I replied, "It's going to say, 'Shaft in Africa,' it's going to have all these scenes in Africa, and the Eiffel Tower?" "Yeah, yeah, gotta have that." So I put the Eiffel Tower in the center and built everything else around it. I made a point out of it so it didn't look like we didn't know where it was. At the end, they looked at it and said, "That's fine, we love it. However, take the Eiffel Tower and move it over there behind this building." I said, "If you put it behind the building, without the base of the tower, you can't tell it's the Eiffel Tower. It looks like an antenna." They said, "You're right. Make it a pyramid." If you look close at that ad, around Shaft's legs you can still see pieces of the Eiffel Tower.

I heard a story about why they stopped using illustrations on movie posters. Somebody at Columbia Studios said "Since films are made out of film we should use film for advertising and we shouldn't use paintings anymore." Whoever said it, if this is a true story in the first place, was

convincing enough so they said, "Okay, no more art on the posters, we'll use film from now on." That's now spread through the industry so that very little painting is done on movie posters, except for a Disney thing or something with animation where you are going to have to use it. More than not often as possible they use film. The problem with a photograph is that you cannot distort it the way that paintings can be distorted. I think the painted posters were better because you can make somebody look better. With photography, even with makeup and retouching the photograph, you're still limited to the reality of it. With painting you can make people larger than life, you can make muscles on the people that didn't have them. You didn't have to be Stallone, but you could look like Stallone.

Good movies are art and they should be sold with art. The medium is entertainment, the medium is romance, and that's loosely termed romance, whether it's gun fights or kissing. An artist can do that and can sell that and can feel that, and a computer can't and a camera can't. There are artists with cameras and I have seen photographers who are great artists themselves. But just about anyone can learn to shoot a camera. Most anyone cannot learn to paint the pictures. The ones who learn to paint the pictures are so devoted to it that they are willing to give up everything else in their life for that.

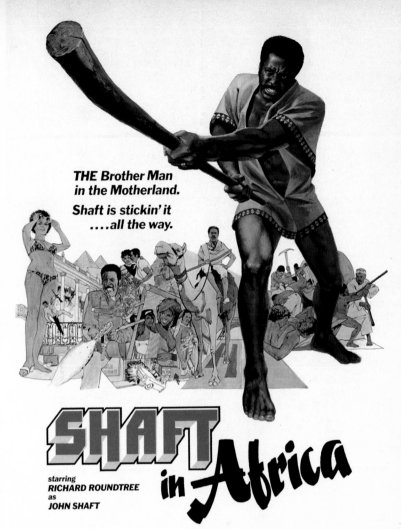

THE Brother Man in the Motherland.
Shaft is stickin' itall the way.

SHAFT in Africa

starring
RICHARD ROUNDTREE
as
JOHN SHAFT

MGM Presents A STIRLING SILLIPHANT · ROGER LEWIS Production "SHAFT IN AFRICA" Starring RICHARD ROUNDTREE · VONETTA McGEE Written by STIRLING SILLIPHANT · Produced by ROGER LEWIS
R RESTRICTED Directed by JOHN GUILLERMIN · Metrocolor · Panavision® MGM

I don't really look too much at posters today. If I'm in the theater, I'll look at the ones that are up on the wall. Usually I see that they are photography and I pass on by. That's not particularly exciting to me. The old posters were, in many cases, better. What happened was the committee got too large. Pretty soon, there was not one person making these decisions anymore, there were so many people making these decisions that they got watered down until there was no image anymore. It became the rendering of a bunch of stuff stuck together and something stuck together badly. The committees had so much to say about these sorts of things that it killed the creativity. Pretty soon you didn't care anymore. Why should I work so hard to come up with a concept if it is going to become a political issue? It happened over and over again and toward the end, it was happening all the time. I finally went into illustrating book covers. It paid a lot less money but I got the freedom back again.

From the standpoint of the illustrator, I'm afraid its over, in almost all commercial endeavors. They're using computers for book covers now and they are going to continue more and more. As far as a painting illustrator goes, I think it's a buggy-whip business. They can do so much more with computers so much cheaper, or at least they will be able to. Since money is the bottom line in every commercial endeavor, they are going to go that way.

WHAT IT WAS...

Black body— white brain!

The world's first brain transplant

A change of living.
A change of loving...

CHANGE OF MIND

CINERAMA RELEASING CORPORATION

WALT REED

Walt Reed is the owner of Illustration House, based in New York City. Illustration House is America's foremost gallery devoted to the art and history of illustration and one of the leading auction houses dealing in illustration art spanning the past 150 years. Reed is a leading expert on American illustrators and the author of the book, The Illustrator in America 1880–1990. *The period of the '70s is described as the golden age for the illustrated movie poster.*

The very fact that illustrated movie posters were used so much during the '70s provided a training ground and a big market for motion picture poster art. It attracted some of the best talents. Naturally, that resulted in some

excellent work being produced. I think people like Bob Peck and Bob McGinness and a few others whose work was used a lot brought movie poster art to a high level. This poster art was extremely effective. I think they used the top talent of the day and the artists did a good job with it. But I think the '70s was a particularly interesting period, when the artists were doing an excellent job of selling the films.

The blaxploitation art work is very similar to the art work being done by the same artists for other movies. You don't see any influence on the art on the Black aspect of film-making; I don't know if there was any way that it could have been done. Certainly the art is very effective in the way its being done, but I don't see that talent was taken from the Black art community to produce them. The art is very typical of its time.

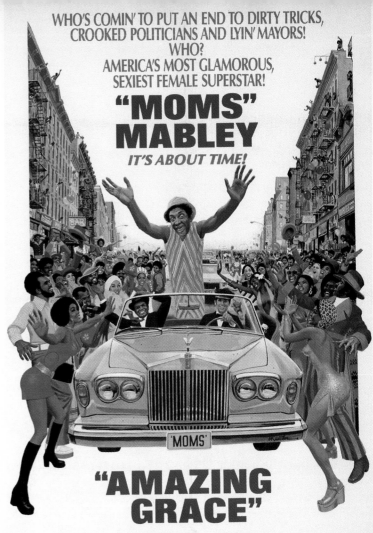

There are fads in advertising and illustration that come and go and this was a culmination of a period when art for movie posters was pretty much at its height. Then in reaction against it, someone decided to come up with something new and they went to all photography. The same thing happened in magazine and story illustrations, when the magazines started using photos instead of paintings. But it's hard to predict what the length of time will be before we'll go to art again. The artists who produced illustrated movie posters had an advantage over photography in that they could be much more selective and high-light the various actions that were part of the background of the film better than photography does. Things all tend to look the same when you look at a photograph. The artists can select elements of the poster to emphasize or play down. Usually they'd

WHAT IT WAS...

pick the highlights of the film and use them as vignettes behind the principal actors. I'm a proponent of illustration so I have a biased opinion, but I still think it does a better job than photography does. There was always the question of who was to dominate the poster, and the stars were given the size according to their weight in their project. If someone was The Star, they had to be larger than anyone else, no matter what the rest of the action was, the artist had to find some way to make it plausible to accommodate the extra importance that was given to the main character.

WHAT IT IS...

A lot of these posters are very similar to the artwork that was used on paperback novels with a lot of interplay between the type of the novel and the characters in it. Here we had the title of the movie and the characters in it. So the type had a lot to do with the way the artist designed the poster. I think in the earlier days the type played less important role in designing the poster. Certainly it was always there from the beginning, as artists we're given a little more authority at this time to let the picture dominate the ad.

The artists were beginning in this period to use acrylic colors and they were certainly much more intense than the oils were or even the opaque water colors—designer colors that they used before. There was a heightened intensity of color and some introduction of psychedelic colors but that was not universally employed.

Television has had a big effect on the way we look at things, and it certainly affected the audience for illustration. In the days before television, there was a reliance on the illustrator to help sell the fiction in the magazines. Once television came along, the fiction went along with it, so the illustrators were left high and dry without an audience. The audience became more accepting of the photography and the live action figures that it presented and there was less reliance on the illustrators to sell the movies because they weren't needed. Most people nowadays don't know who the illustrators are necessarily. That was always the case with movie posters—the artists were not given a byline. Producers of movies wanted to be sure that the audience focused on who the actors were and who the movie company was rather than who did the poster, so the artists names very rarely got on the poster. There were a few exceptions, such as when they wanted Norman Rockwell to do a movie poster—they wanted his signature too—but for the most part, doing movie poster art was an anonymous profession.

The movie poster art of the '70s was very good art and should have continued, but unfortunately the powers that be decided to try a new approach. We're moving in real fast times these days, and illustration is being taken over by computer approached tools more and more. I think there will soon come a time when nobody will even be able to paint like these fellows did.

WHAT IT WAS...

Part of this is a pendulum swing to something so-called new. There is not an audience for name illustrators like there used to be so the public doesn't necessarily identify with the pictures they see. They just look for them to see who the star is or what the action promised is. It's too bad but I'm afraid that's the case. It will probably come back but in a little different variation. Every time there is a style, there's an eventual reaction against it and the search for something new, so it's hard to predict what that something new will be. After the photos start to look alike to every-body, they're going to want to get a new look. Let's hope it's illustration.

WHAT IT IS...

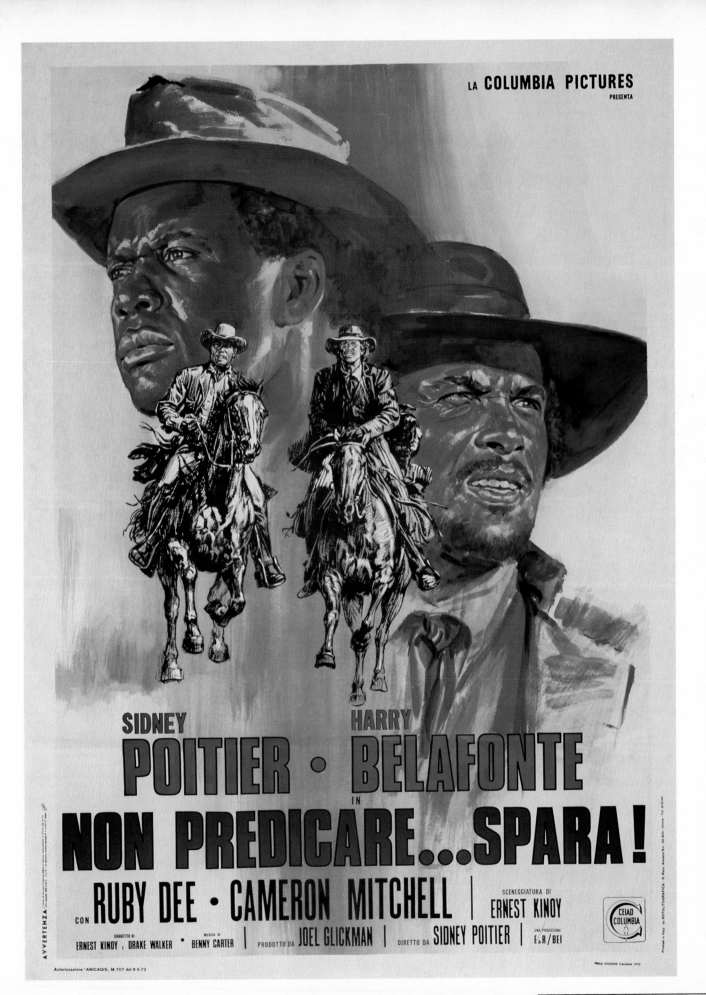

SWEET SWEETBACK

A film of
MELVIN
VAN PEEBLES

WILL NEVER DIE
A NATURAL DEATH

WHAT IT IS...

THE FILM EXPLOSION

WHAT IT WAS!

MELVIN VAN PEEBLES

Every film with an African-American theme made since 1971 owes a debt to Sweet Sweetback BaadAsssss Song. That seminal film was rejected by the Hollywood establishment but broke box office records all over the country. For the first time it showed a Black man winning against the White establishment; caught the accent, music, and spirit of the Black urban ghetto; proved that movies with Black themes and stars could be commercially successful. It started an era in the '70s of Black-oriented films, some of which were called blaxploitation.

Every Independent American filmmaker since 1971 owes a debt to Melvin Van Peebles, who wrote, directed, produced, and starred in Sweet Sweetback. He showed it was possible to create films outside the Hollywood establishment and make money. Sweet Sweetback is still on Variety's All-Time Top-Grossing Independent list. Filmmakers as diverse as Spike Lee and Quentin Tarantino have acknowledged Van Peeble's contribution.

At the time, in the early '60s, independent filmmakers were very, very far out . . . drastically. An independent film was experimental film. Most independent filmmakers were people who scratched on film and bloop . . . bloop . . . bloop, put little things like that on the sound track. They were all anti-Hollywood. Nobody was interested in telling stories. But all I wanted to do was tell stories. I made these three short films. I came to Hollywood, and of course, they threw me down the steps. I took my film and showed it to them, and they said, "Okay, we'll offer you a job." They offered me a job as an elevator operator. I said, "I want to write and direct." They said, "Whoa, whoa. Hey kid!" and they offered me a job as a dancer. So I went back to my second love, which is mathematics and astronomy. I moved to Holland to take my Ph.D. in astronomy. Through a series of events, this guy showed my short films to the Cinémathèque of France. They found out where I was and sent me a postcard in Holland and said, "Jesus, you should be in cinema absolutely." So I hitchhiked to France. They took my films and me in a limo to the Champs Elysées to a little private screening room and they showed my films. They oohed and ahhed and everything. They came down and everybody kissed me and drove off. There I stood in the middle of the Champs Elysées with three little cans of film, two wet sheets, and not a fucking penny to my name. Most people intimidate themselves by saying, "I'm gonna make it." I said, "I'm gonna make it or die in the attempt." So then you're not intimidated; it lets you off the hook. I don't believe right triumphs; it might, maybe. But, you gotta be in it to win it. So I became a beggar and taught myself French. You look at a situation and sell yourself cheap on a deal, if you're betting on yourself. I took the long shot. I became a crime reporter. I did of a lot of the dirty work that nobody wanted to do. I had some scoops and then my novels began to get published. Along the way I found out that a French writer had the right to a temporary director's card. Aha! I went to the French Cinema Center. I had

SWEET SWEETBACK

A film of
MELVIN VAN PEEBLES

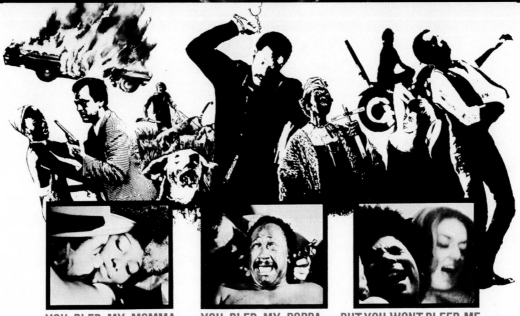

YOU BLED MY MOMMA — YOU BLED MY POPPA — BUT YOU WONT BLEED ME

ORIGINAL SOUNDTRACK ALBUM AVAILABLE ON STAX RECORDS ORIGINAL PAPERBACK SOON AVAILABLE AS A LANCER PUBLICATION

MELVIN VAN PEEBLES and JERRY GROSS present "SWEET SWEETBACK'S BAADASSSSS SONG"
a CINEMATION INDUSTRIES Release • COLOR

RATED
BY AN **X**
ALL-WHITE JURY

WHAT IT WAS...

The Uppity Movie.

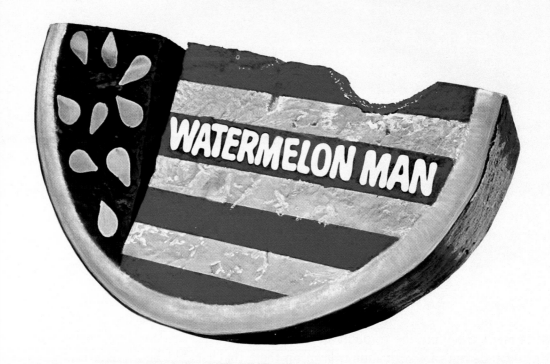

COLUMBIA PICTURES Presents

GODFREY CAMBRIDGE · ESTELLE PARSONS

A BENNETT—MIRELL—VAN PEEBLES Production

Written by HERMAN RAUCHER · Music by MELVIN VAN PEEBLES

Executive Producer LEON MIRELL · Produced by JOHN B. BENNETT

Directed by MELVIN VAN PEEBLES · COLOR

RESTRICTED
Under 17 requires accompanying
Parent or Adult Guardian

really cased the joint like it was a bank robbery. The French are very difficult. If they make a decision, it's hard for them to back off. So I knew I had one fuckin' shot. They had just instituted the coffee break at 10:30 A.M. So I figured I'd go in right after the coffee break. They'll feel they'd gotten away with something because they just had a coffee break. I go in: "Why are you here?" "I'm here for my director's card. Look it says French writer, I write in French so I'm a French writer, right?" That's not what it meant but it said French writer. The guy looked at me and said, "Yeah." That's how I made my first feature, *Story of a Three Day Pass*.

In 1967, I won the San Francisco Film Festival Critic's Choice Award, for *Story of a Three Day Pass*. When I went to San Francisco, I came as a French delegate. No one knew I was an American, let alone Black, so everyone freaked out. But they couldn't afford to have the only Black American director being a French director. So then Hollywood embraced me: "Oh, where have you been . . . blah, blah, blah." All the studios offered me a job, however I couldn't take the job, politically, because if I did, they would have had the one colored threat out of the way. "Oh, it's not that, he's a genius, not like the others . . . dadah, dadah, dadah." I didn't have a job. I ended up living on a park bench on tenth and Greenwich, near the Lion's Head in New York City. But I still refused.

The search was on for the great Black hope. It was at that juncture that Ossie Davis was "discovered." Ossie had been trying to get into films for years as a director. Then, Gordon Parks was "discovered." Gordon had beaucoup credits and he too had been trying for years. But suddenly, the arms opened to them. Gordon and Ossie had shot their films on location because they didn't dare have these Ubangees running around Hollywood. They were still pursuing me, so I said, "Okay, I'll come," because it was time for the next step. I said, "I'll shoot *Watermelon Man* if we shoot it in Hollywood," which they agreed to do. I felt it was the next political barrier to break down.

So I made *Watermelon Man*; there are a gazillion hilarious stories about that. This guy called me up and gave me the script. We've talked to some people, he mentioned Jack Lemmon, Alan Arkin, and they were trying to find just the right guy. I read the script. I called him and said, "I think you sent me the wrong script." He said, "What is it?"

"The guy's Black." "Yes, but he starts off white." "So get a Black guy to play it in white face." "Is that possible?" They were perfectly willing to get a white guy to play in black face but could a Black guy play a white man? They put me through all kinds of hell. Tests, this and that, makeup test. They gave me a lot of latitude out of . . . it didn't dawn on them that I might be cleverer than they were.

For example, in the original script, *Watermelon Man* ends with the guy having to get up in the middle of the night and then he's white again, it was all a bad dream. I said, "I don't find that ending acceptable." We're sitting around a room with a bunch of executives. What are you going to do? "We'll shoot it both ways. Okay, Mel, we'll do that and we'll see later on." They gave me twenty-three days to shoot *Watermelon Man*. They programmed me for failure. As soon as I realized they were trying to fuck me, I shot it in twenty-one days and I shot things all out of sequence, so they couldn't follow what I was doing, so they couldn't start fucking with me . I'll never forget it. About day twenty, the guys came down, "Mel, just came down to see how things are going. How many extra days are you going to need?" I said, "Didn't you get my card for the wrap party? Day after tomorrow." Then, during editing,

WHAT IT WAS...

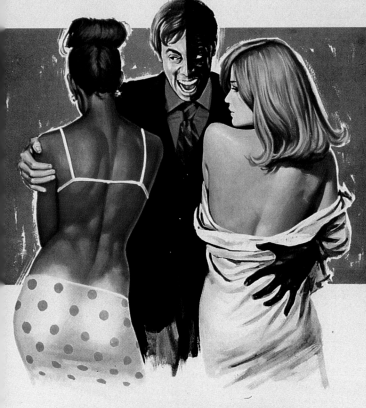

the guy calls me, "Mel, the other ending, we want to try that out to see how it works."

The other ending?, "Yeah, you know where he wakes up . . ." "Lawd have mercy, this colored boy done forgot to shot that part. Oh, lawd, I sorry Cap'n." Now their racism is saying, "Is this nigger fucking with us or something?" They didn't know which foot to jump on. I never shot the other side because you can believe it would have been the other way. Since they didn't give you credit for cleverness, it allowed me a latitude I wouldn't have had.

I do my homework and my homework told me that there was a huge, huge Black audience. But at the time there was the mindset that a Black film could never be a blockbuster. It could do all right but never do good. I said, "Hey, how would you guys know? You never made Black film." They're making *The Liberation of L.B. Jones* and *Lilies of the Field*. They said, "My maid likes it." I said, "She needs her job. She's gonna say she doesn't like it?" Fuck this.

I had a three-picture deal with Columbia, but I struck out on my own. I was paid $70,000 for *Watermelon Man*. I ended up with $72,000 because I kept all of my per diem too. The lab extended credit for the film and processing to me. I must be honest. I led them to believe that I was just shooting a little film for the girl I was trying to get next to. The equipment company gave me the equipment. A loan they said, we'll settle up later. Because when I do my next feature for Columbia, they wanted the business. So, that's how I did it. That's how I got *Sweetback* shot.

When I finished the film, at the very end, I ran out of money. Bill Cosby loaned me $50,000 but he wouldn't take an equity share, "Just give me my money back." Nobody wanted a piece.

I went to the distributor, who said, "What do you want?" I said, "I want a million in front." He said, "A million, what do you mean? What did this cost you?" I said, "Wait a minute, when you buy a Picasso, you don't ask him what the chalk cost." He said, "Why so much?" "'Cause you're going to steal and I want to be able to sleep. Fuck you, I wanna be able to sleep." "Well, no Mel." So nobody would deal with me. There was a company that was in Chapter 11, Cinemation. I made a deal with Jerry Gross. After $5 million, I get 50 percent. Up to that point, it was a 60/40 split. The guy fell on the floor laughing. He said, "Ok, you got it Mel." The day we were getting ready to finish the deal, I got the contract and the contract says, *Sweetback* formerly known as *Sweet Sweetback's Baadasssss Song*. "No,no, this is the title." "Well, I don't understand it." I says, "Who gives a shit?" You don't have to understand the title. People would say, "Mel, what's the title of the film?" *Sweet Sweetback's Baadasssss Song*. "Yea, but what are you really going to call it?" "I'm gonna call it *Sweet Sweetback's Baadasssss Song*." "Yeah, right, you'll never get away with it." I bet people all over the country. The reason I spelled it, *"Sweet Sweetback's Baadasssss Song,"* was so I could get the papers to run it, because they wouldn't run anything. The *New York Times* finally ran it and that's how I got away with it and why I did what I did.

Now *Time* Magazine, *Newsweek*, *New York Times* refused to even review the film. Not to say it was bad, they refused to review it. I decided I was gonna have to be up in your face, stay up in your face. Since I can't count on these people, I don't have to pander to them. That was the start of this whole Black esthetic.

How am I going to advertise the film if I don't have any money? Okay, Black people like music, I'll write a hit song. I wrote a song; in fact, I wrote the whole score. Music was not used as a selling tool in movies at the time. Even musicals, it would take three months after the release of the movie before they would bring out the album. I had this whole marketing idea to use the music to sell the movie. I taught this process to a company called Stax Records. We did so well with this unknown group, Earth Wind and Fire. It was their first album. MGM got so taken by this, they hired the Stax people to bring out their next one, which was *Shaft* with Issac Hayes. That became the whole stencil for using the soundtrack as a marketing tool. Before that Black movie, *"Sweet Sweetback's Baadasssss Song,"* it hadn't been a marketing tool. After that comes the posters or conceptual advertisement. I knew what I wanted, so I designed the conceptuals all myself.

Black films were never shown first run. I demanded that my film be shown first run. Anyway, with all these demands, etc., etc., etc., only two theaters in the United States would show the film. The Grand Circus theater in Detroit and the Cornet in Atlanta, Georgia. The first night, a Wednesday, it broke the record at The Grand Circus in Detroit. *Sweet Sweetback* became the most successful independent film ever released, up to that time.

Sweetback, I considered a very, very revolutionary film. The Black Panther party even required all its members to go see it. However there are aspects of it that can be taken and subverted and it begot the blaxploitation movie.

WHAT IT WAS...

The film was so successful that everybody jumped on the bandwagon. The original *Shaft* was a white guy. So when I made all this money, they threw in a couple of "mother fucks," found a Black guy, and made themselves a Black detective. That's what happened. They took away the political content, the revolutionary aspect, in such a way as to be counterrevolutionary.

On a profound level, Hollywood was in a bind, they wanted the money but they didn't want the message. So, they still kept the Bwana syndrome. *Shaft* was allowed to be flamboyant and do little things. *Foxy Brown* and so forth, but in each case they still had a higher white authority over them. *Cleopatra Jones* was a narcotics agent, so Bwana big daddy, *Shaft* argues with the police commissioner, who gave him a little leeway. "You've got your unorthodox ways, *Shaft*, but you're getting the right thing done." The subliminal message still is the Bwana syndrome.

People sometimes point to *Superfly* as an example of someone escaping the ghetto on his own terms. But you see, on your own terms, without a larger sentiment, is in many ways counterrevolutionary. For example, in the beginning Sweetback was *Superfly* in many ways. After he helped the young activist, the kid said, "What do we do now?" and Sweetback said, "Where do you get that we shit?" But through a series of steps, he realized how he was being used by the system. The first high point was when the guy said, "I can't carry two of you on the motorcycle," and Sweetback says, "Take him, he's our future." Which is the political message of the thing.

I found I was in despair for a while, for a number of years because I felt, Didn't anybody get my message? There were no people immediately after me because they didn't have the infrastructure and they had already been taught they couldn't do it. It was like when somebody broke the four-minute mile, the guys who came before him and immediately after couldn't break it because they were taught that it couldn't be done. But a little further along, boom, the guy said, the four-minute mile, yeah, you can do it. It's so important, the liberation of the mind.

Spike Lee called me the Godfather of modern Black films. That's all fine and people say "Melvin is this what you would have done?" No, I wouldn't have done any of those films. Mario's (Van Peebles, my son) work is not what I would do. I like Spike, I like Singelton, I like Townsend, the Hudlin brothers. I go see all their stuff. Is it my sensibility? No, but I didn't want clones. I just want them to write, to have the opportunity to be who they are and what they are. Color is not monolithic either nor does it have to be.

She's "Ten miles of bad road" for every hood in town!

6 feet 2"
and all
of it
Dynamite!

Cleopatra Jones

starring
TAMARA DOBSON as CLEOPATRA JONES · co-starring BERNIE CASEY · BRENDA SYKES and **SHELLEY WINTERS** as "Mommy"
PANAVISION® TECHNICOLOR®· Screenplay by Max Julien and Sheldon Keller · Produced by William Tennant · Directed by Jack Starrett

PG PARENTAL GUIDANCE SUGGESTED
Some material may not be suitable for pre-teenagers

Celebrating Warner Bros. 50th Anniversary · A Warner Communications Company

WILLIAM MARSHALL

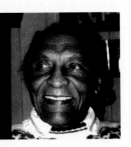

*William Marshall's film career began in the 1950s with **Demetrius and the Gladiators** and **Lydia Bailey**. During the '60s while living in Paris, Marshall organized a march, along with James Baldwin, to coincide with the March on Washington. On his return to the United States, he was very involved in working to improve roles for Black actors and Black-themed projects. In addition, Marshall worked as a professor of Black film and theater at California State University, Northridge. Marshall has had a vast theatrical career. He played the lord in the Broadway revival of Marc Connelly's **Green Pastures** and his performance as Othello in the Irish Theater Festival was called the best Othello of our time. But despite such a theatrical background in a wide variety of roles in movies and TV, Marshall gained his widest recognition for his role as Blacula. Known for his dignified presence and resonant and compelling voice, William Marshall also appeared as Dr. Richard Daystrum on Star Trek. Marshall also played the King of Cartoons on Pee Wee's Playhouse.*

I will live forever!

I daresay the vast majority of people don't go to the theater, so I don't mind that I'm still so strongly identified with Blacula. I did enjoy *Blacula* to a great extent. Early on, young Black people who didn't know my name, would yell at me on the street, "Mamuwalde . . . Hey Mamuwalde!" It was especially pleasing to me that I was being called by the African name that I gave the character. I asked one young fan "Who do you think I am?" He said, quoting from the night club scene, "You know, you're the Strange Dude."

I remember going to several movie houses and seeing the film and seeing the reaction of African American audiences. You couldn't get them to leave, because they hadn't seen anything like this. Who had? Not I.

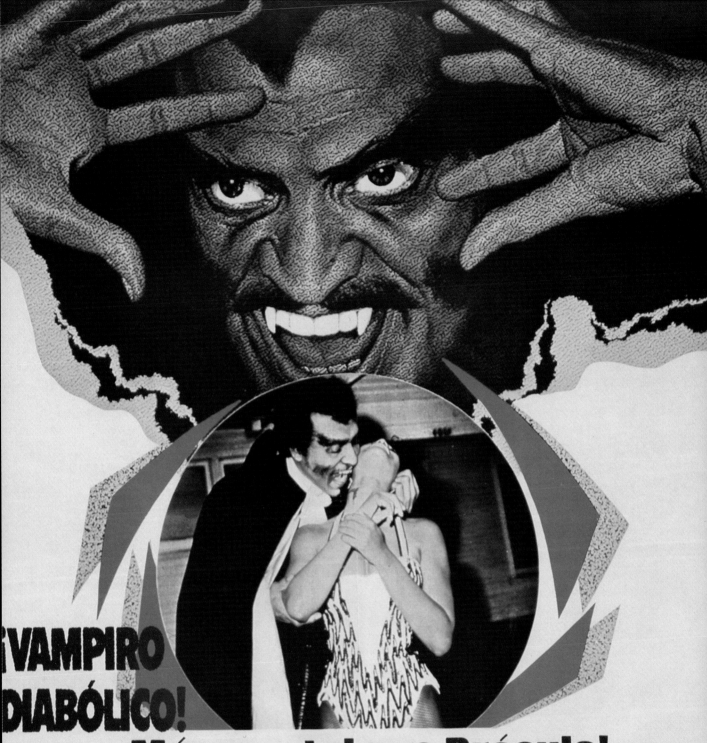

¡VAMPIRO DIABÓLICO!

¡Más mortal que Drácula!

DRACULA NEGRO

ESTRELLAS
WILLIAM MARSHALL • DENISE NICHOLAS • VONETTA McGEE

But certainly they hadn't. And they were so delighted. "There's our representation!" they said. In many theaters throughout the United States when the trailers were shown, the audiences were so wild about the trailers they couldn't stop applauding through the opening of the next feature. The trailers became so popular that people were coming to the theater just to see them. In some places the opening of *Blacula* was postponed so people could continue to enjoy the trailers. People were so excited about seeing people of color on the screen.

I was very amused when I got the call to play Blacula. Change comes in such unexpected ways. I laughed when I saw the movie poster showing Blacula biting the neck of a white woman, but I was not really amused. First of all, that never happened in the movie. I wasn't ready for a sensationalized image of Black-on-white lust to advertise *Blacula*. My contribution to the first story of a Black movie vampire was in a very different direction. Blacula's straight life name was Andrew Brown in the original script, the same as Andy's name in the Black face white comedy team of Amos and Andy. I wanted the picture to have a new framing story. A frame that would remove it completely from the stereotype of ignorant, conniving stupidity that evolved in the United States to justify slavery. I got involved with developing the character. I suggested an African hero who had never been subjected to slavery, an African prince traveling in Europe with his beloved wife, to persuade his "brother" European aristocrats to oppose the African slave trade. After all, how did African people get to the United States anyway? I don't think any of them hitchhiked. While on this moral mission, he succumbs to European vampirism, which he didn't even know existed.

At first the producers didn't know quite how to respond to my suggestions. They'd say, "Well, I don't know if any of that will work." And I'd say, "Well none of us really know, it's an experiment. Getting up and getting out of bed in the morning is an experiment. So its well worth the energy and time, let's look and see and sit down together and talk about it like equals. I stayed with it and looked for ways to try to help them be more accepting. I sketched out a

few scenes to show that the characters of Prince Mamuwalde and his beloved wife Lyuka, played so well by Vonetta McGee worked, that they were attractive, moving, and believable as central figures. After watching the audience enjoy *Blacula*, I felt good. I felt better about the whole thing, about the genre and *Blacula* in particular. The audience laughed, talked, and were excited to see the "African Prince."

I think the producers were quite surprised at how strong the positive response to the film was. They never explicitly thanked me for building the Blacula character or even offered me a bonus, but they were obviously delighted. Not for a moment did they think this was something that would become as meaningful to audiences as it did. It was more, I believe, than they had dreamed it could be.

Blacula isn't a regular vampire, he has a sense of responsibility. Compared to other vampires – mine had a different personality, a couple of different ones. There was Prince Mamuwalde, on a mission of international morality. Then there is Mamuwalde, the husband, in a very tender love story that really matters and endures beyond death. When he says, "I have lived again to lose you twice," you really feel their tragedy. You get a sense of his humanity. Yes, I think my performance as a vampire holds up easily to the performances of other actors.

It was often frustrating when some of the most rotten scripts were sent to me during this period, although I was told that the view was, "If you could get William Marshall to play it—at least it would have a little substance to it. He could elevate it." Saying "No" to bad projects was a contribution, of course, but I would much rather have been able to say "Yes."

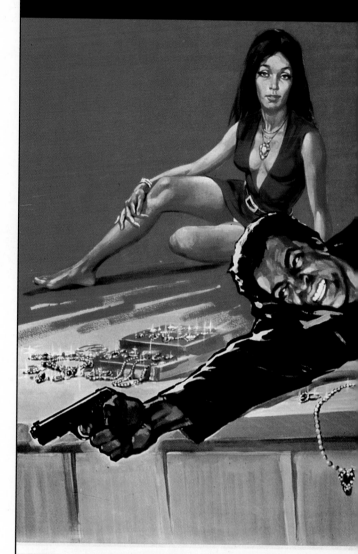

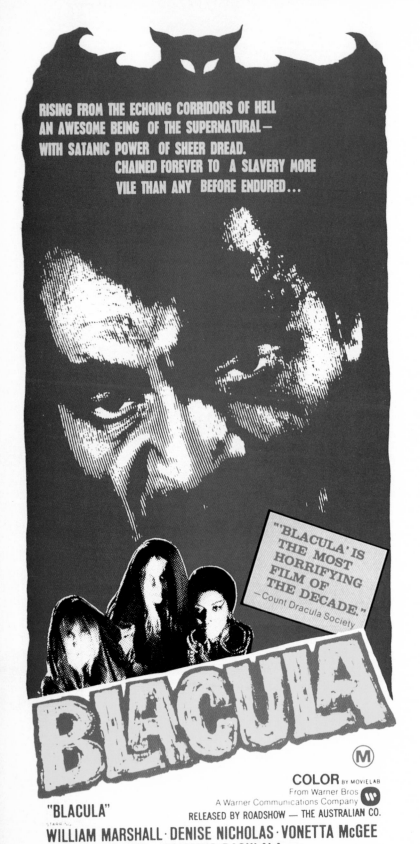

I wasn't pleased with *Abby* because of the overall script. The promised improvements never happened. For me it was a very disappointing experience because the screenwriters had insufficient craftsmanship and knowledge about Africa to create either a rich character or a distinctive story.

It's really not clear to me why the genre stopped, probably because the standard type of movie stories had been used up—the cliched stories that could be refreshed for the moment by using African American actors. By the time *Buck and the Preacher* came along it was very close to some of the historical stories we'd been working on and issues we were struggling to dramatize in our Society for Black Heritage Drama. We still have a number of stories based on the courage, wit, and wisdom of the African Americans that will be done some day, if not by us then by others.

I enjoyed my work as a genius inventor and astrophysicist in *Star Trek*. I felt very good about the role throughout that work, it was new and intriguing and very enjoyable. I was replacing a white actor, I often did that in getting roles for which I was later highly praised. The greatest compliment I received in this business, however, came from the fans. Brothers and sisters would stop me on the street to say that they felt good when I was in a movie and that they never had to worry about being insulted. One young sister said, "I feel safe when you are on the screen."

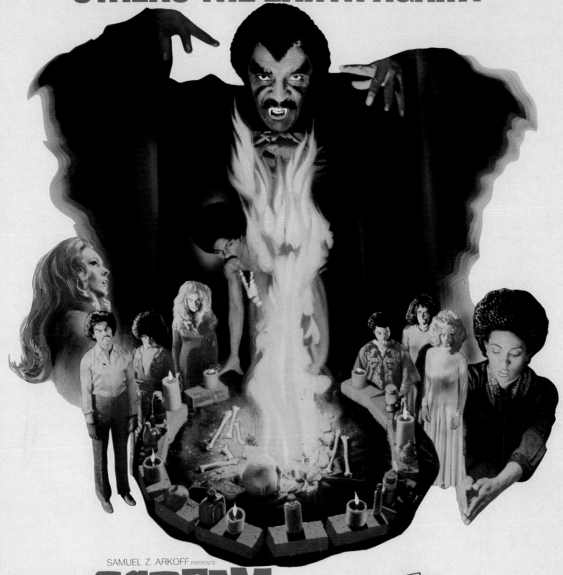

THE BLACK PRINCE OF SHADOWS STALKS THE EARTH AGAIN!

SAMUEL Z. ARKOFF PRESENTS

SCREAM BLACULA SCREAM

AN AMERICAN INTERNATIONAL PICTURE STARRING

WILLIAM MARSHALL · DON MITCHELL · PAM GRIER

MICHAEL CONRAD · BERNIE HAMILTON INTRODUCING RICHARD LAWSON COLOR BY MOVIELAB

EXECUTIVE PRODUCER SAMUEL Z. ARKOFF · SCREENPLAY BY JOAN TORRES & RAYMOND KOENIG AND MAURICE JULES

STORY BY JOAN TORRES & RAYMOND KOENIG · PRODUCED BY JOSEPH T. NAAR · DIRECTED BY BOB KELLJAN

PG PARENTAL GUIDANCE May not be suitable for pre-teenagers

73/211

PAM GRIER

Pam Grier is considered an icon of Black film in the '70s. Grier is acknowledged for her strong contribution to the films of the '70s as a female retro hero that combined both beauty and strength. Uniquely, Pam performed her own stunts. Her first on-screen performance was in the cult favorite **Beyond the Valley of the Dolls.** She also appeared in **The Big Bird Cage.** Grier's popularity soared in the '70s with her starring roles in **Coffy, Foxy Brown, Sheba Baby, Friday Foster,** and **Scream, Blacula, Scream.** Following her film work of the '70s, Grier concentrated on theater work and appeared on television. Grier also appeared in the films **Mars Attacks** and **Escape From L.A.** In 1997, Pam received the Phoenix Award from the Black Cinema Society for her career achievements. Grier played the title role in Quentin Tarantino's **Jackie Brown** for which she received Best Actress nominations from both the Golden Globes and The Screen Actors Guild.

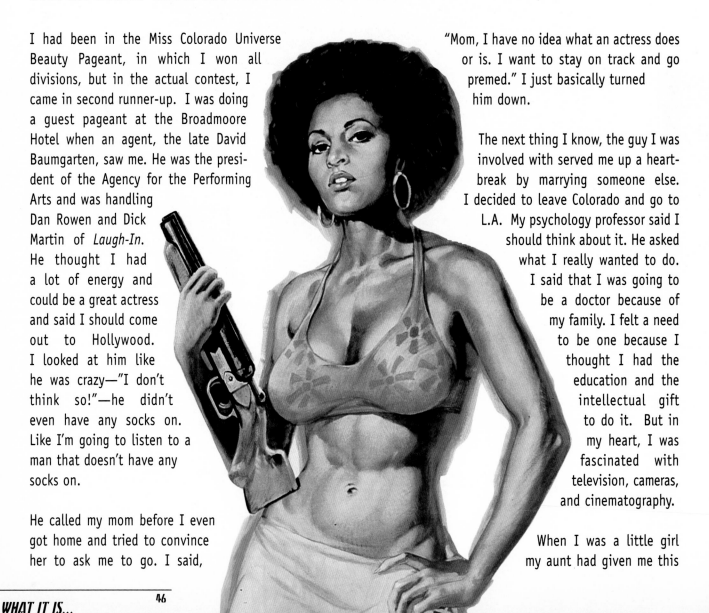

I had been in the Miss Colorado Universe Beauty Pageant, in which I won all divisions, but in the actual contest, I came in second runner-up. I was doing a guest pageant at the Broadmoore Hotel when an agent, the late David Baumgarten, saw me. He was the president of the Agency for the Performing Arts and was handling Dan Rowen and Dick Martin of *Laugh-In.* He thought I had a lot of energy and could be a great actress and said I should come out to Hollywood. I looked at him like he was crazy—"I don't think so!"—he didn't even have any socks on. Like I'm going to listen to a man that doesn't have any socks on.

He called my mom before I even got home and tried to convince her to ask me to go. I said,

"Mom, I have no idea what an actress does or is. I want to stay on track and go premed." I just basically turned him down.

The next thing I know, the guy I was involved with served me up a heartbreak by marrying someone else. I decided to leave Colorado and go to L.A. My psychology professor said I should think about it. He asked what I really wanted to do. I said that I was going to be a doctor because of my family. I felt a need to be one because I thought I had the education and the intellectual gift to do it. But in my heart, I was fascinated with television, cameras, and cinematography.

When I was a little girl my aunt had given me this

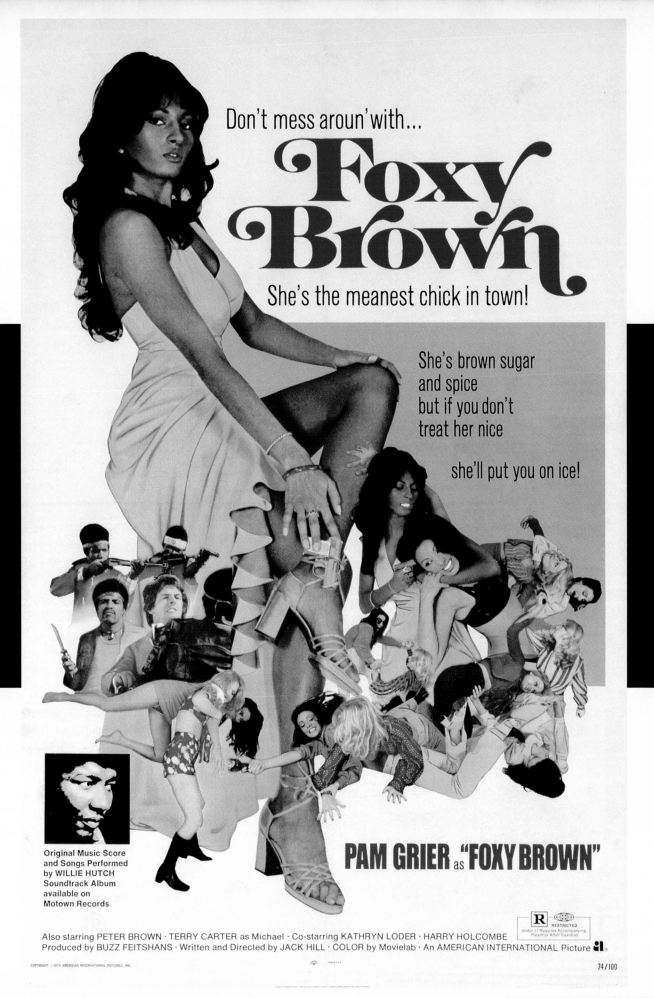

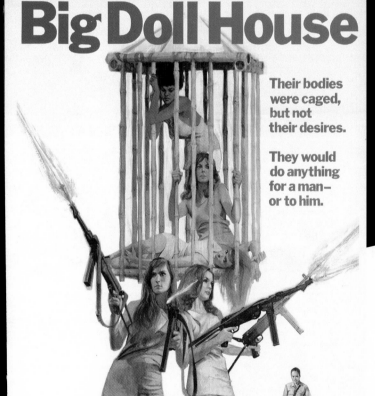

ancient, antique Brownie camera. I used to take pictures and tape them end to end to make a little movie out of them. But we didn't have film schools in Colorado, we weren't being exposed to those ideas. My family to this day doesn't think it's a tangible career. I'm constantly trying to prove to them that it's worth something.

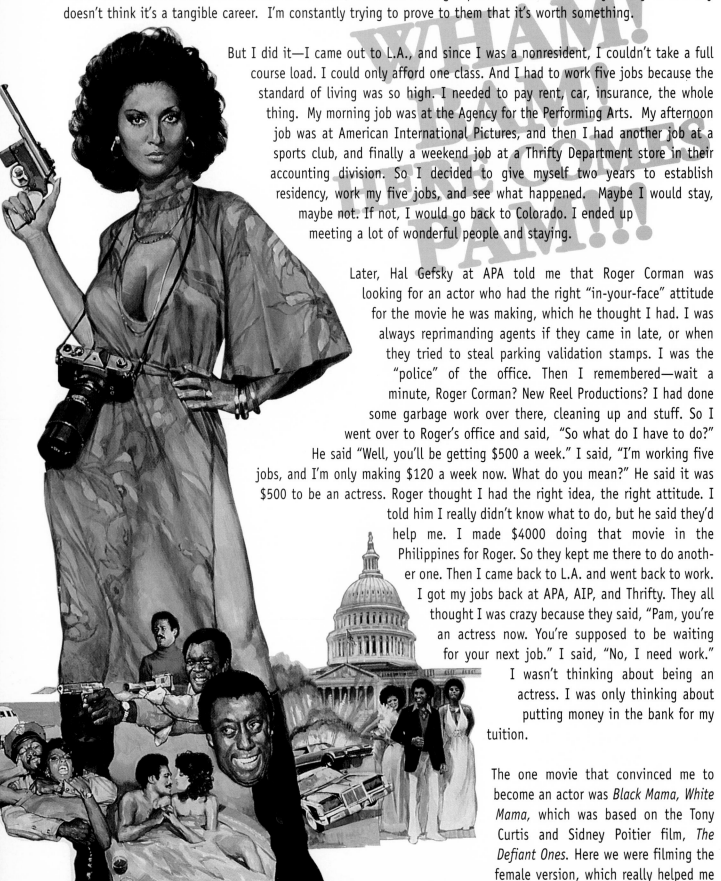

But I did it—I came out to L.A., and since I was a nonresident, I couldn't take a full course load. I could only afford one class. And I had to work five jobs because the standard of living was so high. I needed to pay rent, car, insurance, the whole thing. My morning job was at the Agency for the Performing Arts. My afternoon job was at American International Pictures, and then I had another job at a sports club, and finally a weekend job at a Thrifty Department store in their accounting division. So I decided to give myself two years to establish residency, work my five jobs, and see what happened. Maybe I would stay, maybe not. If not, I would go back to Colorado. I ended up meeting a lot of wonderful people and staying.

Later, Hal Gefsky at APA told me that Roger Corman was looking for an actor who had the right "in-your-face" attitude for the movie he was making, which he thought I had. I was always reprimanding agents if they came in late, or when they tried to steal parking validation stamps. I was the "police" of the office. Then I remembered—wait a minute, Roger Corman? New Reel Productions? I had done some garbage work over there, cleaning up and stuff. So I went over to Roger's office and said, "So what do I have to do?" He said "Well, you'll be getting $500 a week." I said, "I'm working five jobs, and I'm only making $120 a week now. What do you mean?" He said it was $500 to be an actress. Roger thought I had the right idea, the right attitude. I told him I really didn't know what to do, but he said they'd help me. I made $4000 doing that movie in the Philippines for Roger. So they kept me there to do another one. Then I came back to L.A. and went back to work. I got my jobs back at APA, AIP, and Thrifty. They all thought I was crazy because they said, "Pam, you're an actress now. You're supposed to be waiting for your next job." I said, "No, I need work." I wasn't thinking about being an actress. I was only thinking about putting money in the bank for my tuition.

The one movie that convinced me to become an actor was *Black Mama, White Mama*, which was based on the Tony Curtis and Sidney Poitier film, *The Defiant Ones*. Here we were filming the female version, which really helped me

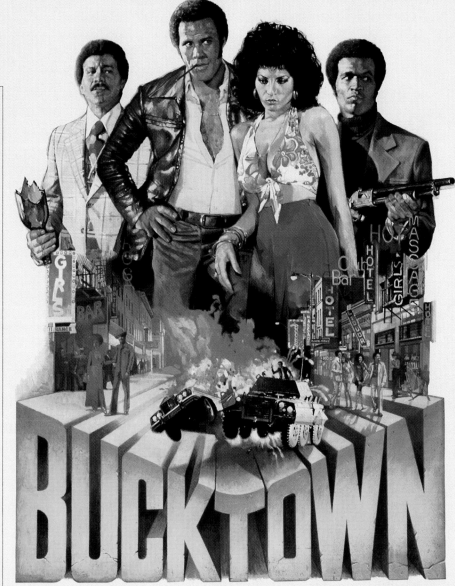

WHATEVER YOU WANT THEY'VE GOT...
and Bucktown is where you'll find it!

BUCKTOWN

starring

FRED WILLIAMSON · PAM GRIER
THALMUS RASULALA · TONY KING

BERNIE HAMILTON · Music by JOHNNY PATE · Written by BOB ELLISON
Produced by BERNARD SCHWARTZ · Directed by ARTHUR MARKS · COLOR PRINTS BY MOVIELAB

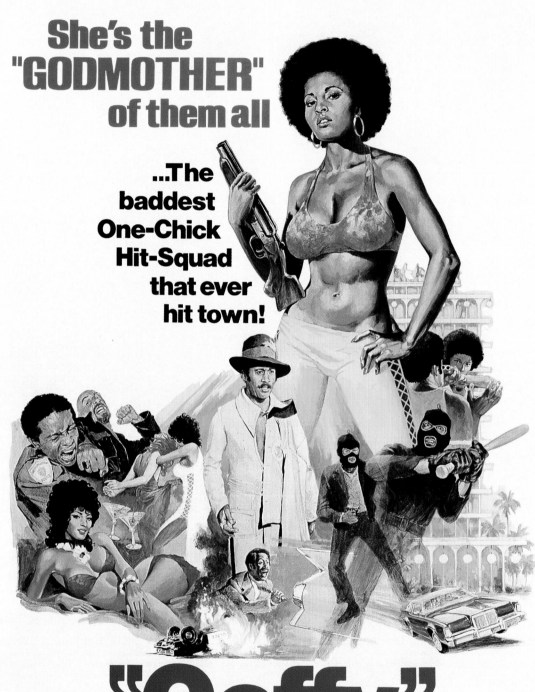

She's the "GODMOTHER" of them all

...The baddest One-Chick Hit-Squad that ever hit town!

"Coffy"

R RESTRICTED
Under 17 Requires Accompanying Parent or Adult Guardian

ai ® Samuel Z. Arkoff presents
an American International Picture
"COFFY"

starring
PAM BOOKER ROBERT WILLIAM ALLAN and
GRIER BRADSHAW DOQUI ELLIOTT · ARBUS SID HAIG

Produced by Robert A. Papazian · Written and Directed by Jack Hill · COLOR by Movielab

as Vitroni as Omar

COPYRIGHT ©1973 AMERICAN INTERNATIONAL PICTURES, INC.

73/157

"COFFY"

focus as an actor. I didn't think I had the capacity to do that, since the examples that were being put in front of me were all about physical and aesthetic beauty. I didn't have a sense of myself yet or what beauty meant to me. It didn't fit with my upbringing to look at one person and see them as more beautiful than the next person. *Greased Lightning* with Richard Pryor was also a favorite—to work with him was a great opportunity back in '76. But it was interesting to see how the movies—especially *Coffy*, *Foxy Brown*, and *Sheba*—reflected the Black community through language and music. We basically documented what was going on . . . musically, religiously, and politically. I appreciate that happening now because now we can look back and see what we were about, and what we were saying. In the '70s we reaped the rewards of the '50s and '60s—we had lovefests, Woodstock, the power of love was exploding. It was a time of freedom and women saying that they needed empowerment. There was more empowerment and self-discovery than any other decade I remember. All across the country, a lot of women were Foxy Brown and Coffy. They were independent, fighting to save their families, not accepting rape or being victimized. I just happened to be the first one that these filmmakers—Roger Corman, Jack Hill, Sam Arkoff and AIP, found to portray that image. I was a tomboy and a physical athlete but I also had these images of the women in my community who were standing up to the world and saying, "Oh no, you're not going to steal the last five dollars I have to feed my children with. You're not going to rob my house. I'm going to get a job. I'm going to do these things to save my family and myself." This was going on all across the country. I just happened to do it on film. I don't think it took any great genius or great imagination. I just exemplified it, reflecting it to society. So I'm not taking any credit for it . . . So there!

Foxy Brown, the rapper who has taken the name, and I talk all the time. She's seventeen going on eighteen. Just by using that name, she's saying "I'm independent and I will try to use my own wits and intelligence to get by, and to get over and learn." Some people say that Foxy Brown is a castrating character, but the truth is she just doesn't need a man. Personally, I still like having a man protect me, that's still part of the process and the evolution of mankind, but if he's not around, I'm not going to be a victim. I can take care of myself and my family if he's not around. If I have a man, we can fight together. But if a man approaches me and says something unkind I expect him to step up. Period. If he doesn't, I'm going to be in his face, because that's the way I am. You can stand up by yourself, if necessary, and that's what Foxy Brown and Coffey are all about. Nowadays, you don't have to lose your femininity to be powerful, you maintain it. You can have high IQ's, study, take martial arts, whatever . . . It's very different than male power. Just maintain that female power always. Now I see young women in the hood dressing like men in very masculine clothing because to them, that's a sense of empowerment. I really question the significance of such a statement.

Regarding my role in *Jackie Brown*, "I don't wait. I'm an active person." Jackie is a woman in her forties who has taken her falls but still kept her looks and maintains a lot of energy. I think a person succeeds when they recognize their failures. She doesn't have control of her life, but she's saying "I have allowed people to ruin my life, and now it's time for me to control it." Jackie uses her wits to win. But on her own, with her own methods—namely style and intelligence. I think she embodies the human will and spirit to win and heal and survive against all the odds, and all the bad things that happened to her. She's not very good at being a victim, which I like about her. We're both like that. Me, I'm going down kicking and screaming, and I'll have someone's eye in my hand, and that's who Jackie is too. Quentin felt that he had to have a woman who can embody the will to survive. I, Pam Grier, survived twenty years in this business, and I've got the scars to show for it. But guess what? I didn't fall through those failures. I succeed again! I'm blessed. But you know what? I got my womanhood from my society, from my community, by listening to people, from being taken care of by the wonderful women in my family, by learning from people, by giving and taking. It all pays off. It comes from somewhere. I know I'm a messenger.

WHAT IT WAS...

DAVID WALKER

David Walker attended New York's prestigious School of Visual Arts after graduating from high school. In 1988, he decided to pursue a career in film. Since then he has worked on features, commericals, TV shows, industrial film, and music videos. His latest work in progress, Macked, Hammered, Slaughtered and Shafted, *is a film documentary exploring the cultural importance of Black films of the '70s. He is also the editor and publisher of the magazine,* BadAzz MoFo.

There has been a lot of speculation about the origins of the term, "blaxploitation." Based on my research, a man named Junius Griffin, who was the head of the Hollywood chapter of the NAACP at the time, coined the term in an August 16, 1972, *Variety* story headlined "NAACP Blast Super Nigger Trend." The word *blaxploitation* had not been used at this point. They're still calling them Black exploitation films. But by the end of August 1972, Griffin, along with Roy Innis of CORE and others, formed the Coalition Against Blaxploitation. In an August 28, 1972, *Newsweek* story reporting on the formation of the Coalition Against Blaxploitation, it states CAB was ". . . founded by Junius Griffin, who resigned last week as president of the Beverly Hills chapter of the NAACP. CAB plans to institute its own ratings system of Black movies." His name is in every article that deals with different civil rights organizations protesting what started out as Black exploitation and then turned into blaxploitation films. His name is consistently attached. People that I personally interviewed, Ron O'Neal, Max Julian, and Roland Jefferson, all say that he is the one who coined the term blaxploitation. One interesting note: Griffin was a press agent who weeks before had tried, and failed, to get the *Superfly* account from Warner Bros. *Superfly* was one of the pictures specifically targeted by CAB.

Whatever Griffin's intentions were, the term took on a life of its own. The term was often used in a negative way. While I do believe the term blaxploitation is racist, the term exists. It serves as a marker or a milestone for this era in the history of film. To denounce it or deny it isn't going to make it go away. What people need to do is learn what that era was all about and what those films were all about and maybe that will take away some of the sting that word has for a lot of people.

There have been many definitions. I have two definitions of blaxploitation. The first is the era itself, roughly from 1970 to 1979. The other definition is the genre. It is the films that were produced within that era that deal with a Black subject matter. It doesn't necessarily have to be a film that is produced and directed by Black people but it had a running Black theme or a predominately Black cast, or dealt with issues that, at least as Hollywood perceived it, were African American in nature.

YOUR KIND OF BLACK FILM

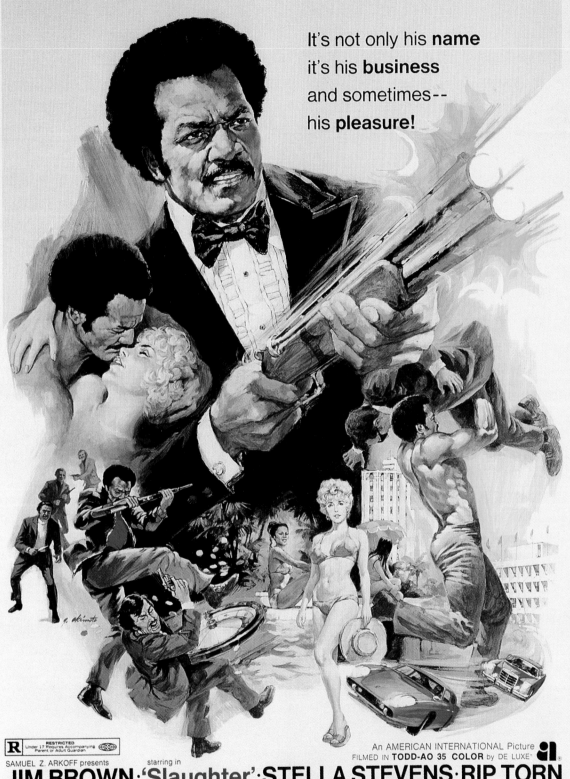

WHAT IT WAS...

Most film historians say the blaxploitation era started in 1971 with *Sweet Sweetback* and *Shaft*. They were the films that proved that there was a hardcore urban audience. In 1972, you had these follow-up films: *Blacula*, *Superfly*, *Across 110th Street,* and *Lady Sings the Blues*. Those films did stellar box office. From mid-1972 on, companies like American International Pictures really began pushing their product. In 1973, *Black Caesar*; the first of Pam Grier's movies, *Coffy*; *The Mack*; *Cleopatra Jones*; *Slaughter's Big Ripoff*; and the documentary *WattsStaxx* were released. The year of the blaxploitation film was 1973, at least the majority of the ones that people think about and really know were released that year. By 1974, things almost become legitimized. Cosby and Poitier did the first of their comedies together. Then in 1975, we get *Cooley High*. By 1975, the genre was doing two things: It was moving off in slightly different directions—there were more *A* Films. *Car Wash* is considered by many to be one of the *A* films of that era along with *Greased Lightning* and *Blue Collar*. The other aspect of the genre was quickly going into the toilet in that year. Some of the worst films of the genre were also released. I should point

out that by the time *Car Wash* was released it was almost like those films had become completely legitimate. Richard Pryor had moved into leading man roles but everybody else was working less and less. There were some straggling remnants, movies like *Youngblood*, for example, but by 1977, it was over. For the sake of argument, I like to say that *Penitentiary* was the last blaxspolitation film. It was released in 1979, the end of the '70s, so it was really the last film of that era.

At the very least, the blaxploitation movies played a very integral role in keeping a lot of production companies afloat or solvent. When you look at how many movies were produced form 1970 to 1979 and the amount of money those movies made, there's no denying that this was one of the bread-and-butter genres of the film industry.

Box Office grosses are the total amount that a movie brings in. That's the standard figure that *Variety* reports after the opening week. Film rental is what the m o v i e makes

IT RIDES WITH THE GREAT WESTERNS

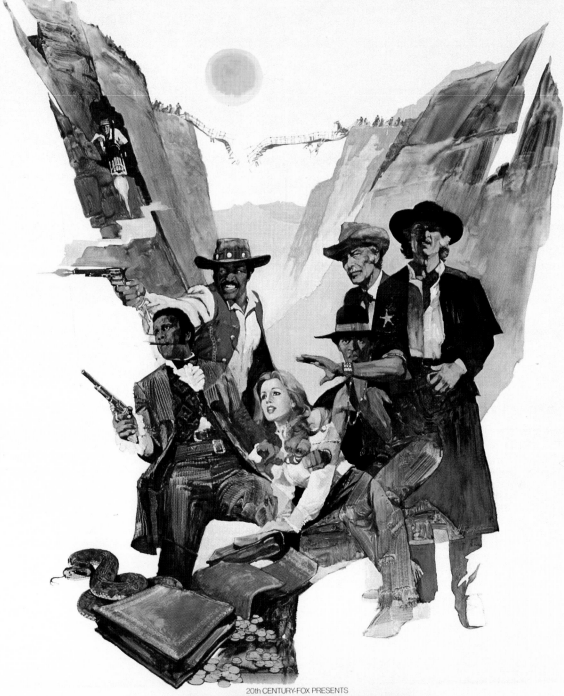

20th CENTURY-FOX PRESENTS

JIM BROWN LEE VAN CLEEF
FRED WILLIAMSON CATHERINE SPAAK
JIM KELLY BARRY SULLIVAN

A BERNSEN-LUDWIG-BERCOVICI PRODUCTION

TAKE A HARD RIDE

CO-STARRING **HARRY CAREY, JR.** · **ROBERT DONNER** · **CHARLES McGREGOR** · GUEST APPEARANCE BY **DANA ANDREWS** · PRODUCED BY **HARRY BERNSEN**

PG PARENTAL GUIDANCE SUGGESTED DIRECTED BY **ANTHONY M. DAWSON** · WRITTEN BY **ERIC BERCOVICI** AND **JERRY LUDWIG** · MUSIC BY **JERRY GOLDSMITH** · COLOR BY DE LUXE

PRODUCTION SERVICES BY EURO GENERAL PRODUCTION COMPANY FOR GRAVURE MAATSCHAPPIJ N.V.

WHAT IT WAS...

after exhibitors and distributors take their share. The term "film rental," which is always a much smaller figure than the box office gross, is the amount of money that was actually made by the people who produced the film. The percentages are always quite different because some movie producers are going to get a higher percentage. But for blaxploitation movies, you were looking at a fifty-fifty split. So if a movie made $2 million in rentals, it's safe to say that the movie made double that, and that half went to cover the distributor/exhibitor cost. Look at the fifty top grossing films, according to *Variety*, for the week ending September 27, 1972. The number one grossing film in the country that week was *Superfly*. The number three film, *Come Back, Charleston Blue*. The number six film, *The Man*. The number seven film, *Hickey and Bogss*. The number nine film, *Slaughter*. Then on down the line you have *Melinda*, *Hammer*, *Blacula*. Out of the top fifty films, 16 percent were blaxploitation or Black-related films.

Here are the domestic rentals for some of the movies of the era:

Title	Domestic Rentals	Title	Domestic Rentals
Abby	$2.6 million	*Let's Do It Again*	$11.8 million
Cotton Comes to Harlem	$5.1 million	*Car Wash*	$8.5 million
Across 110th Street	$3.4 million	*Lady Sings the Blues*	$9.6 million
Dolomite	$1 million	*Cleopatra Jones*	$4.1 million
Black Godfather	$1.3 million	*Mandingo*	$8.6 million
Hell Up in Harlem	$1.6 million	*Coffy*	$4 million
Blacula	$1.9 million	*The Mack*	$4.3 million
Legend of Nigger Charley	$3 million	*Cooley High*	$2.6 million
Candy Tangerine Man	$1 million		

One of the reasons the '70s blaxploitation films were so successful was that, for the most part, they were really low-budget productions. But they'd turn around and make a lot of money. Some examples:

Title	Estimated Production Cost	Box Office Gross
Sweet Sweetback's BaadAsssss Song	$ 150,000	$ 15,180,000
Shaft	$ 1.2 million	$ 23,250,000
Cotton Comes to Harlem	$ 2.2 million	$ 15,375,000
Superfly	$ 149,000	$ 18,900,000
Coffy	$ 600,000	$ 12,944,000

These figures speak for themselves. There were nearly two hundred films that we call blaxploitation.

There were a number of factors in the demise of the blaxploitation era. The campaign by the civil rights organizations had an impact on the studios. When you have a group of political activists who are using every opportunity to make a soundbite and denounce an entire genre, it doesn't help anybody's cause. There wasn't a lot of emphasis put on variety or originality in the films. The same stories rehashed over and over again, watered down variation of the same themes: the get whitey movies. The budgets were increasingly smaller and smaller. When you have smaller budgets and the same story being retold for the third or fourth time you lose your market, lose your audience. There were other aspects as well.

There were an increasing number of white people moving to the suburbs so they began building movie theaters out in the suburbs where there weren't as many Black people. One of the main reasons blaxploitation came about was that you had these theaters that were in the inner cities in Chicago, New York, Washington, D.C., and parts of Los Angeles that were empty because so many white people had left the inner city for the suburbs. You had these empty theaters and you needed something to get people into these theaters. Hollywood didn't have that many blockbusters in the early '70s; *The Exorcist* and *The Godfather* were two exceptions. You had these theaters in the inner city and Black people in the inner city. Hollywood came up with a formula to combine the two. The result is what we call blaxploitation. Then in 1975 *Jaws* started bringing white people back into the theaters. When *Star Wars* and *Superman* were released, there were more and more multiplexes in the suburbs. Then in the '80s you had the *Friday the 13th* series and the *Nightmare on Elm Street*

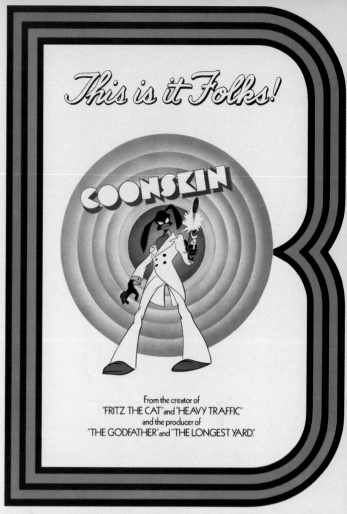

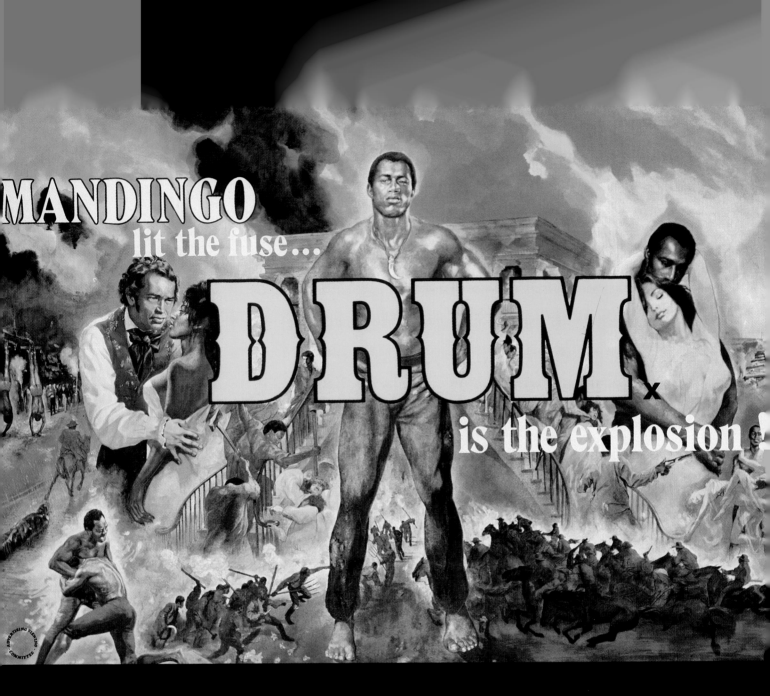

MANDINGO lit the fuse... DRUM_x is the explosion!

series, and the other slasher movies. Suddenly, Hollywood had a venue and they had films and they had an audience that really precluded Black people. It wasn't necessary to make product for this audience because they had rediscovered their original audience, the white teenagers and working-class Americans.

I think one of the things that really lead to the demise of the genre and people's careers was that Black filmmakers as a whole, the Black community and Black businessmen, never rallied to the idea of producing films themselves. Had we done that, we could have continued to control, granted a very small, niche market, but we would have been able to grow. We would have given ourselves the opportunity to grow that we complain that main stream Hollywood never gave us. But instead we kept waiting for them to deliver us our salvation. It was, in some ways, like the welfare system. We were more than happy to take the money that they gave us. There were some exceptions.

Superfly and *The Spook Who Sat by the Door* were independently financed by Black entrepreneurs. But by and large most of them were produced by white studios.

My belief is this: Hollywood, and the entertainment industry as a whole, only utilizes its Black players when it is in a bind. We see a new resurgence of Black films when white films aren't making as much money or they are not getting enough of the Black audience. During the '80s all the factors that lead to the demise of blaxploitation—new theaters in the suburbs, the return of the Big Picture and the political backlash—were the same things that kept any major Black stars from rising. No one came along and said, "Okay, we are going to finance our own films," until Spike Lee did it. He financed *She's Gotta Have It* and proved a lot of things. There's still a Black audience hungry for product but also that they were hungry for something other than the Eddie Murphy and Whoopie Goldberg stuff that was being forced upon us.

What we are seeing today is a direct by-product of the barriers that were broken down during the blaxploitation era. Just as what we saw during the blaxploitation era was a result of the intense sacrifice of people like Oscar Michaeux and Spencer Williams during the '20s, '30s, and '40s. Films like *Waiting to Exhale* and *Soul Food* are a nice break from the 'hood films like *New Jack City*, *Boyz N the Hood,* or *Menace II Society*. We

are finally getting to see more diversity but we're still not seeing as many films. When we can look back and say they produced over two hundred Black films in the '90s and there was a wide variety of them, then maybe we've made some huge strides and huge advances. On the surface it might seem that things are better but it's not necessarily so.

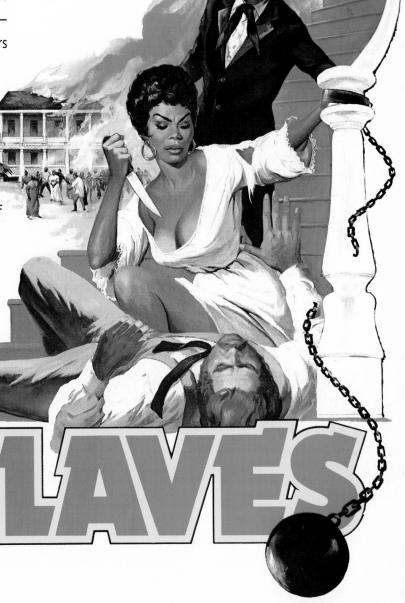

61

ROSCOE ORMAN

A native New Yorker, Roscoe Orman is best known for his character, Gordon, on Sesame Street. He made his acting debut in the 1962 production of If We Grow Up. He spent two years touring the South with the Free Southern Theater before returning to New York. He amassed a long list of credits including being a founding member of the Lafayette Theater where he both acted and directed; worked with Joseph Papp's Public Theater, the Negro Ensemble Company, and he appeared in August Wilson's award-winning Broadway production of Fences. His film credits include: Willie Dynamite, Follow that Bird, F/X, and Full Court Press. He has toured the country in his one man show, Gordon of Sesame Street Show, and in Matt Robinsons's The Confessions of Stepin Fetchit.

Willie Dynamite was my first feature film. The director, Gilbert Moses, and I had worked together in theater prior to that a number of times. He was also one of the founders of a theater troupe of actors and theater artists who traveled the South during the civil rights era performing plays. I joined up with them after their first year and did a few seasons. That's how we got to know each other originally, and then later on we worked together a little bit more in New York. He suggested me to the producers Zanuck & Brown. I came out and did a screen test and I was told I was the unanimous choice just based on the test. So it was really a good opportunity for me and for Gilbert Moses; it was his directoral debut.

One of the things that Gilbert and I decided was to do as much research as we could into the whole lifestyle of prostitution and pimps and the relationships between the pimp and his women. There were a few prototypes that we found, one was *Pimp* by Iceberg Slim. The *Willie Dynamite* character, at least in our conception, had a certain charm about him and a sense of charisma that allowed him to exercise control without a lot of external force. He was more of a very persuasive and charismatic character.

There was a warm kind of creative environment on the set because Gilbert and I had that kind of a relationship. I think all of the people that he and the producers selected were really chosen for that kind of collaborative ability. We did a lot of rehersals, especially the important scenes, before we got into the shooting schedule. I really enjoyed the process of exploring the character and relationships.

There was a tragic aspect to the production. My co-star, Diana Sands, was a really popular New York stage actress who did quite a few films as well. *Willie Dynamite* was her last film before she died. She was diagnosed with cancer while we were filming. We had to take a short break in the shoot so that she could be tested and diagnosed. She bravely continued after finding out what her condition was. None of us really knew about it until after the fact. She didn't live long enough to see the film in its entirety. It was really a tragic part of that whole experience for all of us.

Ain't no one crosses WILLIE "D"
He's tight, together, and mean.
Chicks, Chumps, he uses 'em all.
He's got to be Number-One.

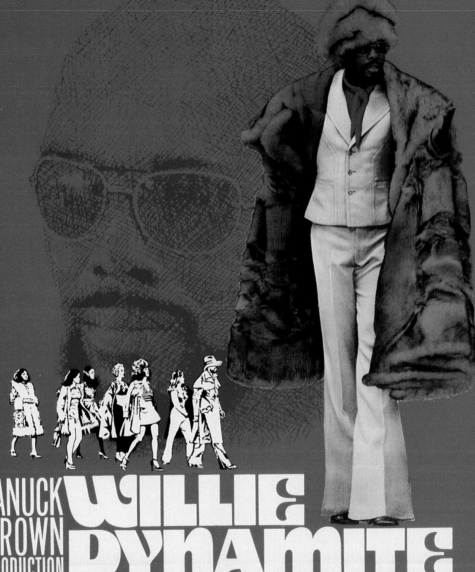

A ZANUCK /BROWN PRODUCTION **WILLIE DYNAMITE**

STARRING
ROSCOE ORMAN · DIANA SANDS · THALMUS RASULALA · ROGER ROBINSON

AND INTRODUCING SCREENPLAY BY STORY BY
JOYCE WALKER RON CUTLER JOE KEYES JR. and RON CUTLER

DIRECTED BY PRODUCED BY
GILBERT MOSES RICHARD D. ZANUCK and DAVID BROWN A UNIVERSAL PICTURE
TECHNICOLOR ®

MUSIC BY LYRICS BY
J.J. JOHNSON GILBERT MOSES, III

Original Soundtrack
Album available exclusively
on MCA Records & Tapes

R RESTRICTED
Under 17 requires accompanying
Parent or Adult Guardian

ie Dynamite was one of the early films produced by Richard Zanuck and David Brown. They had a string
cessful movies including *Jaws*, *The Sting,* and years later, *Driving Miss Daisy*. The same year that we were filmi
ie Dynamite, they were also producing *The Sting*. I think we may have suffered in the kind of promotion that v
eived. We might have had more promotion if they weren't working on something that was as big a commerc
cess as *The Sting*. But I think artistically, especially for a first feature by a director, *Willie Dynamite* was not
film at all. I certainly had a good time working on it and learned a lot.

ie Dynamite, *The Mack, Superfly,* and even the *Shaft* series, represented a genre of film that is kind of primitiv
he sense of where Black film is now. I think it was a necessary stage for Black film artists to move through. If v
at the films of the '70s from that historical perspective, we don't necessarily have to categorize them as bei
oitive. The writing on a certain level wasn't that advanced. It had action and characters that the gener
ience, and the general Black audience, could relate to and recognize.

of these films was raw in its honesty and its ability to not really hide from what it was depicting ar
rying to explore the truth in those characters and their society. *Superfly* in particular had a combination
ments, not the least of which was the music. I thought Curtis Mayfield's score captured a certain pulse, a certa
ment of style and language and rhythm that brought those characters and that lifestyle to a much, much full
ression. I felt the same was true with Isaac Hayes's music for the *Shaft* series. There was a certain element of th
Willie Dynamite and *The Mack* and the others, but I think the musical elements in those films in particular real
ghtened the reality, so there was a real forcefulness that would not have been there without that contribution

films were commercially viable. There was some good work done. I personally, and those of us who worked c
ie Dynamite, were trying to do the best work that we could. We all learned from it. People like Spike Lee ar
ers, if they're students of the history of film, can learn from it as well.

he early '70s, there had begun to be a movement of exploration of Black themes. It was a body of work and
y of experience that would have evolved into doing a much more varied collection of work. I looked at those fil
a kind of entry level for Black actors and directors to at least get in the business. There was also more of a

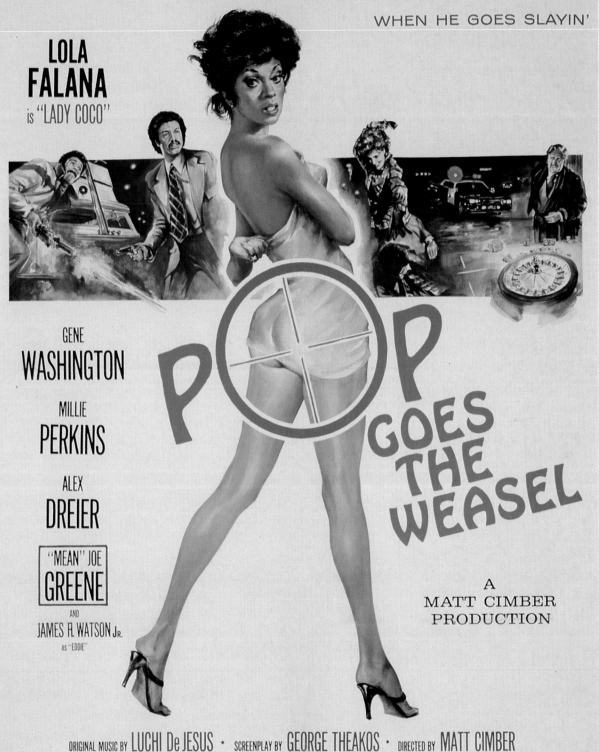

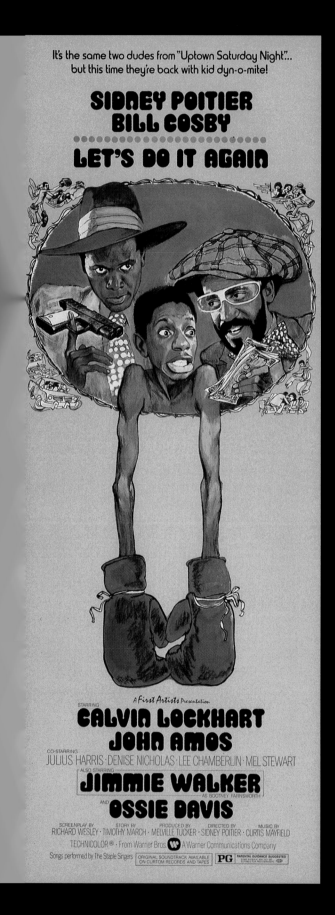

There seemed to be a couple of dynamics going on. One was the reaction from a certain segment of the Black community against films that showed the "negative aspects of Black life." Films dealing with prostitution, gangsters, and a certain street life that didn't reflect the middle-class values that a lot of the critics represented. When that kind of reaction comes from within a segment of the Black community itself, then Hollywood feels that it can legitimately respond by doing nothing, rather than responding by doing something different. A lot of the Hollywood establishment decided, I don't know if they used it as an excuse, that it wasn't viable to continue doing Black films. They could have, and in some cases they did, choose other kinds of subject matter, like *Sounder*. There were a few other films that dealt with family subjects and a variety of variations on Black life. But for the most part, they just retreated. I don't think the industry per se has ever really had the ability to see beyond a certain framework of commercial viability.

I think each new level comes from within a certain really viable creative force that needs to be expressed. But that doesn't come from within Hollywood, I think it comes from the artists themselves. That didn't really happen until the '80s, when things started happening with Spike Lee and others. They brought a new wave of interest in Black films and various subjects dealing with Black characters. That was something I had hoped might have happened after the early '70s but didn't.

One of the most significant aspects of the current work and the wave of work that seems to have developed is the larger sense of the business of filmmaking. Back in the '70s, the filmmakers, directors, and actors were not so much plugged into becoming power brokers and forces within the industry. With the exception of Melvin Van Peebles, who was really a visionary in that sense. The primary purpose that *Sweetback* served historically was that it was created totally independently of the Hollywood industry.

THE ADVENTURE MOVIE TO END THEM ALL!

HOT POTATO

A WEINTRAUB-HELLER PRODUCTION · JIM KELLY · GEORGE MEMMOLI in "HOT POTATO"
Starring GEOFFREY BINNEY · IRENE TSU and JUDITH BROWN as Leslie · Produced by FRED WEINTRAUB
and PAUL HELLER · Written and directed by OSCAR WILLIAMS · From Warner Bros Ⓦ A Warner Communications Company

PG | PARENTAL GUIDANCE SUGGESTED ⊛⊚⊛
SOME MATERIAL MAY NOT BE SUITABLE FOR PRE TEENAGERS

It was based on this vision of this singular guy, Melvin Van Peebles, who conceived it, wrote it, directed it, produced it, and starred in it. But even he was not able to establish any kind of continuity in that effort. Now there is at least the understanding that there be some way of addressing the business. Even establishing studios and obtaining some real positioning within the industry that allows for a continuity of work can really make things happen. We have to get beyond these spurts of activity and then recession into nothing or very little, then another spurt ten years later. There has to be more of a connection to the business of filmmaking as a continuous industry, either by it becoming more powerful within the industry as it exists or by establishing other entities of our own that are independent. There's a much stronger sense of that now than there was back then.

The films of the '70s are viable films. They're credible, they're expressions of that time and of those artists and subject matters. They should be accepted just on that basis, just as when people look back at Paul Muni, Jimmy Cagney, and Edward G. Robinson movies. They look at them as expressions of their times, and valuable and viable ones. But by categorizing and labeling, just as Stepin Fetchit was labeled and the Black exploitation films were labeled, you oversimplify and take away the viability of the work by not giving them the respect they deserve. I think those labels tend to do that. We have to get to a point where we can look at the work for what it was within its time. We all can learn from it and I think appreciate the value that it had. As a whole, we have not done that with the films of the '70s.

There was one landmark film I saw that comes from a different genre and a different period. *Nothing but a Man* from the '60s with Ivan Dixon and Abbey Lincoln. This was one of the seminal pieces in my early film viewing that really inspired me a great deal as an actor. That's the kind of character, a figure of such simple strength and dignity, that we have yet to really come back to; where we're just telling real human stories, simply and honestly, things that obviously transcend race and ethnicity and culture. It's about what it means to be a human being. Ivan Dixon also directed *Trouble Man*. But my sense is that Ivan became really disillusioned with the whole system. He spent all those years afterward doing *Hogan's Heroes*. He had to put food on the table. He got himself a little niche similar to what I've done with *Sesame Street*. The system is such that someone like an Ivan Dixon or Ron O'Neal or Max Julien, or whoever may have had early experiences that would have or maybe should have led to other kinds of opportunities. But they were jut not there for them; for those particular types of talents, at that particular time, I think the Laurence Fishburnes and Denzel Washingtons are heirs to that.

Each stage of work that has been achieved by Black artists in film has been in some way, either directly or indirectly, built upon past successes and experiences, even if there were large gaps between these movements. I really would like to see more attention paid to the history of Black cinema and to really examine these different ways and these different periods, and really understand that there is a tradition that they are a part of. They can do whatever they want with it and find their own voices. But these are, I think, very valid and viable bodies of work for them to study and to use. I don't think there's enough of that and I don't think that kind of respect is paid to the past works.

Double Prize Winner
—Venice Film Festival

"NOTHING BUT A MAN"

starring IVAN DIXON / ABBEY LINCOLN with Gloria Foster & Julius Harris
Produced by Robert Young-Michael Roemer-Robert Rubin / Directed by Michael Roemer
Written by Michael Roemer and Robert Young / A Roemer-Young
Du-Art Production / A Cinema **V** Presentation.

ROGER CORMAN

Since 1953, filmmaker Roger Corman has directed and/or produced more than 215 films and television programs. He retired from directing in 1971 to concentrate on production and distribution through his company New World and later Concorde, primarily making low-budget films.

Roger was involved with a number of the "blaxploitation" films, including **Big Doll House,** *featuring Pam Grier;* **TNT** Jackson, *featuring Jeanne Bell; and* **Savage!,** *featuring James Englehart and Carol Speed.*

Starting in the '60s, the major studios were realizing that the independents and counterculture were making a type of film that was cutting into their audience. As intelligent executives, they decided to make similar films. I think the term "blaxploitation" denigrates and somewhat trivializes the films, many of which were quite serious in their intent—the intent being to show Black people in a position of strength, not in the traditional subservient role. They empowered Black people because the films showed that they could become the protagonist and, particularly in the so-called blaxploitation films, become the strong protagonist of action films. I would prefer to refer to them as Black-themed action films or just Black-themed films.

The whole concept of equal rights and the Black Power movement during that time created the opportunity for these types of films to

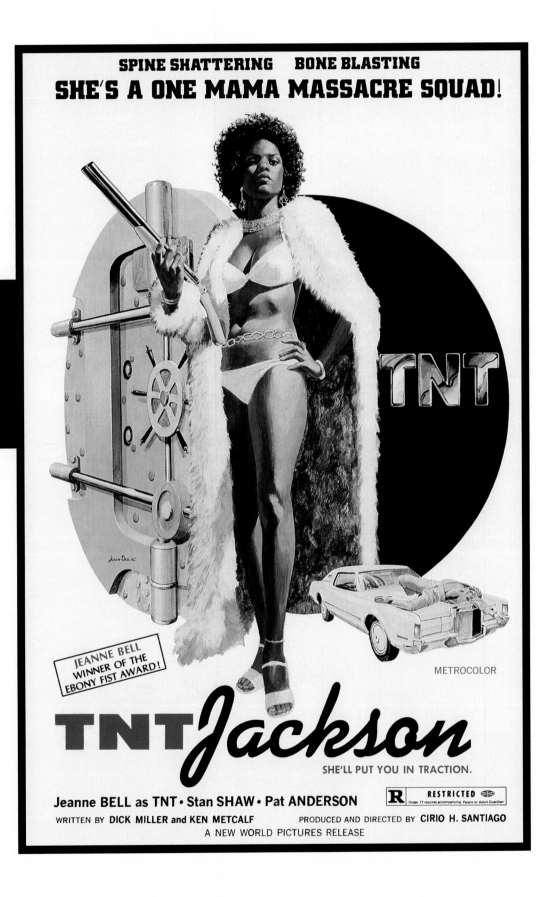

WHAT IT WAS...

succeed. But to produce films only for that 10 percent of the country didn't really make economic sense. The only way these films could work commercially was to hit that 10 percent of the country and then crossover into the mainstream audience, play mainstream theaters as well. As a marketing tool, it probably brought people out to see the films who might not have come ordinarily.

These films were simply a new genre that was successful, very profitable, and reached a different audience. And success begets success. It was obvious that the films were aimed toward the Black community, but there was a strong crossover audience, and it was simply a new and different type of genre that helped particularly the independents. But I wouldn't rate it as something that saved Hollywood or helped it heavily over difficult times.

BLACK SLAVE
WHITE SLAVE

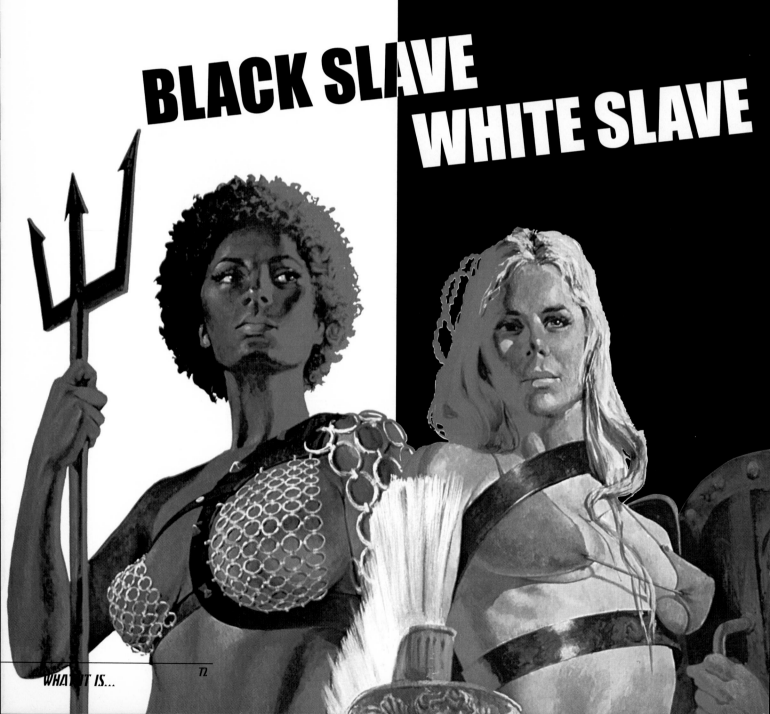

They were primarily low-budget and medium-budget films. I think their influence was probably greater than their economic impact, although they did have some economic impact. It was a genre that went from zero to maybe as high as 5 percent or 10 percent of total gross.

But I think, more significantly, the Black-themed films of that period probably were the first series of pictures with Black actors in the lead to crossover. There may have been an occasional picture before, but this was the first time for a whole series of films. I do think the net result was positive in that the mainstream audiences began to accept Black people in positions of power in ways they had not been accepted before. I don't want to overstate that, but I think it had a slight affect.

This movie will fry your eggs!

We started our involvement with this genre in 1971 with *The Big Doll House*, which was a story of a women's prison. One of the three leads was Pam Grier, who had actually been a receptionist for American International. She was discovered by Jack Hill. It was her first film, which was quite successful. It was clear that the audience responded more to Pam than to any of the other actresses. So we came back the next year with *The Big Bird Cage*, in which we starred Pam. Pam was and still is a beautiful woman, with great energy; an excellent actress and a flair for comedy. So she could play her roles with a little humor in dramatic situations. I think, just by her own persona, she became a star of Black films.

We tried to branch out in 1978 with the film, *A Hero Ain't Nothin' but a Sandwich*, based on a novel written by Alice Childress. It was a very well-made film; we marketed the film very well. It got good reviews. I had great hopes for it. But it was not successful—the people simply did not come—and I was heavily disappointed. That indicated to me that the market for Black-themed film really was in the exploitation action-oriented films.

There were also two films that were action-oriented, but also had political themes: *Savage!* and *The Final Comedown*. They pointed up the Black experience as underdogs and as revolutionaries. The *Final Come Down* was written and directed by Oscar Williams. He brought me the idea, put up part of the money, and I put up part of the money. It was almost a totally Black operation. We made a point to try and bring more and more Black people into our production organization—directors, writers, and so forth, as well as actors.

WHAT IT WAS...

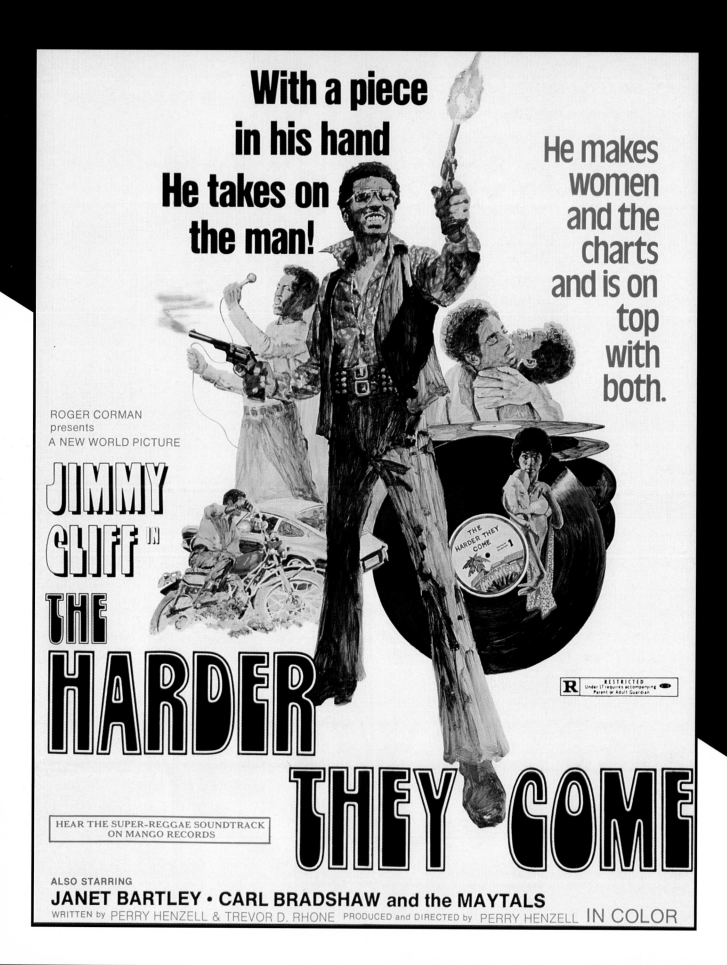

THE BRIDE FINALLY DIED...HER TORTURE ENDED.
FOR HIM, IT WAS THE BEGINNING OF A
BRUTAL, SAVAGE TRAIL OF
POSSESSED
HORROR!

HE BECAME **THE**
OBSESSED
ONE ... playing the GAME OF DEATH
with the DEVIL!

Out of this period also came wilder, more creative movie poster art. Most key art at the time were paintings rather than the accepted style of today, which is a photograph. You could be somewhat more creative and more design-oriented with a painting. For instance, I still remember the poster for *TNT Jackson*. John Davison, who was head of our advertising department, came up with the catch line "TNT Jackson, she'll put you in traction!" And we had a beautiful painting of Jeanne Bell with a white fur coat carrying a shotgun and it was just great. I think that was one of the areas where marketing did help. The picture was quite successful for us.

Ultimately, the resurgence of interest in these movies in the United States, Europe, and Japan, I believe, reflects an increased interest in the industry as a whole, not just the '70s. Motion pictures were initially thought of simply as entertainment. But now, the motion picture industry is more or less one hundred years old and has a history. People are studying the history of motion pictures in schools and are increasingly aware of it. So the interest in so-called blaxploitation films goes along with it. I think it's a part of a whole burgeoning interest in the history of motion pictures.

WHAT IT WAS...

JOHN SINGLETON

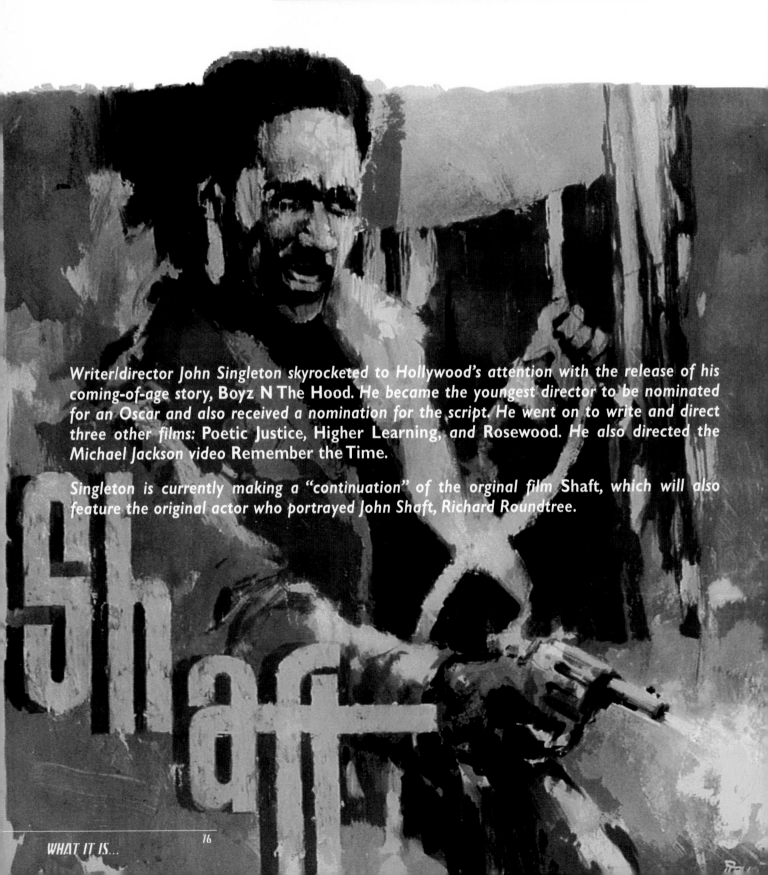

Writer/director John Singleton skyrocketed to Hollywood's attention with the release of his coming-of-age story, **Boyz N The Hood**. He became the youngest director to be nominated for an Oscar and also received a nomination for the script. He went on to write and direct three other films: **Poetic Justice**, **Higher Learning**, and **Rosewood**. He also directed the Michael Jackson video **Remember the Time**.

Singleton is currently making a "continuation" of the orginal film **Shaft**, which will also feature the original actor who portrayed John Shaft, Richard Roundtree.

Shaft

WHAT IT IS...

would not term *blaxploitation*. For instance, I wouldn't term a film like Shaft exploitation. It was a detective film. It was written by Ernest Tidyman, who also wrote and won an Oscar for the *French Connection*. It was directed by Gordon Parks, the world-renowned photographer, author, composer, and director. He was the first African American man to make a studio film in 1969 with *The Learning Tree*.

Shaft is the film that I look at as a benchmark in American film. The Black hero was strong; he didn't take no shit off nobody. John Shaft's image came straight out of the Black revolutionary period sweeping the country; the Panthers, the free love, hippies, and what not. He was the first equal opportunity lover. Up until that time, you really only had Sidney Poitier, who portrayed the characters Hollywood viewed as acceptable for Black men.

Shaft was both an inspiration and influence in my own work. Mind you, it's not a perfect movie. But Gordon Parks' images and the way in which he shot them; what he was able to do, just with pictures. You have a whole generation totally influenced by the image of a Black man walking down the street in a leather coat, walking through Harlem; the close-ups on

METRO · GOLDWYN · MAYER Presenta **"SHAFT VUELVE A HARLEM"**
Con **RICHARD ROUNDTREE** y **MOSES GUNN**

Escrita por ERNEST TIDYMAN · Basada en personajes creados por ERNEST TIDYMAN · Música de GORDON PARKS
Producida por ROGER LEWIS y ERNEST TIDYMAN · Dirigida por GORDON PARKS · PANAVISION · METROCOLOR

77

They Say This Cat
SHAFT
Is a Baad Mutha...

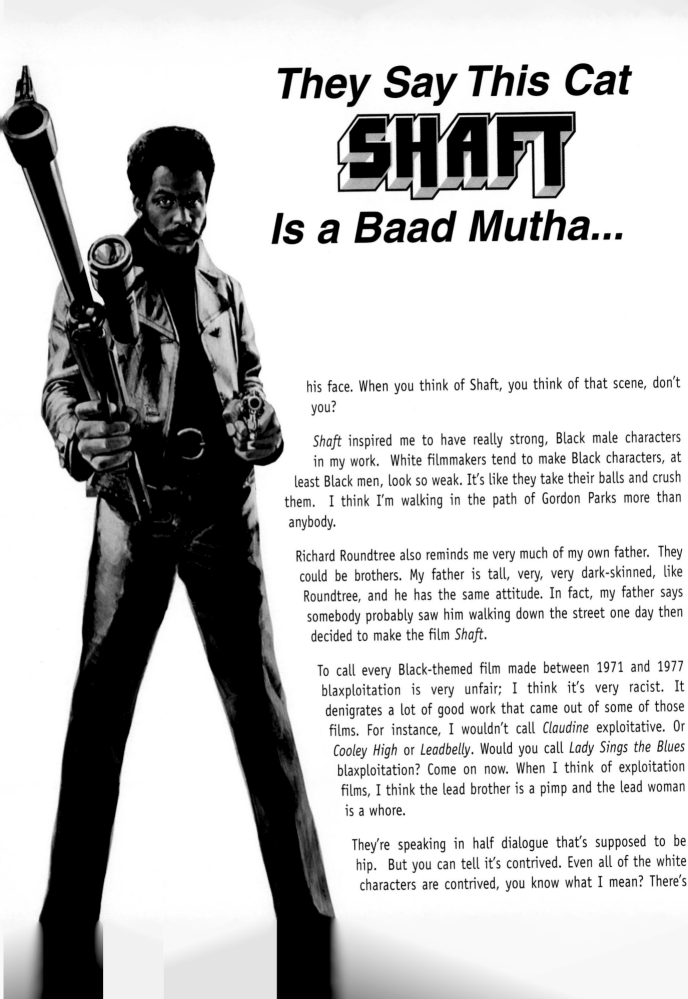

his face. When you think of Shaft, you think of that scene, don't you?

Shaft inspired me to have really strong, Black male characters in my work. White filmmakers tend to make Black characters, at least Black men, look so weak. It's like they take their balls and crush them. I think I'm walking in the path of Gordon Parks more than anybody.

Richard Roundtree also reminds me very much of my own father. They could be brothers. My father is tall, very, very dark-skinned, like Roundtree, and he has the same attitude. In fact, my father says somebody probably saw him walking down the street one day then decided to make the film *Shaft*.

To call every Black-themed film made between 1971 and 1977 blaxploitation is very unfair; I think it's very racist. It denigrates a lot of good work that came out of some of those films. For instance, I wouldn't call *Claudine* exploitative. Or *Cooley High* or *Leadbelly*. Would you call *Lady Sings the Blues* blaxploitation? Come on now. When I think of exploitation films, I think the lead brother is a pimp and the lead woman is a whore.

They're speaking in half dialogue that's supposed to be hip. But you can tell it's contrived. Even all of the white characters are contrived, you know what I mean? There's

Shut Yo Mouth!

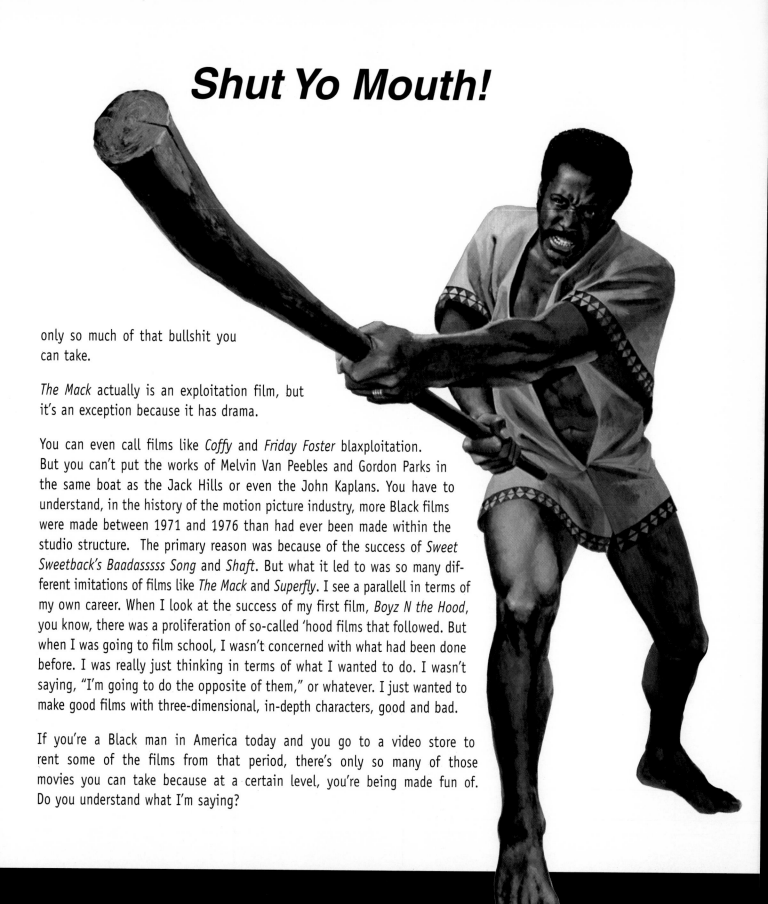

only so much of that bullshit you
can take.

The Mack actually is an exploitation film, but
it's an exception because it has drama.

You can even call films like *Coffy* and *Friday Foster* blaxploitation.
But you can't put the works of Melvin Van Peebles and Gordon Parks in
the same boat as the Jack Hills or even the John Kaplans. You have to
understand, in the history of the motion picture industry, more Black films
were made between 1971 and 1976 than had ever been made within the
studio structure. The primary reason was because of the success of *Sweet
Sweetback's Baadasssss Song* and *Shaft*. But what it led to was so many dif-
ferent imitations of films like *The Mack* and *Superfly*. I see a parallell in terms of
my own career. When I look at the success of my first film, *Boyz N the Hood*,
you know, there was a proliferation of so-called 'hood films that followed. But
when I was going to film school, I wasn't concerned with what had been done
before. I was really just thinking in terms of what I wanted to do. I wasn't
saying, "I'm going to do the opposite of them," or whatever. I just wanted to
make good films with three-dimensional, in-depth characters, good and bad.

If you're a Black man in America today and you go to a video store to
rent some of the films from that period, there's only so many of those
movies you can take because at a certain level, you're being made fun of.
Do you understand what I'm saying?

KEENEN IVORY WAYANS

The multitalented Keenen Ivory Wayans first came to national attention as the co-star and co-writer of Robert Townsend's Hollywood Shuffle. He made his directorial debut in I'm Gonna Git You Sucka, his affectionate satire of the Black action movies of the '70s. His other films include A Low Down Dirty Shame, Don't Be A Menace to South Central While Drinkin' Your Juice in the Hood, Most Wanted, and co-starring with Steven Segal in The Glimmer Man. However, he is best known as the creator, producer, and star of In Living Color, the Emmy award–winning comedy show. He also hosted the late night talk show The Keenen Ivory Wayans Show.

I'm Gonna Git You Sucka was my homage to the generation of films that I grew up on. Everybody had their John Waynes and Gary Coopers. That's who these guys were to me. At the same time I was able to have fun with some of the ridiculous and low-budget nature of those movies. It was a great experience because I got to do a lot of things in one small movie, half the things I accomplished were so subconsciously unintentional that at the time I didn't even recognize that I was doing it. What I was conscious of at that time was this is a funny movie, and I have these few dollars to make this film. I'm going to be as inventive and creative as I can within this confine. I chose this genre because it was something I knew well. I loved *Airplane*, and I said I'm going to do my version of *Airplane*. I thought what they did was brilliant. I'm going to take the B movies of my generation and I'm going to do my version.

What was exciting about having those guys participate was the fact they were people who had a sense of humor about themselves. When Jim Brown said he would do it, and how funny he thought it was, he became the coolest guy in the world to me. He's got a sense of humor; he really doesn't think he's *Black Gunn*. You know what I mean? He knows that some of that stuff was funny. When Bernie Casey came along and all of those guys, what was inspiring and what was exciting about it was these were real people who could separate themselves from their work. They did have a sense of humor about the stuff and were now willing to help another young filmmaker get his thing done. What I did was make fun of the clichés, not the men.

Shaft was the prototype. It was the first one that sort of launched the quote, unquote Exploitation Era. But *Shaft* was not an exploitation movie. *Shaft* was a good film, and it was in many ways the first for a lot of things. It redefined the image of the

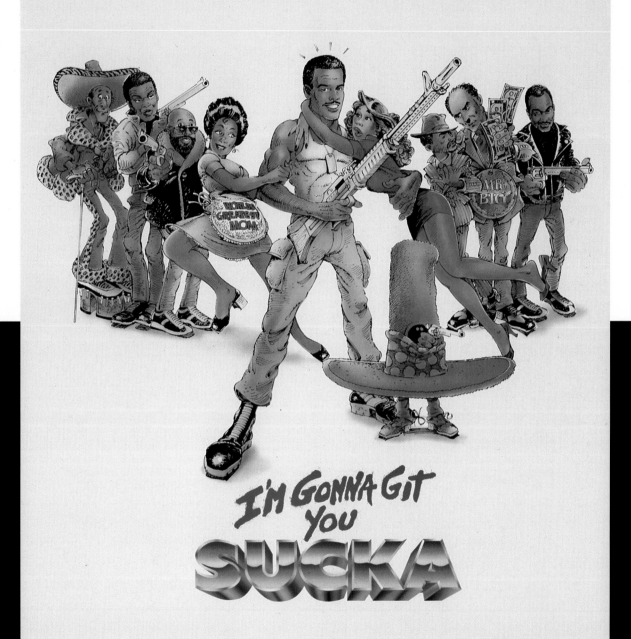

IT'S TOUGH TO BE A BLACK HERO.

WHAT IT WAS...

Black male on screen for the next decade. Isaac Hayes won the Oscar for the score of *Shaft*. But obviously there were some movies that were made just to capitalize on its success. Today, for example, you have *Terminator*. Since *Terminator* there've been a hundred cheesy versions. It just becomes a formula, that's all. But you would never call that science fictionploitation. It's just a bad movie. The same thing holds true for these films. There were the good versions and the bad versions. The good versions were probably personal stories or just well-crafted stories or a beginning format for a new kind of genre film. Everyone comes along trying to make a quick buck, and they do the bad version of it. That terminology, blaxpolitation, hasn't gone away. We hear it now, it's just a continuing stigma that follows African Americans no matter what they do. The terminology is being used to describe the works on UPN or WB. It's always race related as opposed to the quality of the work

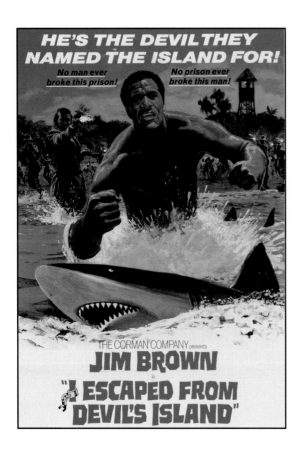

My personal view of the term "blaxploitation" is that it's a racist term. There's no such thing as a genre of film being Black. Black is not a genre. There's no white film. It's film. There are good films; there are bad films; there are exploitation films. Many of these terms start out in a very innocent way. It's how they are used. This term was used in a very negative way, both by the Black self-interest groups and the mainstream media. It really did a disservice to the creative community. It made people actually ashamed of their work, whether it was good or bad. If you sit and talk to any of these guys from that era, most of them are pretty embarrassed. At the time they were just working actors; no one should have to be subjected to that kind of stigma. But even worse than that, great movies got lumped into that category, movies like *Claudine*. Unfortunately, any Black film from the '70s era has been viewed as an exploitation movie when there were some really wonderful stories told, some really great acting done. And, yes, some really shitty movies made.

I was very young when I saw *Shaft*. What I loved about *Shaft* was it was the first time I ever saw a brother with attitude on screen. He wasn't docile, he wasn't nonsexual. He was threatening. He was in charge. It was just something completely different. *Claudine* was very close to our own personal experience in terms of having a big family

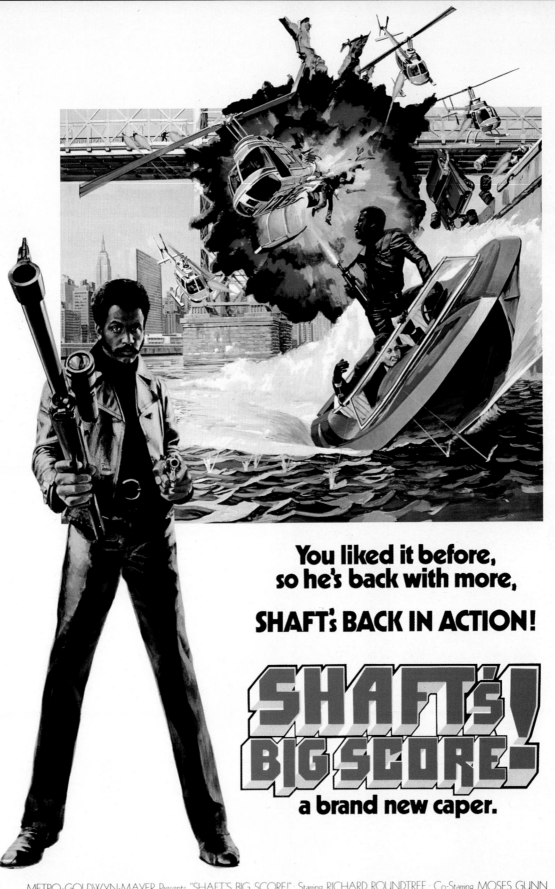

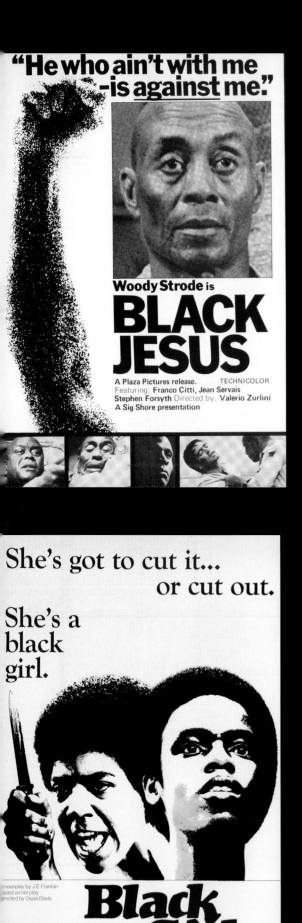

"He who ain't with me -is against me."

Woody Strode is

BLACK JESUS

A Plaza Pictures release. TECHNICOLOR
Featuring: **Franco Citti, Jean Servais**
Stephen Forsyth Directed by: **Valerio Zurlini**
A Sig Shore presentation

She's got to cut it... or cut out.

She's a black girl.

creenplay by J.E. Franklin
ased on her play
rected by Ossie Davis

Black Girl ...your girl.

inerama Releasing presents
Lee Savin production "Black Girl"
arring Brock Peters Louise Stubbs Claudia McNeil
eslie Uggams as Netta Special guest Ruby Dee
so starring Peggy Pettit Gloria Edwards Loretta Greene
scutive Producer Robert Greenberg Produced by Lee Savin
tle song sung by Betty Everett
riginal sound track on Fantasy Records

and the stress of trying to keep your family together and the love within the family despite all the problems. That was a thing that had a personal effect on me when I was watching it.

I wasn't affected by *Superfly*. I thought it was an interesting story, and I thought the character was cool in his own way. But I didn't run out and buy the gear or grow the long sideburns. I didn't get caught up in the trends.

I tend to agree that movies like that do not send out a positive message, but I don't think that was the intent. The intent is to tell a story. Again, one of the burdens of race is that everything you do has to send out a message. It's not just about a movie; you become responsible for the entire community. All of a sudden racism is your fault, unemployment is your fault. High murder rates, high suicide rates, misogyny, all of those things become your fault as the result of one film, as if these things didn't exist before you got there. I don't think the actors' or the filmmaker's intent was to send out any message, they were telling a story. Once the story was told, the criticism just steamrolled. A lot of things come upon you that you never calculate because you're not a politician, you're not trying to change the world or to change society. You go, "This is a great idea for a movie," and you go do it. But among African Americans or just minorities period, I've seen it happen time and time again, you become responsible for more than just telling a good story, as if this one movie is going to be that impactful. The truth of the matter is, movies are not that impactful. Movies are impactful for the two hour experience. But there hasn't been one film made, and there won't be any movies made, that will change society. In order to affect society it's far more than an imaginary experience, you know?

The shame of being a part of those films caused us to lose sight of the good along with the bad. Like throwing the baby out with the bathwater; everything was abandoned. As opposed to saying, okay, if we're not going to be a part of exploitation, then let's not do that. But that doesn't mean, let's not make movies with African Americans in them, because that's what happened. The movies just went away. Up until Spike Lee, Robert Townsend, and myself, out of naïveté and sheer determination were able to get these small movies done, we were vacant from the screen.

I think the problem is an extension of race problems in America. A lot of times when you're Black it's like the cloud of judgment is too thick. If you look at the first movie I did, or the first movie Spike did, or Robert's *Hollywood Shuffle*, you're talking about people who made movies with credit cards. You always hear, Why don't you do this? Or do that? People are very naïve about what the process in Hollywood

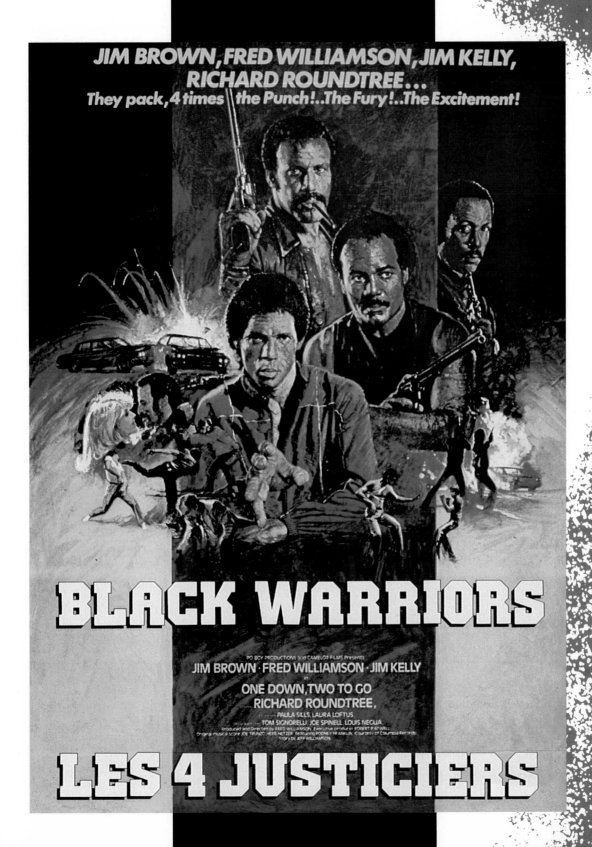

is. That's like saying to somebody who built a house out of tin cans, "Why didn't you build a mansion?" Well, because all you had was tin cans. The same thing holds true in Hollywood. It's not like there is a huge pool of money that everybody just has access to and can green-light the stories that they want and make the beautiful images that they all have in their heads, or everyone has the education to do that, or has the film school experience to know how to go out and shoot a movie. These are all people who are working with resources that in the real world are impossible to craft work from. So the fact that you get it done is monumental. Then you have to get over the hurdles of everyone trying to stop you before you can grow into someone who actually can make a good movie. I mean, if you look at Steven Spielberg, now he's taking on movies like *Schindler's List* and *Amistad*. This is a guy who could have made these movies fifteen years ago, you know. You need room to fail. You need room to grow. You need to get better at what you do. I think that a lot of times, the first thing you do, everybody's on you. Everybody's on you! Let's go beyond African Americans. I look at Margaret Cho. She tried to do a show about the Asian community. They beat her down so hard that by the time her show came on the air, you didn't even know they were Korean people. She couldn't even be funny, she couldn't even be herself. To have that weight on your shoulders going out the gate, trying to be creative, you think you've done something great. You made a movie. It's like, "Oh, God, I got a movie made!" Then the onslaught comes. It's just amazing that people continue.

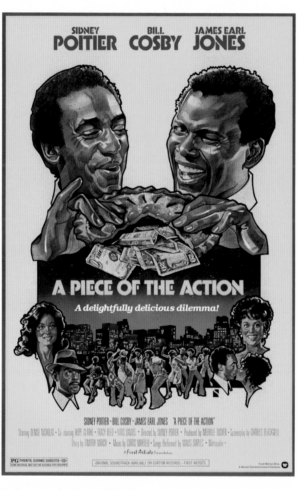

What I envy about the '70s was society. I think that society was at its best in the '70s. The blood, sweat and tears of the '60s and the '50s paved the way for a decade of true openness with people actually having a desire to get to know one another, a desire for opportunity, and to make opportunity for others. I think that's been lost.

It's not so much gone back, it's actually worse than before. Now the mind-set is, "We tried it. It didn't work. So fuck it." As opposed to, "No, you never actually tried it. The first opportunity you got to stop, you stopped. The first excuse that came along, you took it and ran." So what happened was, people abandoned the ideology very quickly.

Affirmative action is so typical of the kind of mentality that I'm talking about, the runaway mentality. The fact that people would actually think that affirmative action could be biased against a white person is just ludicrous. It is ludicrous. The fact that the mainstream media has supported that ideology just shows you the lack of true intent on the part of our society to change. They say that affirmative action is set-asides. What they don't talk about in terms of set-asides is that what's set-aside is not, let us say, twelve jobs out of a hundred. That's one way to look at it. The other way to look at it is eighty-eight jobs out of a hundred have been set-aside for white males and twelve for white females, Black males, Hispanics, Chinese, Indians. So the set-asides that need to be addressed are not the twelve; they are the eighty-eight.

The truth of the matter with affirmative action is that the quotas haven't even been filled. There's not one corporation in America that has fulfilled those quotas. There's no upper management in any Fortune 500 company that has any marginal percentage of any minority. Not one, and that's with government regulation, that's with laws. Now remove that, and are we to think that it's going to grow, it's going to get better? No, I think we're in a very dangerous time right now.

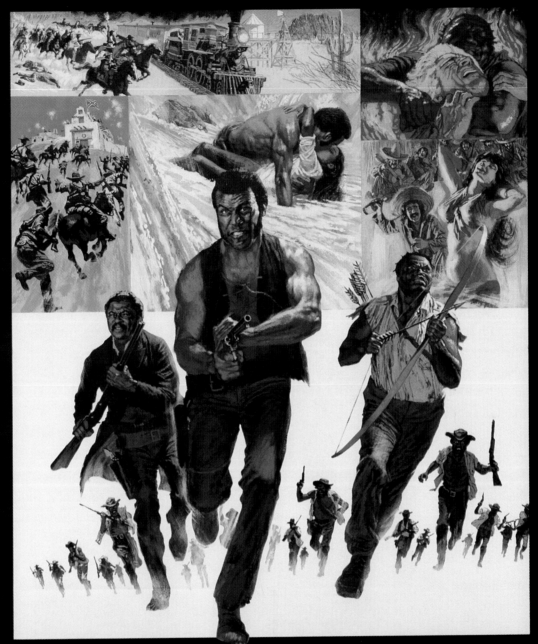

FRED WILLIAMSON

Fred Williamson was a major star of the Black action films of the '70s. Although trained as an architect, Williamson went on to play professional football after graduating from Northwestern. He played in the first Super Bowl, for the Kansas City Chiefs. His film career began in 1970 with a supporting role in M*A*S*H. In the early '70s, he formed his own company, Po'Boy Productions. To date, Williamson has produced or appeared in over thirty films.

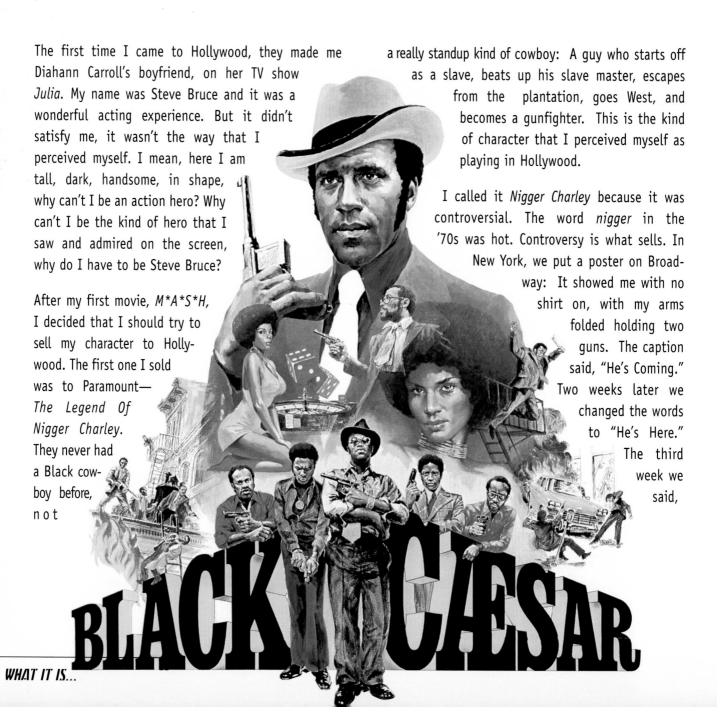

The first time I came to Hollywood, they made me Diahann Carroll's boyfriend, on her TV show *Julia*. My name was Steve Bruce and it was a wonderful acting experience. But it didn't satisfy me, it wasn't the way that I perceived myself. I mean, here I am tall, dark, handsome, in shape, why can't I be an action hero? Why can't I be the kind of hero that I saw and admired on the screen, why do I have to be Steve Bruce?

After my first movie, *M*A*S*H*, I decided that I should try to sell my character to Hollywood. The first one I sold was to Paramount— *The Legend Of Nigger Charley*. They never had a Black cowboy before, not a really standup kind of cowboy: A guy who starts off as a slave, beats up his slave master, escapes from the plantation, goes West, and becomes a gunfighter. This is the kind of character that I perceived myself as playing in Hollywood.

I called it *Nigger Charley* because it was controversial. The word *nigger* in the '70s was hot. Controversy is what sells. In New York, we put a poster on Broadway: It showed me with no shirt on, with my arms folded holding two guns. The caption said, "He's Coming." Two weeks later we changed the words to "He's Here." The third week we said,

BLACK CAESAR

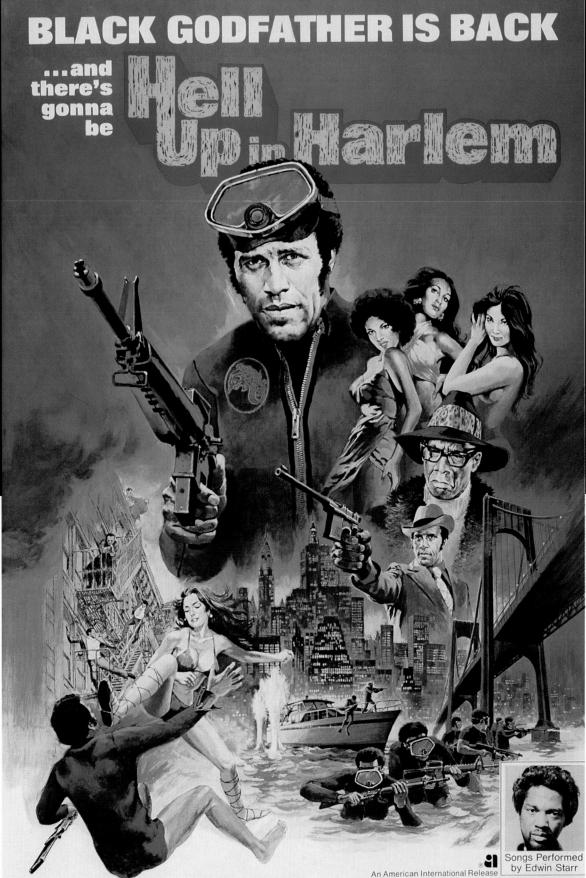

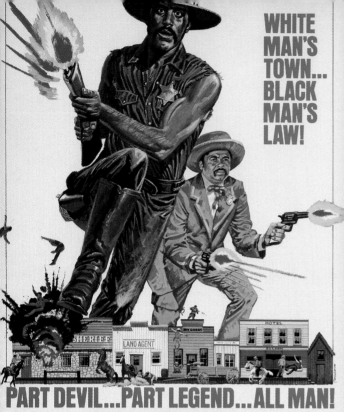

WHITE MAN'S TOWN... BLACK MAN'S LAW!

PART DEVIL...PART LEGEND...ALL MAN!

FRED WILLIAMSON as

BOSS NIGGER

with **D'URVILLE MARTIN** CO-STARRING R. G. Armstrong and William Smith

Produced by JACK ARNOLD and FRED WILLIAMSON Directed by JACK ARNOLD

Original Motion Picture Soundtrack on "WE PRODUCE" Records and Tapes. Written by FRED WILLIAMSON COLOR BY DE LUXE® Todd-AO 35

PG PARENTAL GUIDANCE SUGGESTED A DIMENSION PICTURES RELEASE Some material may not be suitable for pre-teenagers

BOOZIN'!.. BRAWLIN'!.. BLASTIN'!..

FRED WILLIAMSON AND RICHARD PRYOR

TWO SHARP DUDES TAKING TURNS WITH CHICKS AND TRICKS

"ADIOS AMIGO"

STARRING JAMES BROWN · ROBERT PHILLIPS · MIKE HENRY

WRITTEN, PRODUCED & DIRECTED BY FRED WILLIAMSON

PANAVISION EASTMAN COLOR

PG PARENTAL GUIDANCE SUGGESTED SOME MATERIAL MAY NOT BE SUITABLE FOR PRE-TEENAGERS

AN ATLAS FILMS RELEASE

Music by: LUCHI DE JESUS Performed by: THE BLUE INFERNAL MACHINE Available on LONDON RECORDS

"Nigger Charley Has Arrived." The press grabbed on to that nationwide, and it was so controversial that a lot of press called the film *Black Charley* or *The Legend of Charley*.

The controversy brought a lot of people into the theater, not knowing what the film was about. They came to see it because of the controversy.

Back in the '70s, the poster media was the way to sell films. When you went to Cannes film festival and you presold your film, you did it on the poster. The poster had to tell the story pretty much in one glance. *Adios Amigo* was a very good poster because it showed me and Richard Pryor on a horse. You don't see many Black guys on horses. He was going one direction and I was going another direction, and behind us you saw ten or twelve guys chasing us. Richard Pryor was going off on his own while everybody was chasing me. It told the story at a glance. All my posters have been good, there's not one poster that I made that I didn't like, because I was personally involved in every poster to my films that I made. I wanted to be involved in all aspects of my films.

Black Caesar was right after *Nigger Charley*. *Black Caesar* was an idea that Larry Cohen and I came up with together because they had never had a Black gangster before. My idea of a Black gangster was the Edward G. Robinson–Humphrey Bogart–James Cagney type. The guy who had a style, the guy who robbed from the rich and gave to the poor. This is how we see gangsters, this is Gotti gangster style. A guy who is a pimp, running around in a purple car with yellow suits, everybody knows what he does. But a guy who fits into society, goes to social functions, who dresses nice but not overly flamboyant, this is the kind of character that I wanted to bring to *Black Caesar*. He took care of his mother, he never forgot his moth-

er. But, his mother, like all mothers, wanted to know where he got this tremendous wealth, so, she did not readily accept all the gifts that he bestowed upon her. Larry Cohen and I together wrote the scene in the penthouse. The mother was a maid in the penthouse and he was in the bed. When the mother came in, and he jumped out from under the covers and said, "Mama this is yours." She said, "Nah, nah, where did you get this from? You stole it." This is reality.

I wanted to make something dynamic in Hollywood, something true to myself, not just get a part and become an actor. So I started writing my own films and raising my own money. From 1970 to about 1976, the Black actor being the winner, being the hero was happening. In my films, I was trying to say, "Hey, we're tired of

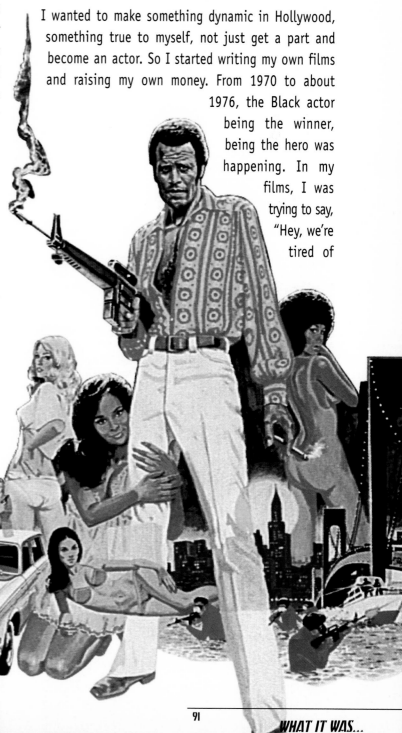

WHAT IT WAS...

seeing the train porters, the waitresses, the maids, we're tired of seeing that. There's another side of us that is real. There are tough guys, we can be tough, we can be the Eastwoods." Getting an actor to work in that kind of project was not a problem. All the roles that the Blacks got at that particular time were things that they wanted to do. I wasn't asking him to be a porter or shine shoes, I wasn't asking him to be anything he didn't want his kids or his family seeing him doing. Today, even though there are a lot of Blacks working, even though the money is good for what they're doing, deep in their hearts, if they're honest, many Black actors would like to be playing something that was a little more acceptable to their friends. Something they wouldn't have to explain to them by saying, "I only do that because they pay me a lot of money," and "I get a lot of accolades." That's all well and good, but, when you wake up in the morning and look

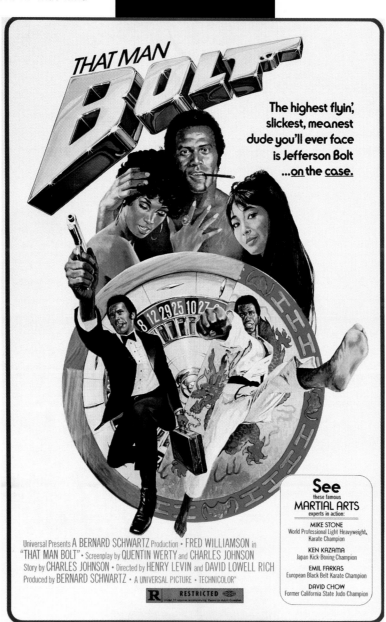

in the mirror, that's the person you have to answer to.

At the time we made our movies, heroes were needed more than they are now. They were still arresting more than four Black people on a corner because, they said, they were instigating a riot. We were going through some trying times. Anytime any Black person stood up for themselves, or did anything that involved any kind of physical confrontation, they always lost, they were always taken to jail. You'd see on the news, Blacks getting beat up, dogs being siced on them, firemen spraying water on people. This was one of the things that motivated me to make action movies with Black heroes in the first place. Heroes are still needed and we are heroes. We, in our personal lives, stand for what we stood for in the movies. We don't fight and shoot and kill people, but we do stand up for what we believe is right regardless of the consequences. Maybe I could have been a bigger producer or a bigger star had I not been so-called con-

BRUTAL!... BLASTING!... BLAZING!

FRED WILLIAMSON
IS
Mean Johnny Barrows

MEAN JOHNNY BARROWS Starring FRED WILLIAMSON · RODDY McDOWELL
STUART WHITMAN · LUTHER ADLER · JENNY SHERMAN and Special Guest Star ELLIOT GOULD
Produced by and Directed by FRED WILLIAMSON

R RESTRICTED

AN
ATLAS
FILMS
RELEASE

WHAT

troversial. That's the kind of heroes that were needed at that time and nobody could ever call us an Uncle Tom. I mean, you can't even come close to calling me, Jim Brown, Richard Roundtree, an Uncle Tom. We are what we represent on film and our lives are pretty much the same way. We are legitimate, genuine, heroes. I think there's no question about that.

Unfortunately, they began describing our films as blaxploitation. The term blaxploitation means absolutely nothing. I can't imagine who was being exploited. My checks cleared, we were working, we had a job. Who the hell was being exploited? The public came because they wanted to see what they like. If they can call my films a Black exploitation, then why didn't they call Burt Reynolds's films white exploitation? Burt was hot at the same time that we were making our films. He was making all those movies about running moonshine whiskey through the back Southern woods and they never called his films white exploitation. Why don't they call Clint Eastwood or Charles Bronson movies white exploitation films? What the hell is the difference? Our characters were interchangeable. It was equal opportunity employment for me, man. If you were bad, you went down. I didn't just kill white people, I beat up white people, yellow people, pink people. When the smoked cleared, I was the last one standing, no matter what color they were.

Part of the demise of the films in the '70s began when they started calling them blaxploitation movies. The Black public accepted this terminology without fully understanding what it meant. They started saying, "You're showing us in the wrong light," and Blacks got caught up in the same derogatory descriptions of the films. The producers started saying, "Well if the Blacks don't like the films then maybe we shouldn't make these films because maybe they won't go see them." Even though the films were successful, they weren't really big blockbuster films. All the films were being made for under a million dollars and they were making 10 million dollar grosses, 12 million dollar grosses. That's not really a big gross for Hollywood, even though they were successful. You know, 10 million dollars, 12 million dollars, is just enough to pay Universal's

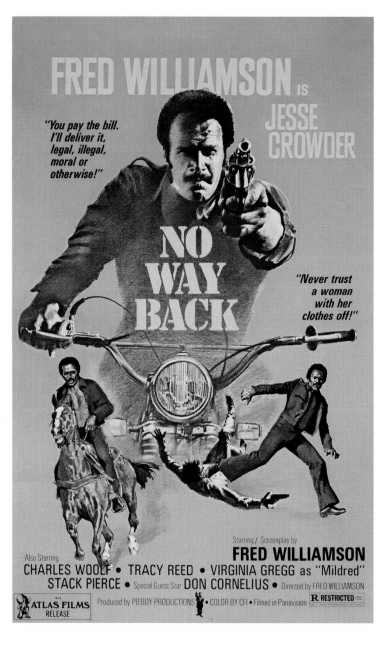

FRED WILLIAMSON IS JESSE CROWDER

"You pay the bill. I'll deliver it, legal, illegal, moral or otherwise!"

NO WAY BACK

"Never trust a woman with her clothes off!"

Starring / Screenplay by
FRED WILLIAMSON

Also Starring
CHARLES WOOLF • TRACY REED • VIRGINIA GREGG as "Mildred"
STACK PIERCE • Special Guest Star DON CORNELIUS • Directed by FRED WILLIAMSON

AN ATLAS FILMS RELEASE • Produced by PO'BOY PRODUCTIONS • COLOR BY CFI • Filmed in Panavision • R RESTRICTED

WHAT IT IS...

light bill. They wanted more grosses, and all of a sudden here comes organizations like NAACP and CORE, saying, "Yeah, these films are not right." We were our own worst enemy. It hurt the growth of the films and the actors of that time. We never really got a chance to change out of what they call Black exploitation into just action films. Maybe had we continued, they might have just called them action movies. Even today, if I make a film, and I'm the only Black person in it, it's Fred Williamson's latest Black action film. So, it gets pigeonholed into certain neighborhoods and into certain theaters. What that does is limit the distribution of the film, it limits where they play it and consequently it limits the box office.

Look at how my films are marketed in Europe. There, my films are action movies. My European market is ten times bigger than my American market. I'm not categorized as a Black actor. I'm an action star. I'm a person who knows martial arts. My movies are played where Eastwood and Bronson movies are played. As long as the film did not deal with the racial conflict, as most of my movies did not, the European market accepted it. In Europe, they don't fully understand why white people don't like Black people. They appreciate and respect us more in the European communities than here. That's why you find a lot of jazz musicians who have much greater success overseas, than here in America. They are respected for their talents, which has nothing to do with their color. It's the same thing with me as an actor; I'm respected as an actor, not a Black actor.

I was trying to show that in one's life, one shouldn't be so guided by consequences. Being concerned about consequences stops a lot of people from taking chances or doing the things that they wanted to do. If you want to do something and you want to do it your way, you have to take charge of it. So, all I was trying to do is make a point. Step up to the plate, take a swing, 'cause you got nothing to lose.

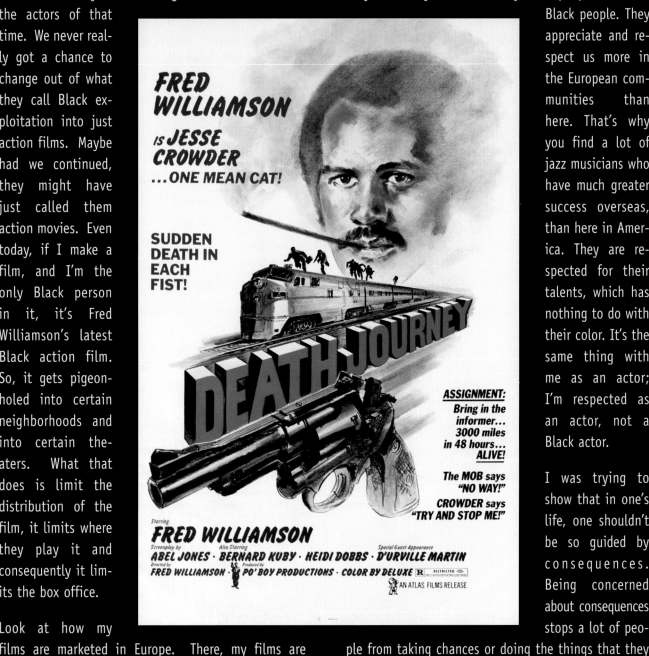

FRED WILLIAMSON
IS JESSE CROWDER
...ONE MEAN CAT!

SUDDEN DEATH IN EACH FIST!

DEATH JOURNEY

ASSIGNMENT:
Bring in the informer...
3000 miles in 48 hours...
ALIVE!

The MOB says "NO WAY!"
CROWDER says "TRY AND STOP ME!"

Starring
FRED WILLIAMSON
Screenplay by ABEL JONES · Also Starring BERNARD KUBY · HEIDI DOBBS · Special Guest Appearance D'URVILLE MARTIN
Directed by FRED WILLIAMSON · Produced by PO' BOY PRODUCTIONS · COLOR BY DELUXE R RESTRICTED
AN ATLAS FILMS RELEASE

ARTHUR MARKS

Arthur Marks grew up in the movies. His father was an assistant director at MGM during the Golden Era who worked on many of the classic musicals including Singin' in the Rain. As a boy, Marks had a role in Boys Town. Later, as an assistant director himself, he worked on numerous fillms, including The Lady from Shanghai and The Caine Mutiny. In 1957, Marks produced, directed, and wrote for one of the most celebrated shows in TV history, Perry Mason. After Perry Mason he worked on a number of hit shows including I Spy, Mannix, and Starsky and Hutch. In the '70s, he directed some of the best-known Black films, including Friday Foster, Bucktown, Detroit 9000, J.D.'s Revenge, and Monkey Hustle. Marks continues to write and is a highly regarded script doctor.

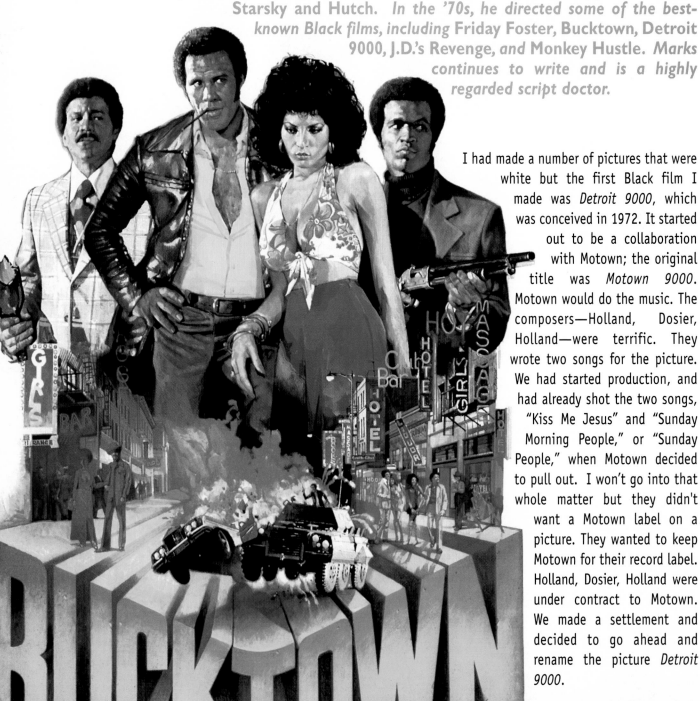

I had made a number of pictures that were white but the first Black film I made was *Detroit 9000*, which was conceived in 1972. It started out to be a collaboration with Motown; the original title was *Motown 9000*. Motown would do the music. The composers—Holland, Dosier, Holland—were terrific. They wrote two songs for the picture. We had started production, and had already shot the two songs, "Kiss Me Jesus" and "Sunday Morning People," or "Sunday People," when Motown decided to pull out. I won't go into that whole matter but they didn't want a Motown label on a picture. They wanted to keep Motown for their record label. Holland, Dosier, Holland were under contract to Motown. We made a settlement and decided to go ahead and rename the picture *Detroit 9000*.

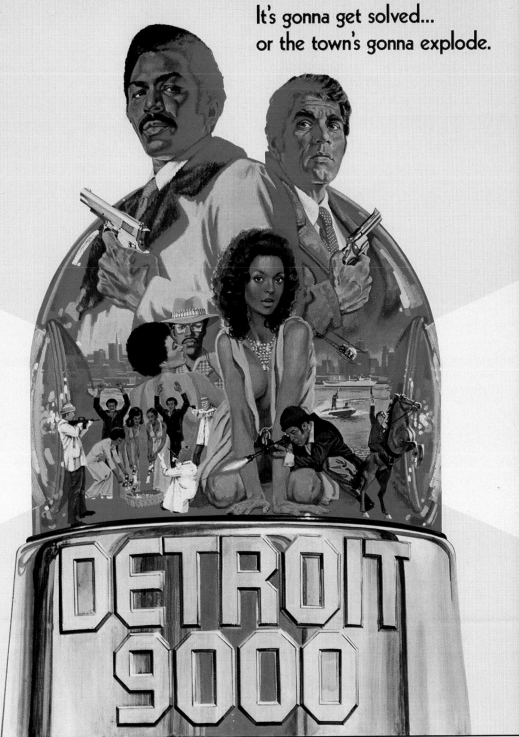

IT'S THE MURDER CAPITAL OF THE WORLD.
AND THE BIGGEST BLACK RIP-OFF OF THE DECADE

It's gonna get solved...
or the town's gonna explode.

DETROIT 9000

GENERAL FILM CORP. Presents "DETROIT 9000" Starring ALEX ROCCO · HARI RHODES and VONETTA McGEE
Co-Starring HERB JEFFERSON, JR. and ELLA EDWARDS · Written by ORVILLE HAMPTON
Executive Producers DON GOTTLIEB and WILLIAM SILBERKLEIT
Produced and Directed by ARTHUR MARKS · PANAVISION® · COLOR

R RESTRICTED
Under 17 requires accompanying
Parent or Adult Guardian

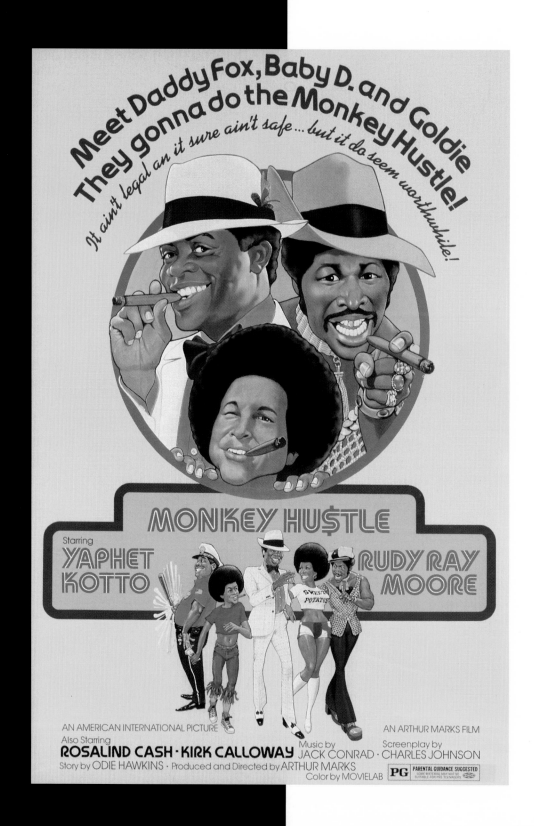

When we released *Detroit 9000* originally, we weren't going to sell it as a Black film. We thought of it as a white film and the first campaign made was a white campaign. What happens in a Black city to a white police department, a white cop? When we were making the picture in Detroit, there was such a whirlwind of excitement, predominantly from Black people. Detroit in those days was a madhouse, but we didn't really change it to a totally Black campaign because we wanted to play in Westwood. We wanted to play across the country.

Let me give a little background about market conditions at the time we opened *Detroit 9000*. For the most part, major studio releases played the suburban theaters, and drive-ins were playing independent films. The guy who ran Dimension, one of the independent studios, once told me, "The drive-ins are our bread and butter." This was a vast market. Rarely did a major go into the drive-ins unless it was an action piece. AIP originally made drive-in movies. They went the same route that I went with my company, General Film. As a matter of fact, I marketed General Film exactly on American International Picture's approach to marketing and making pictures. AIP's whole idea was to get into drive-ins, because they could not compete with the other pictures from the major studios. They made all these crazy pictures. Then suddenly, the majors said, "Gee, this is a wonderful market, these drive-ins." They saw a vast market, and actually drove the independents out. You couldn't get a booking into major drive-ins, because of the major product that was flooding to them.

The owners of the downtown theaters had their own concerns. The cities had became Black, and for Black audiences, their heroes were not John Wayne. The Blacks had no heroes. They had no heroines. When a Black woman was in a white picture, she was usually a prostitute. There was an audience, and they had nothing given to them. So, these big caverns, these huge joints were empty. Downtowns were dying. They couldn't go to white theaters in the suburbs, so they wanted their own theaters. They were dying in downtown houses.

When *Detroit 9000* opened in the Madison Theater in Detroit, it was such a hit, it was taking $50,000 a week out of that house. We got a call from a chain that wanted the picture, but they wanted it as a Black picture. We knew that if we sold it to the Chicago Theater, which is the biggest house outside of New York, at 3,000 seats, that we had a Black picture on our hands because the momentum would carry it into a Black audience. It was taking $90,000 out of Chicago, and then it jumped, not only in Chicago, but went to the State Lake and played both of them. The handwriting was on the wall. It just couldn't be avoided. Except for maybe a handful, *Detroit 9000* never played a white theater in the United States.

Black films were terrific moneymakers for the studios and the downtown theater owners. They were terrific. The grosses in these downtown houses were enormous. I mean they were just astronomical. The profits saved a lot of the downtown theaters. In turn, the theaters resurrected the downtowns through Black pictures. I know that American International Pictures made a bundle on these pictures. They take a fee, they take what they have invested in the picture, plus their interest. They didn't make so much when they made Mr. So and So's *Magic Island of Dr. Moreau*. But their Black pictures were terrific as far as their bankroll was concerned. They made a lot of money on these pictures.

After *Detroit 9000* had been released, a couple people who had seen the movie called and said, "We'd like to do a picture with you." I said, "I read an article in *Time* magazine about a town in East St. Louis. It had a white police department running a Black town, taking extortion, beating up the citizens. It was called "Blacktown." They wanted to do a Black picture. I came up with a script that was written by a friend of mine, and we called it *Bucktown* instead of *Black Town*. It was actually Buchanon, Missouri.

Bucktown was about a Black man coming to bury his brother, who supposedly died of pneumonia in an open field but was actually beaten to death. Here was Fred Williamson, who inherits a barmaid, a kid, and a bartender. Bernie Hamilton plays the bartender, and Pam Grier is the waitress. The white police department in this town starts to do

the same things to him that they did to his brother. He calls his friends from Philadelphia to help him take care of the problem. They take care of the problem. But the key to it is that they liked it so much that they decided to play and take the war rewards for themselves. Fred has to go against his friends, to recapture his own. It's just like a Western.

Sam Arkoff, who had tried to get me to work with AIP, then purchased *Bucktown* from the group and distributed it. The producers and the theater chain who put up the money for *Bucktown* made their money back overnight from AIP. They were so ecstatic that they were just beside themselves. Arkoff wanted me to do pictures for him, but he wanted me to do a Black picture. I had just taken the rights for *Friday Foster*. I had a hunch about it. I felt that if I could get Pam Grier, take her out of *Sheba Baby* or *Foxy Brown* type roles, and dress her up, that this elegant girl could be terrific and she was. She was wonderful in the picture.

Friday Foster is worlds apart from blaxpolitation. It's got humor. It's not Black humor. It's humor of two people. She was elegantly dressed, Yaphet Kotto never used Black expressions in the picture. He might

have used one. I don't remember. But he never, in a sense, played off as a Black detective from Harlem. He was strictly working with Friday as her buddy.

In the same way, another one of my other films, *J.D.'s Revenge,* is not an exploitation movie. In this picture, J.D. and his sister were killed. Thirty years later his spirit possesses a Tulane University college student, played by Glynn Turman. After I saw Turman in *Cooley High*, I thought "My God, this is an actor, just wonderful," and cast him in *J.D.'s Revenge.* The student drove a cab to make ends meet. He lived with a girlfriend who was intelligent and she went to school. The shady Black minister was played by Lou Gossett. The Black cop was a sharp cop.

I don't think *J.D.'s Revenge* was sold primarily as an "exploitation." When I met with AIP on that picture, I met with the advertising people and the whole group. There was no intention to sell that with bullets flying. There is no great action in that picture.

It's strictly a supernatural thriller. They wanted a Black

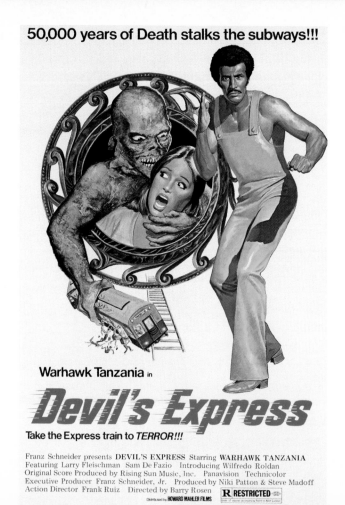

picture for their market, but it was never thought of as a Black exploitation picture. It was never thought of the same as *Sheba, Baby*. It was sold strictly without the sell of a female being raped, or the idea of a machine gun, even though there was shooting in the picture. There was some action in the picture. I don't think *J.D.* is in that same caliber. But it was tagged a Black picture because of the cast. I could have put Robert Redford in the part at that time, as a matter of fact, I considered it at one time. When I first got this script, it was sent to me by Art Buff, and I said, "Gees, it's a good script. It's a good story. It could be a wonderful picture." And I started thinking of people like Redford, who was a young actor at that time. I wanted a young student. But they called me and they wanted to do it Black. And by doing it Black, they felt that their market was assured X amount of dollars. So, we made it a Black picture.

There's been a lot of renewed interest in the Black films of the '70s. I probably made more Black films during that era than anybody else, and I think the better ones. I got a call from the Festival of New York once, but they turned me down, because I wasn't Black. But I don't think a Black man would have made a picture any better. I don't think he had any more experience. They say, "Well, how can you put Black environment in the picture?" I think that intelligence is intelligence. If you write a script, and you're dealing with Black environment, and you're looking and wanting to learn Black environment, well, you breathe it. You take it in, and you put it into the film. You let the Black environment sell itself. You don't have to have people talking jive. That's phony. Most Black people don't talk that way.

I believe that good filmmaking was what got all these movies made and good filmmaking is what drew the audiences. They were attracted by good films and I still think that good films makes audiences come to theaters. I don't think there has ever been a change. Bad films will drive audiences away. You can sell them with an idea of Black, but once they're in there, what happens? Do you play a second week and drop off 50 percent and never get a third week? That wasn't my aim. My aim was to make a good picture. That was the key, to make a picture as good as you know how.

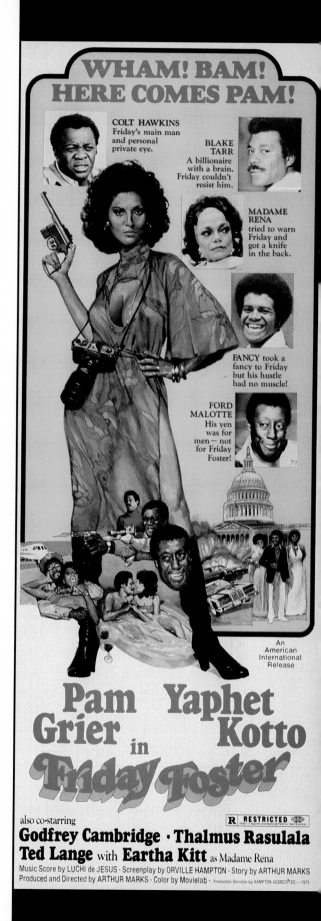

WHAT IT WAS...

KEVIN HOOKS

A second generation actor, Kevin Hooks has accomplished much both in front of and behind the camera. He began his acting career on his father's, Robert Hooks, '60s TV series NYPD. *He went on to a supporting role in* Sounder *and the lead in* Aaron Loves Angela. *He became well-known to TV audiences for his role in* The White Shadow. *Hooks left acting for the director's chair and became one of those rare directors who moves easily between TV and features. He's directed episodic TV, like* The Profiler, Homicide, St. Elsewhere, *and* Fame *and TV movies such as* Glory and Honor, Heatwave, *and* Roots: The Gift. *Some of his feature films include* Fled, *the smash hit* Passenger 57, *and* Black Dog *with Patrick Swayze. Hooks develops projects under his own banner, Hooks Filmworks, Inc.*

Acting was the family business with the Hooks family. My father, actor Robert Hooks, started acting when he was in his twenties. I grew up watching him; in fact, the first piece of acting that I did was in a series called *NYPD* back in 1969, where my father was a regular. That little bit part was opposite a relatively unknown actor at the time by the name of Al Pacino. My father was one of the co-founders of the DC Black Repertory Company in New York City. All of the prominent Black actors of the time came through, even if only briefly, the Negro Ensemble Company, or the NEC. I knew a lot of those people from there, Moses Gunn, Roz (Rosalind) Cash, and Esther Rolle, I mean just a ton of people. They all came through the NEC. When Hollywood started making movies about Black people, they needed actors. All of those actors, including my dad, moved in a wave to Los Angeles because that's where the work was. There was an excitement that I don't think has ever been duplicated. Let's face it, actors like to act. They like to work. People like to work in this business because jobs are few and far between. During that time, there was a lot of work. People were building their careers, they were able to play different roles. They were able to fill up their dance card as it were with work, they were going from movie to movie. People were getting an opportunity to play leads that hadn't had that opportunity before. Everything was really working and it was a very optimistic, hopeful time for Black actors because historically, we hadn't had those opportunities. When you look at the films that were being made, there was a dichotomy of material out there. There were *Leadbelly* and the *Learning Tree* and *Sounder.*

I was fortunate enough to work on *Sounder,* with Cicely Tyson and Paul Winfield. I was really excited about doing that film. That was the first feature film I was in and obviously it was a very important role for me. The cast in that film was extraordinary. I knew Cicely Tyson, again, she was a friend of the family's. I knew Paul Winfield was a very important up-and-coming actor. I was working with Martin Ritt, the director who had done *The Great White Hope* and *Hud;* he was an important filmmaker in Hollywood. I was twelve years old, I had my thirteenth birthday on the set. I knew that I had a huge responsibility. I was never formally trained as an actor. All I knew was how to react. It all came from the heart for me. In that respect, it was easy, because I didn't really worry about the formalities of it, whether or not I had submerged myself within the character properly. I didn't know any of that. I really had a good time on that film. And then there were little things, like the day the dog decided he didn't like me anymore. They set up a shot on a long lens, like a thousand milimeter lens, because I remember having to run forever to get to the dog. If you know the story, the dog just goes away, he's gone for a long time and I can't find him. Then suddenly

COLUMBIA PICTURES Presents **AARON LOVES ANGELA** Starring MOSES GUNN · KEVIN HOOKS · ERNESTINE JACKSON
Introducing IRENE CARA · ROBERT HOOKS as BEAU · a ROBERT J. ANDERSON/GORDON PARKS, JR./LLOYD S. GILMOUR, JR. film
Written by GERALD SANFORD Music by JOSE FELICIANO and JANNA MERLYN FELICIANO Songs Performed by JOSE FELICIANO
Producer ROBERT J. ANDERSON Director GORDON PARKS, JR. **R** RESTRICTED *Special Guest Appearance by JOSE FELICIANO and WALT FRAZIER

Columbia
Pictures

one day outta nowhere the dog shows up again. So I run to him; it seemed like I ran for at least half a mile to get to him. It's a really wonderfully composed back-lit shot with me and the dog meeting underneath the tree. I ran all the way down there, and I guess because I was running at this dog . . . he didn't understand, he hadn't read the script, so he didn't know that we were supposed to be friendly. He decided that he was gonna try to bite me instead. This dog was trying to chew my hands off and there I was about half a mile from anybody that could help me. I could hear Marty on the megaphone saying, "Okay, let the dog lick you in the face now." I was trying to say, "No, he's trying to bite me in the face, Marty," but nobody could tell. But, we had a great time on that movie. Now, my aspirations are to make a movie as good as *Sounder* because, to me as an actor, it never got as good as that anymore.

I remember saying to Marty Ritt at one time, "You know, Marty, this is turning out to be a really, really good movie. This feels like we're making a really good movie. This is the kind of a movie that gets nominated for Academy Awards, right?" I guess he probably thought, "Oh, my goodness. Now I got this twelve-year-old kid whose head is starting to get big. And I better make sure that I keep him in check." And so he said to me, "No. This is the kind of film that never gets nominated for Academy Awards. It's too small and it's too personal." He said, "You're right, it's gonna be a good movie. But I wouldn't expect too much from it." I thought, "Wow, that's, that's really a surprise," because it felt like a big film that clearly had some important issues that we were dealing with. I went on about my work and we had a great, great time making the movie. But I just never will forget Marty's response to me. I don't know whether he truly believed that or not. I mean no filmmaker ever wants to believe that his movie is going to do well, God forbid. I was always intrigued by that response because the film did do so well. It opened a year-and-a-half later and turned out to be one of the most critically acclaimed movies of our time. It was nominated for four or five Academy Awards.

Ironically enough, *Sounder* was out at the same time as *Superfly*. I remember there was a lot of dialogue about the dichotomy of film that year. People were saying this is perfect because if we can have a *Superfly* we should balance that with a *Sounder*.

I was about fourteen years old and I was too young to see *Superfly*. I thought that it was just another film about another drug dealer who was basically rippin' off his own people, and really had nothing more than that to say. We've seen that portrayal a number of times during the '70s. It wasn't until like maybe five years later that I was able to see *Superfly*. I'd already worked with Gordon Parks Jr., whose motion picture debut was *Superfly*. A lot of the crew that worked on *Aaron Loves Angela*, which was another film that I did during that era, had worked on *Superfly*. So I'd heard a lot about the film, but I'd never seen it. When I did, I was really

quite surprised and really quite impressed by what the film was trying to say to me. Ron O'Neal was wonderful in the lead role and really gave an honest portrayal of a guy who was essentially a business-man who had come to the end of the road. He had matured, he realized that there was something more to life than what he had been doing. He was going to do one last score and then he was outta the business. I think the film was actually saying we shouldn't be totally judgmental about people no matter what it is. This guy was really trying to make ends meet and was trying to further himself as a human being. Part of that was dealing drugs. There are a lot of people like that who are in that business and who are looking to do something else. They saw that, "Hey, even if I'm a drug dealer or if I'm a pimp or whatever the thing is, socially people are gonna knock that. But that does not necessarily mean that I can't feel good about myself and try to better myself. I'm not gonna be doing this for the rest of my life." I think people related to that.

We are in the entertainment business, let's not forget that. If we are going to sell a product, we have got to find the common denominator that makes those films commercial. What made those films commercial were the sex, the violence, and the cool way in which these characters kind of glided through difficult cultural situations. And *Superfly* had that. But the positive message spoke more to me than did the negative in that film. I have to say that it was one of the few that did that, and that's part of the reason why it was so successful. It wasn't just because the guy drove a cool car and dressed well. But I think it was because people saw a lot of themselves in it. My father was actually in one of those films during that period. *Trouble Man* was directed by Ivan Dixon, who is African American, with a dynamite soundtrack by Marvin Gaye, which I'm sure anybody who knows anything about music probably remembers.

It was a very exciting time for anybody who loved movies. I was really quite proud and quite entertained by the variety and breadth of material that I saw offered to African American actors. People saw that finally we were being recognized as

20th CENTURY·FOX presenta **DETECTIVE G.**
con **ROBERT HOOKS**
e **PAUL WINFIELD·RALPH WAITE·WILLIAM SMITHERS**
PAULA KELLY·JULIUS HARRIS

prodotto da **JOEL D. FREEMAN** · produttore esecutivo **JOHN D.F. BLACK** · diretto da **IVAN DIXON** · soggetto di **JOHN D.F. BLACK** · musica di **MARVIN GAYE**

COLORE DE LUXE(R)

WHAT IT WAS...

an integral part of the Hollywood system, and that we were given the opportunity to entertain almost on an equal basis with our white counterparts. That was exciting because we thought, "Okay, we worked very hard. We've made these in-roads, and now we have a foundation from which to build." I think that was what the excitement was really all about. It was a very promising time. It was really fun to kind of see everybody working. It really made for a very vibrant, healthy community. And then it all kinda went away. What no one anticipated was the economic downfall and the downward spiral to almost no films being made about, with, or for Black people for another ten years or so.

It is a very personal kind of setback to have had the opportunities that a lot of these people had, only to find themselves totally on the outside just five to ten years later. It has left a lot of people with a tremendous amount of worthlessness, with battered self-confidence, battered self-esteem, and just a lot of doubt about what this industry really has to offer for African Americans. Whether or not they really care about talent and things of that nature as much as they do pure economics. I saw a number of different people who had what they call house-keeping deals, they made a successful film and suddenly they had the two-year, two-picture deal at Fox, Columbia, or wherever it may be. That basically leads one to believe that a studio is really interested in developing material with this piece of talent. And to be limited to the types of things that basically had made the studio money, like the *Superfly*s or whatever those things were was a huge disappointment. It's a process that becomes humiliating, and you feel as though you had been lied to in a sense. They weren't really interested in doing the kind of stories that were important to us as Black people. They were only interested in doing movies that were going to make them money. And so it was really a huge misunderstanding, at best, that disappointed a lotta people. There's still a tremendous amount of bitterness and anxiety when it comes to that subject. There were a lot of wounds and a lot of casualties that came out of the blaxploitation era. The stories are really quite horrific when you listen to them. There's still a tremendous amount of bitterness that if you open the bottle, will come pouring out. I don't think that we've ever really bounced back from that. It clearly created an arc of cynicism that is still very pervasive in the industry among African Americans today. And rightly so, I might add.

It wasn't until the mid-80s when Spike Lee hit it big with *She's Gotta Have It* that we started a new renaissance, if you will, of African American films. The difference between the '70s and the '90s is that we have learned from the '70s the importance of the opportunity, and that we're really seeing much more of a variety of films being made now that speak to many different sides of African American culture.

You've got a much stronger independent film market now, as 1996 proved when four of the five best picture nominees were independent. You're seeing much more of an ability for filmmakers of all different cultures to make stories that are personal, stories that are little bit out of the mainstream. I think that really is the source of change because we've got other avenues to explore in many more creative ways than just the studio system. The

a hero ain't nothin' but a sandwich

"AT LAST, A COMPASSIONATE AND LOVING FILM ABOUT BEING BLACK IN AMERICA.

studio system basically is about product, and not necessarily always exploring new and innovative ideas. The independent market is really the avenue that is going to change things, and frankly, put a lot of pressure on the studios to do more. Now there are other avenues to be explored. They are bonafide, legitimate places where money can be raised and people are willing to hear unconventional voices.

In my own career, I have been very fortunate. After *Sounder*, I stayed in school in Philadelphia and did films and television work during my hiatuses from school and summer vacation. When I graduated from high school, I moved to L.A. and about a year and a half later, I landed *The White Shadow*. I had been in the business at that point for almost a decade. I just kind of was looking to do some other things. The life of an African American actor is very difficult, the roles are very limited and they're just not written. I was also very young-looking. When I was in my early twenties, I still looked like a teenager. I was offered the opportunity to study some, to watch and observe some directors and the opportunity to go to the editing room. One thing lead to another and I was doing episodic television as a director and then went on to direct feature films. One of the films I directed was *Fled*, with Laurence Fishburne.

I first met Laurence Fishburne when he was Larry Fishburne. He was about fourteen years old, and I was about sixteen years old. We were both auditioning and screen-testing for *Apocalypse Now*. Over one weekend we spent in Los Angeles, Francis Ford Coppola basically had invited every major actor in Hollywood to come in and audition for this cast. For three days he filmed a bunch of improvisations with a bunch of different combinations of actors. As the weekend went on he eliminated certain people from the mix. By Sunday there were two people that were there for the role of Clean in *Apocalypse Now*. One was Laurence Fishburne and the other one was Kevin Hooks. I remember that Laurence at that time was like this tall skinny kid from New York who talked a lotta shit, and basically listened to his boombox all day long and distracted all of the people who thought that they were method actors. I thought to myself, "No way this kid's gettin' the role, 'cause number one, he's too young. And number two, he's not that serious about acting." It wasn't until I was on the plane that I had some time to think about what had just happened to me that I realized, "Wait a minute! Hold it! That guy's gonna get the role! Because that's exactly the type of guy that went off to Vietnam." And that's how it turned out. But that's where we first met. So he and I have a history that goes back twenty-plus years. We really enjoyed working together on *Fled* again. In fact we laughed about that story, because that was a film that changed both of our lives dramatically. He went off to the Philippines for almost two years. He came back and he was clearly a man. He grew up on that picture. And for me, I think that the experience of losing that role, which was probably the role that I wanted the most in my career, and didn't get was something that I had to learn to live with. I think that experience really had a lot to do with why I am behind the camera now. That was the beginning of the idea that maybe I can do something other than audition for roles and not get them all the time. It had a profound impact on both of our careers. And I'm happy for it.

I am very proud of the accomplishments that I have made, both as an actor and as a filmmaker. I consider myself to be blessed that I have the opportunity to do the kinds of films that I do and speak to the different audiences that I speak to and to have the ability to go and do movies like *Heatwave*, which was about the 1965 Watts riot for TNT and then turn around and do a *Passenger 57*. I really feel I will have a body of work that is basically entertaining and commercial. But also that within that, there will be some very important statements socially that I hope to make. There have been so many people before me that have really made tremendous inroads, which has allowed me to do the work that I'm doing. I'm just really trying to lay some things down, and to say some things to people that hopefully we can all find insightful and maybe learn a little bit from.

"SOUNDER"
A Robert B. Radnitz/Martin Ritt Film

WHAT IT WAS...

Born in Florida and raised in Newark, New Jersey, Gloria Hendry's first job was as an assistant to the legal secretary in the New York office of the NAACP. She would take modeling jobs on the side and eventually became a Playboy Bunny. While working at the Playboy Club she was offered a part in For the Love of Ivy *and her film career began. Hendry starred in some of the most popular action movies of the '70s, including* Slaughter's Big Ripoff, Black Belt Jones, *and* Black Caesar. *In addition to her filmwork, she has extensive stage and television credits. She has completed her first CD and produced and directed* The Paul Robeson Story.

This was a Renaissance time. On the high side, it was like a party. It was definitely an exhausting, exhilarating, exciting, and adventurous time. Speaking for myself, on the low side it was tiring, treading through territory that you knew nothing about.

I was a New Yorker and auditioning quite a bit for Broadway. I had done some stage reviews and commercials and I was also a Playboy Bunny. We came from all different fields as well as being from the industry. We were all experimenting. From Micheaux swing up to the early '70s when all of a sudden you see—boom, a whole influx of features. It was all new territory.

I resent the term blaxploitation. Who in the heck started that? Someone said a particular individual had started it. I resent the term *blaxploitation* or Black exploitation. All films are exploitation. Exploiting that area, this area, that period, this period. But to mark us as Black exploitation, what is that? It doesn't mean anything. Someone is trying to put us all in and tie it up with a bow. Why don't they say, The Renaissance, or the Black Renaissance. Put it where it belongs. You need to ask what was happening to us as Black Americans at that time. What was the feeling surrounding us that influenced us and anyone else that we were dealing with.

Pam Grier, myself, and Tamara Dobson were basically the three females playing the action roles for these movies. How often do you see a Black female lead in an action movie? I did *Black Belt Jones* with karate. *Black Belt Jones* from a physical point of view was wonderful. Out of the all the roles, *Black Caesar* stands out. I think *Black Caesar* was the main role that really allowed me as an actor to really show. Out of all the roles, character was more developed.

Being nude was a very large part of the female role for a number of those films. Looking at my excerpts from my films that's what I had to deal with. At the time the nude scenes were a major, major factor, and maybe some of the ladies don't want to talk about that time. One of the reasons why I got the roles at that time was because it didn't bother me. The second was, I think, primarily because of my talent. When I was able to audition and they liked me, and then they presented the "problem." Each of the films that I did that involved love scenes, I asked for a closed set. I discussed it at length with my leading man to get comfortable and to let him know my feelings, how I felt about it. It made us more human and sensitive as far as artists are concerned. I think I handled the love scenes well. I don't regret any of them.

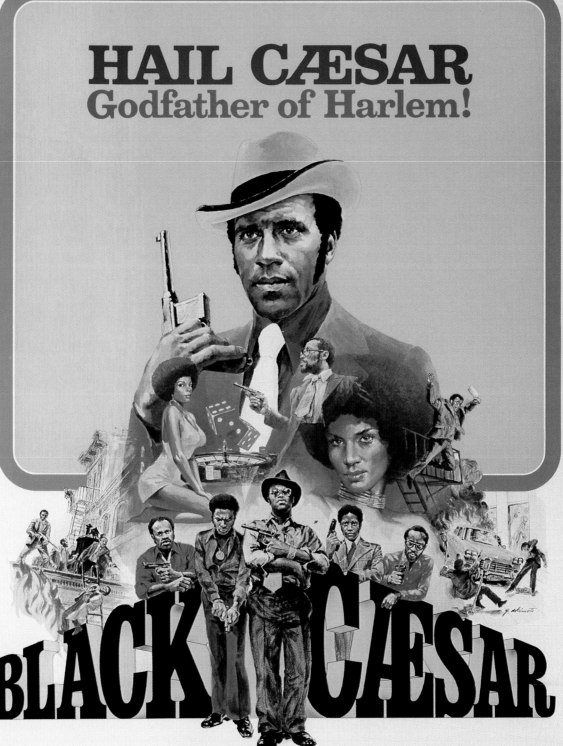

HAIL CÆSAR
Godfather of Harlem!

BLACK CÆSAR

...The Cat with the .45 caliber Claws!

A Larco Production —
An American International Release
FRED WILLIAMSON starring in "BLACK CAESAR"
co-starring MINNIE GENTRY · JULIUS W. HARRIS · D'URVILLE MARTIN
DON PEDRO COLLEY · GLORIA HENDRY · ART LUND · VAL AVERY · PHILLIP ROYE
Written, Produced and Directed by LARRY COHEN · A LARRY COHEN Film

Color by
DE LUXE*

R RESTRICTED
Under 17 Requires Accompanying
Parent or Adult Guardian

Music composed and
performed by
JAMES BROWN
Sound Track Album
available on
Polydor Records

WHAT IT WAS...

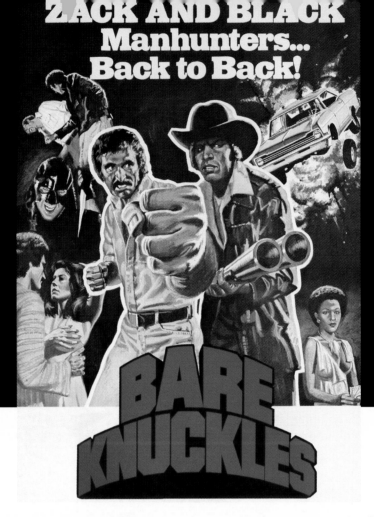

The rape scene in *Black Caesar* between Fred Williamson and me was a classic scene. She didn't give in. They love that scene because I didn't want to make love to my husband because he's a killer. He's a murderer and no matter how painful it was, I still said No, so he just raped me, but I still said NO and the women loved it. They said Yes, they understood. While he's displaying his physical strength, I'm showing my emotional strength and determination and he still wouldn't conquer even if he did, neither of us won.

When I worked with Fred Williamson, it was wonderful. Fred Williamson had a lot of input with Larry Cohen, who was the producer, writer, and director. He was very amicable to suggestions.

To be honest, most of the characters that I played were one-dimensional. I haven't been blessed with a film where the role was an Academy Award piece. I'm still looking down the line to find something like that. I had mixed feelings about each one of my roles. With most of them, we would go to a certain point and then it was stilted and went to a certain spot and then it was the male from that point on. It was like, "You were too strong . . . and we don't need you that strong." But I am that strong.

It was very exciting and very new territory. A lot of rules were broken. We would come to the set and they'd write the scenes right there. They rewrote scenes right there and we had to relearn them. We had to learn them in five minutes before we went on. There were long days—as much as twelve- , fourteen- and fifteen-hour days. It was not like today when you had much more time. We shot films in two weeks or ten days or six weeks or four weeks. It was low, low, low budget, on a shoestring. Everything was done on a shoestring and everything was done now. I didn't ad lib. I really stuck to the script. The ad lib came from the action that came out of the dialogue that moved us from one scene to the next.

Today's kids are not from that time, they have no idea what we were going through emotionally. There are no words to really express that. I understand why some kids today would be attracted to the films. When they are looking at that time by watching the films they are feeling what we we're going through. To see it so forceful, so big, so broad, so untamed, so in your face. It's like Wow! You look at the films today, they are tame, they are polished. The films of that day were Raw!

It could be said that these movies saved Hollywood and the reason why we did save Hollywood. The studios were in tremendous trouble at the time. Why else would they even entertain producing and distributing Black movies? I had a year's contract when I did *Black Belt Jones*. They needed to venture out. When they found out how much money they could make off of making a $10,000 movie. Are you kidding me? We made money hand over fist. We saved 20th Century, Warner's, Paramount, and after they got straight they left us. It's very easy for them to forget that because people in Hollywood change all the time.

We were stopped at the pass. We were killed off. Most of us shared our feelings and said, "Please don't stop us now, we are just beginning to grow, we are learning how to do it right." Our next move was to get out of those heavy emotional, emoting, and blood stuff. We're going to get into the real stories soon. After they stopped us, the next period didn't come until twenty years later. The studios only bought what they felt the audience would buy, and they believed those were the action and horror films. We got that going. We said it on the set, "Please don't stop us now . . . Please!" The organizations were raising up and saying, "Hey you're exploiting us . . . this is nothing but blood . . . and one dimensional." I agreed, we all agreed, but they had to know that there was a Black audience that would come out to see these movies. This was business and we would've evolved. But the studios and everybody were being hit so hard by the population of the churches, they didn't give us time to grow. We needed to grow. We were rare but with the lawsuits, they just dropped us. A lot of us went under. When you ask what happened to us, this is the downside.

Some of us became bag people, some of us killed ourselves, some us dropped out totally, and despondent, some of us

ENTER
JIM
"DRAGON"
KELLY

HE CLOBBERS
THE MOB AS
BLACK BELT JONES

WHAT IT WAS...

pulled in and became very hateful. Some of us went to drugs and went to alcohol. It's awful. I couldn't find some people and when I did it was in whispers, "What happened to you?" It was like being in a corner in hushed tones, hearing "I lost everything."

When the films stopped, it was a double-edged sword because they were so right but when you see the baby going in the wrong direction and you see the baby trying to walk but doesn't know how to do it, you don't beat the baby, you nurture it. And that's what happened to us. We were moving in all kinds of directions trying to find the right slot. We were very hurt and after a while it was like what we did was . . . NOTH . . . ING! It's like I don't exist. I'm telling you I know who I was. I know where I've come from and I know where I've been and I deserve my position and I'm not moving.

I'm very proud that we've come full circle. We're now going back to the times and the shows and going forward after that. We now have *Soul Food* and *Amistad*. We have Black producers who have the money. When we were coming through there was no Black money like that and to talk about the white writers and knock them is ridiculous. To say thank you is to say thank you very much. I might have had problems with writers as far as the depth of being able to understand us rather than a caricature. It would be the same thing if I'm trying to write for a group of people on a certain level, I would have a difficult time. But when you write a real story and turn it inside to any group of people, those are classics and how often is a writer able to write a classic?

This Renaissance period was definitely a stepping-stone for today. I'm so proud of that. People today could not come in at a level that they're coming in now, because they had an opportunity to see and be exposed to the period when we were coming through. We treaded through some treacherous territory. I'm going to stick to the high side. It's always hard but to discuss the pain and bring it through, like it's the main factor . . . Not at all! As I look back there is definitely the high side. We went through the crap for them to reign today.

There is still a scarcity of Black females in strong female roles. I would like to see more strong female roles across the board. For us that is still missing today, and I think the public is starved for it.

JOHNNY SVELTO

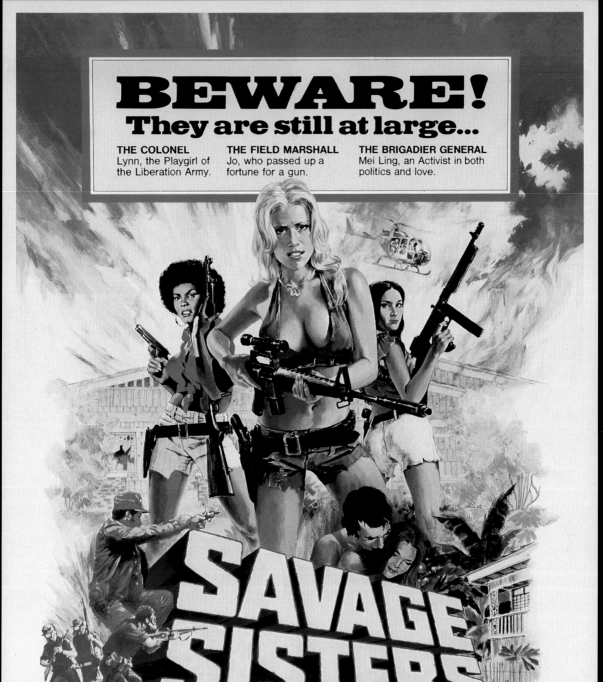

BEWARE!
They are still at large...

THE COLONEL
Lynn, the Playgirl of the Liberation Army.

THE FIELD MARSHALL
Jo, who passed up a fortune for a gun.

THE BRIGADIER GENERAL
Mei Ling, an Activist in both politics and love.

SAVAGE SISTERS

An AMERICAN INTERNATIONAL Release

starring

GLORIA HENDRY That "GINGER" Girl **CHERI CAFFARO** as "Jo"

ROSANNA ORTIZ co-starring **SID HAIG** and **JOHN ASHLEY** as "W. P. Billingsley"

music composed by BAX written by H. FRANCO MOON and HARRY CORNER executive producer DAVID J. COHEN

produced by JOHN ASHLEY and EDDIE ROMERO directed by EDDIE ROMERO · COLOR by Movielab

R RESTRICTED
Under 17 Requires Accompanying
Parent or Adult Guardian

Reginald Hudlin has enjoyed a long string of successes since leaving East St. Louis, Illinois, described as the blackest city in America. Educated at Harvard, his thesis film became the basis for House Party. Not only did it garner the Filmmakers Trophy and Best Cinematography Award at the Sundance Film Festival, House Party was a huge critical and financial success, grossing over $27 million on a $2.5 million investment. The film created a franchise, including two sequels, a Saturday morning cartoon show, and a comic book. His next film, Boomerang with Eddie Murphy, was a megahit, earning $130 million worldwide. His success touches those around him. A list of artists whose careers have received a boost from their association with Reginald includes Kid & Play, Martin Lawrence, Tisha Campbell, Daryl "Chill" Mitchell, Jamie Foxx, and Toni Braxton. He wrote the first African American animated feature, Bebe's Kids. He directed the boxing comedy, The Great White Hype. In addition to his film work, he created an award-winning special for HBO, "Cosmic Slop." He is developing feature projects for New Line Cinema, Miramax Films, and Warner Bros. In addition, he is creating TV shows for Walt Disney, Fox, and HBO. He and his brother Warrington co-produced Ride, a musical comedy.

Every movie you see inspires you one way or the other as a filmmaker, but certainly having grown up in the midst of the blaxploitation film movement had a very direct effect on my career. I know in my brother Warrington's case, he got invited to a screening of *Shaft*. After the movie, Gordon Parks came out and Warrington said, "Oh, my god, a Black man made this movie." That was incredibly inspirational for him. He was inspired in a positive way by what Gordon

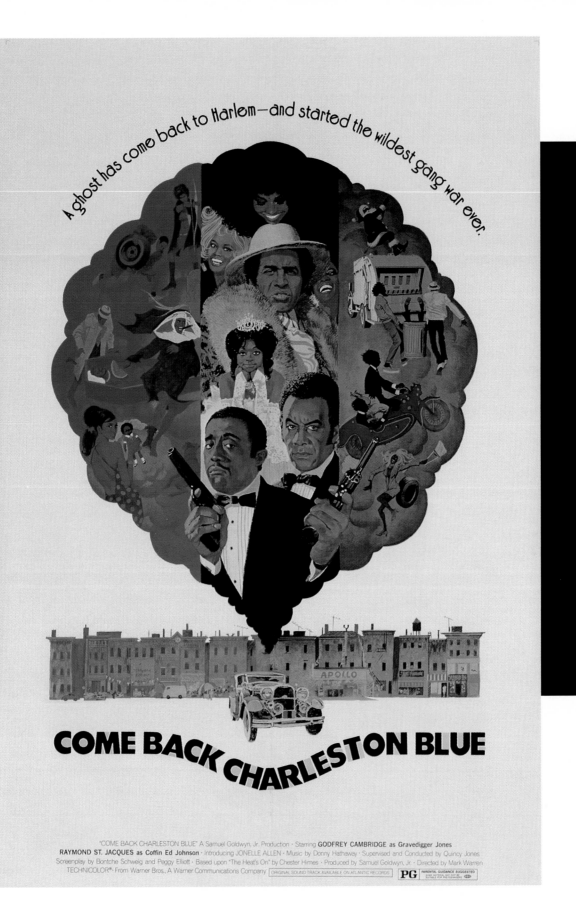

and Melvin were doing. When Melvin Van Peebles did *Sweet Sweetback's BaadAsssss Song*, that was almost a nuclear bomb that started two movements simultaneously. The most obvious one being the blaxploitation film movement. The not so obvious one was the Black underground or independent film movement. I grew up watching both. I love the blaxploitation era, I'm really grateful to have grown up in that era. If for no other reason than you had on a weekly basis movies where Black people just beat the hell out of and/or killed white people and that was just fine for me. I had a lot of frustration and aggression for a very good reason, and to be able to have those dreams, those fantasies manifest is what Hollywood is all about. I felt like I was being serviced.

More than just fantasy fulfillment, many of the blaxploitation films showed a lot of artistic and political freedom. Coming out of the '60s and overlapping into the '70s, people were still very politicized. It was a time of tremendous experimentation throughout American culture. I think some of the freedom of those movies came from the times. When you look at *Sweetback*, which is politically radical, it is an expertmental film more than anything else. That's the thing people forget. Structurally, the kind of camera stuff he does, the overlapping montages, the way the music and the sound montage is

stream of consciousness. There is nothing conventional about it. One of the reasons Van Peebles could get away with that is because he literally was first. There was such a hunger from the audience to see something other than Mulattos, Mammys, and Bucks. Here's a whole other kind of iconography for us as a people. People just loved it, they ate it up. It was so fresh and exciting that whenever Hollywood did bad knock-offs of it, people were still excited, there was so much of a need to see this. I think the filmmakers in the '70s were dealing with a lot of issues. When I've talked to people who were making films in that era, they simply were not allowed to expand in terms of subject matter, the rules were laid down very clearly that they had to make exploitation. I was on a panel with Ron O'Neal. After the success of *Superfly*, he could just walk into the offices of Columbia and sit down with Frank Rose, who, I guess was running the place at the time. He was just totally welcomed because he was that level of star. But when he said, "I want to do the life of Pushkin as my next movie," they looked at him like he was crazy. They were not able to stretch out and raise the production value, the ambition and scope of the movies beyond low-budget action films.

But since the filmmakers weren't allowed to go to the next level, the thing died out for a while. Now, people are very apolitical, they just look at politics in a very different way. I don't think they're looking for that kind of "power to the people" solutions anymore. They're trying to figure out how to take care of their home in a very kind of capitalistic "greed is good" attitude. But I don't see any kind of appetite in a broad way for the kind of movies that were made then.

I do see the impact of those movies in today's rap artists. The reason is it's the first set of iconography that is not embarrassing to them. No one wants to be the young Stepin Fetchit, at least not consciously. People are angry, I mean, there is an anger in the culture, Black and white period. It can be expressed in a kind of nihilistic way, whether you are a Nirvana or whether you're Snoop. There are all kinds of ways of expressing that. When they

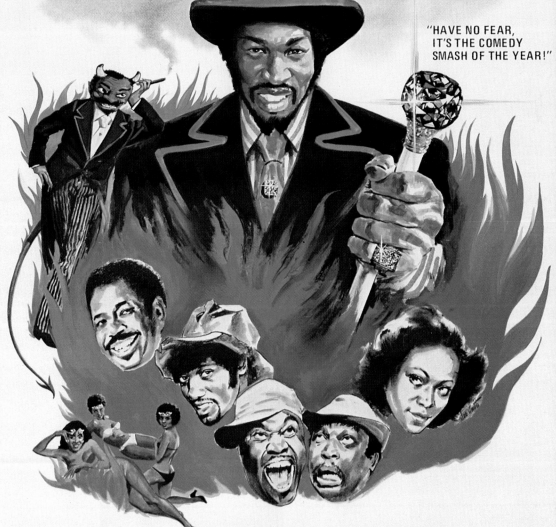

Rudy Ray Moore is
PETEY WHEATSTRAW
THE DEVIL'S SON-IN-LAW

"HAVE NO FEAR, IT'S THE COMEDY SMASH OF THE YEAR!"

STARRING ALSO STARRING INTRODUCING

JIMMY LYNCH–LEROY & SKILLET–EBONI WRYTE–WILDMAN STEVE–G. TITO SHAW

Produced by THEADORE TONEY In Association With RUDY RAY MOORE — Associate Producer FRED WILLIAMS
Executive Producer BURT STEIGER — Written & Directed by CLIFF ROQUEMORE
Director of Photography NICKOLAS VON STERNBERG — Production Coordinator & A/D AYANNA DU LANEY

GENERATION INTERNATIONAL PICTURES RELEASE — COLOR BY PACIFIC FILM LAB

©1977 Generation International Pictures

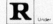

R | RESTRICTED
Under 17 requires accompanying Parent or Adult Guardian

6 ft. 2 in. of dynamite explodes into action.

look back, they see a bunch of tough action heroes, people emulate *Foxy Brown* and *Shaft* the same way you would emulate John Wayne or Clint Eastwood. Here's an iconography that relates to me, they're tough and cool, the same way I want to be tough and cool. Those films have a currency for young people that no films before that had. Some of the strains of hip hop, particularly gangsta rap, is philosophically in line with some of the more exploitative Black exploitation films. When they borrow things from the films, it's not necessarily in a consciously political way.　But that doesn't mean it doesn't have a political meaning.

It has a cultural importance. Cool is an African idea and the kind of anger in nihilism has a political root.　As opposed to a more self-conscious thing like there's a race war or class war going on. Probably the reason kids embrace gangsterism is because it is a rejection of political ideas. In terms of whites' use of Black culture, they can express their middle-class rebellion by identifying with the most outlaw elements of Black culture. That's one of the reasons why that's always been encouraged and more commercial in terms of crossover appeal. You look today, Luther Vandross can't crossover but Public Enemy can. You think it would be the reverse.　But the fact is, if you're a fourteen-year-old white kid in the suburbs, edgy artists like Ice Cube have a practical use. If I'm going to listen to Luther Vandross, I might as well listen to Bon Jovi.

When I look at what's happening in Black films today, there was obviously this period, with *Boyz N the Hood* and *Menace II Society*, where there was this great push to create a sort of a second blaxploitation era with the emphasis on gangster films. But the difference is, when that trend ran dry, movies like *Boomerang*, *Waiting to Exhale,* and *Soul Food* were made. Suddenly Black film has a whole new life that looks even more profitable than the gangster films.　That transition was the difference, it was not allowed to happen then, for whatever reason, and it is happening now.

In my own career, I wanted to make a movie that wasn't about the pathological set of Black culture, because we always saw that. I just wanted to make a movie about regular Black kids. I thought being normal would be really novel. That was the basis for *House Party*.　We showed a cross section of Black society. That's kind of how I grew up.　In East St. Louis, we all went to the same school, we all hung out together.　People from the projects and people who had middle-class families all hung out

They transplanted a
WHITE BIGOT'S HEAD onto a
SOUL BROTHER'S BODY!
The doctor blew it—the most fantastic
medical experiment of the age.
And now, with the fights, the Fuzz,
the chicks and the choppers
...Man, they're really in
deeeeep trouble!

SAMUEL Z. ARKOFF Presents

Ray **Milland** and "Rosey" **Grier** as...

THE THING TWO WITH HEADS

CO-STARRING
DON MARSHALL · **ROGER PERRY** · **KATHY BAUMANN** and **CHELSEA BROWN** as "Lila"

A Saber Production An American International Release

PRODUCED BY **WES BISHOP** · EXECUTIVE PRODUCER **JOHN LAWRENCE** · DIRECTED BY **LEE FROST** · SCREENPLAY BY **LEE FROST & WES BISHOP** and **JAMES GORDON WHITE** · STORY BY **LEE FROST & WES BISHOP**

COLOR by DE LUXE

PG PARENTAL GUIDANCE
May not be suitable for pre-teenagers

119

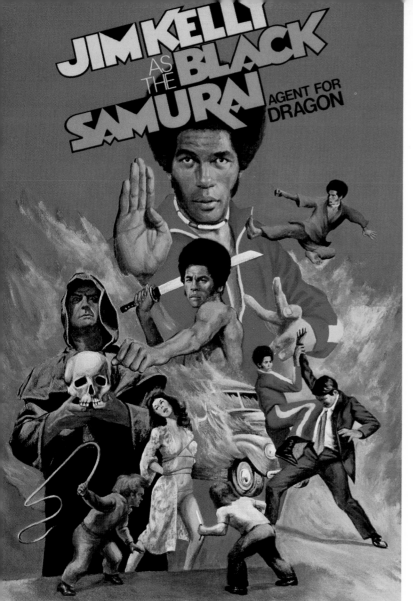

JIM KELLY as the **BLACK SAMURAI**, Produced by BARBARA HOLDEN, Executive Producer LAURENCE JOACHIM, Directed by AL ADAMSON
A BJLJ International Corp. Production, Screenplay by B. READICK, Based on the novel by MARC OLDEN

together, because, literally, the town isn't that big and none of us were that far apart experience-wise.

After *House Party*, Eddie Murphy called me and said, "I want you to make this movie." It took us a year to find a movie that we wanted to make together. When he gave me the script for *Boomerang*, even though the script itself was terrible, I knew the idea was exactly what people wanted. When we made the movie, we said, "Look, let's just make a fine little romantic comedy." I'm thinking that, gee, this movie doesn't really have any political subtext. But, it's still a good thing to do. I didn't know that it would be the most political movie I've ever made in my life so far.

When the first reviews came in, they said, "Well, look, this is a science fiction movie," and I'm literally quoting a review. There was a tremendous...not indifference, it was hostility. It wasn't that the cast was entirely Black. It was that they were middle class and they were successful. It was that whites essentially made no real difference in their lives. Even when they had a racist encounter, it didn't really ruin their day. It was a joke, they made a joke about it and they went on. On a subliminal level, that is shocking and offensive to whites. If you ask any of those critics they would know that's what offended them. Whites would much rather be hated, made the object of frustration, than ignored or just made unimportant.

For the Black audience, *Boomerang* filled a need that nothing else had done. It was a tremendous success, making a $130 million. In a way, *Boomerang* was kind of frustrating because they always call it an Eddie Murphy movie, but the fact is not every Eddie Murphy movie made $130 million. His follow-up set, the movie they ran after that, was *Distinguished Gentleman*. It made $40 million. Now, there's a disappointment. But it got better reviews and was better received than *Boomerang* because it was Eddie in a comfortable context. He was a fish out of water, a Black guy in an all-white context, being a con man. It was iconography whites felt very comfortable with.

Boomerang was an important movie for me. I made this quantum leap in budget and scope from *House Party* to *Boomerang*. I want to make the same kind of leap again, so I've been developing a bunch of science fiction films. I figured, I've got to get to the $100 million club, that's the only way you really get respect. It seems like the best way to get into that club is by making science fiction films. But I was having no luck in getting such a film made. I live pretty inexpensively and I had made two-and-a-half movies, so I wasn't hurting for money. There was no real rush. But like four years had passed and I hadn't made a movie. I said, this is bad, I need to go to work. Then Fox sent me a script for *Great White Hype*. It was a Ron Shelton script, which was a very big deal to be getting. Ron Shelton usually directs his own material and he's one of the best writers in town.

Here was a film that actually was going to be my first movie about race. My other two films were not about race specifically. But I thought, here's a chance to do sort of a *Dr. Strangelove* kind of satire. Given the kind of frustration I was dealing with at that time about race, I was more than ready to dig into it. So we did, and learned a lot of stuff. Satire doesn't sell and the people at Fox admit this. Even though they were very excited about making the film, very excited about me making it, it was a very tough movie to sell, because it was not a flat out Black comedy, Black in the racial sense. It was really something that was probably more appropriate for Miramax because it's this kind of weird art satire that deliberately frustrated the audience. It was a lot of fun to make and working with a racially mixed cast for the first time was great. Actors I would never normally have had a chance to work with, like Jeff Goldblum and Jon Lovitz were wonderful. Now that I've worked with them, I'm getting a whole new level of respect in Hollywood. Somehow, until you work with white actors, they're not sure that you can. Now, I get offered a whole other kind of script than I was ever offered before.

There's the frustration that any filmmaker has, whether you're Orson Welles or whoever. Martin Scorsese complains about his ability to get in Hollywood. So it's a tough nut for anybody. But when I look at where we are in Hollywood, I could compare it sort of in musical terms to the 1950s when Mitch Miller was head of A&R for Columbia Records. When they had first signed Aretha Franklin, they had no idea what to do with her. There was no Black marketing department, there was no Black A&R, no Black producers, there was no mechanism to deal with that level of talent. Now you can be a musical artist and virtually go from being off the street to multiplatinum and have Black people make every major decision. But we are nowhere near that kind of situation in Hollywood.

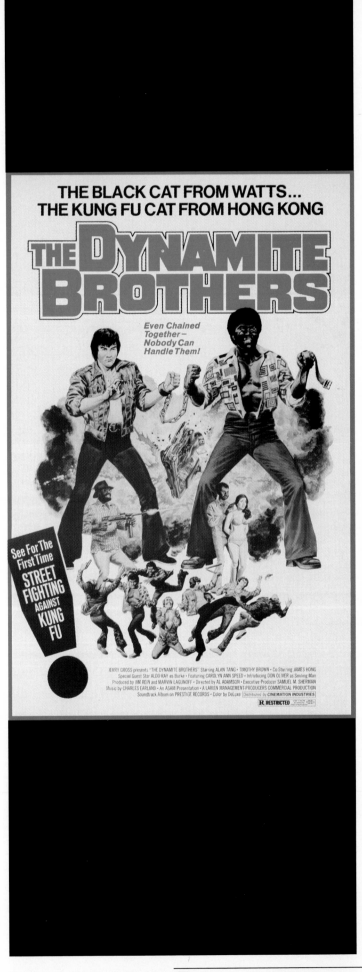

WHAT IT WAS...

ROBERT TOWNSEND

*Robert Townsend was in the coming-of-age film, **Cooley High**, as an extra, which was one of his early acting credits. Townsend skyrocketed to the limelight in 1987 when he wrote, directed, and starred in **Hollywood Shuffle**, a film he largely financed using credit cards. The semi-autobiographical film lampooned the struggles of African Americans in the film industry and established him as a ground-breaking filmmaker and a rising talent.*

*His subsequent films, **The Five Heartbeats**, and **The Meteor Man**, which Townsend also wrote, directed, and starred in, continued to demonstrate his innate sense of comedy, storytelling, and love of film. Amongst his directing credits are Eddie Murphy's concert film, **Raw**, and **B.A.Ps** (Black American Princesses), which starred Halle Berry and Academy Award–winning actor Martin Landau. He currently stars in the popular family sitcom on the WB Network, **The Parent 'Hood**, which he created, acts in, and serves as executive producer.*

The Mack is one of my favorite films—it was well acted and well directed. It showed you the soul of the character, that he was a human being. He made a wrong turn, but he had a mother, he had values, even though his values were messed up in a lot of ways. There's also conflict between the pimp and his brother. The brother is working within the community trying to clean up drug dealers and trying to clean up the pimps, and they get into arguments based on what he is doing. The brother talks about how wrong a pimp's life is. So the film didn't skate around the issue of, "Hey, pimping is the best way to go." It said, "You live this life, you're going to end up in a bad way and things are going to hurt." His mother gets beat up. It's really a deep story, but it's very enlightening as well in terms of that life. The story gave you some insight.

I think the movie that affected me the most in the '70s was *The Spook Who Sat by the Door*. It was about a revolution. Sometimes, even as a kid, I would see the injustices that were being done, and I wondered, why can't African Americans work together to do positive things in their community? Why can't they take responsibility for drugs not getting into their neighborhood? That film addressed a lot of really deep issues that I would see, having had friends die from drugs and friends out there thinking that was the only way of life.

I think that it was very painful for the film's director, Ivan Dixon, because he went through a lot to get that film made. It was a fight getting it to the screen. I know that when I saw it, it was only in the theaters for a week. I wanted to tell everybody about it because it wasn't your normal shoot-em-up kind of picture. The next week somebody said, "Wait a minute, this is not some jive picture for the Black audience. This has a very powerful message and it's saying some really deep things." And somebody said, "Hey, this is the wrong movie to let out." I think that's when they snatched it off. When people discovered what Dixon had really made, I don't think it was welcomed. What it said was very profound and I think a lot of people were afraid of that truth.

A. G. CINEMATOGRAFICA presenta

FRED WILLIAMSON in

TOMMY GIBBS CRIMINALE PER GIUSTIZIA

CON JULIUS W. ARRIS · GLORIA HENDRY · MARGARET AVERY
D'URVILLE MARTIN · TONY KING · GERARD GIRDON
E BOBBY RAMSEN REGIA DI LARRY COHEN PRODOTTO DALLA AMERICA INTER. PICTURE INC.

having African Americans in leading roles in films a negative thing?

Max Julian, Melvin Van Peebles, Fred Williamson, and all those guys and ladies that started this whole journey, created stories that weren't within the norm of Hollywood at the time. You have to understand the images of Black people in Hollywood films before films like *Sweetback* and *The Mack* were made. Black actors were sidekicks. They never had sex lives and never thought about sex. Or they were the ones that got their butts kicked. All the roles for Black actors, especially the comical roles, were stereotypical. And by that, I mean the characters had no substance. So when people use the term blaxploitation

I don't know who coined the term blaxploitation. I don't think anyone was being exploited during that period. What those films were giving to the audience out there, kids like me in ghettos all across America, were heroes. I got a chance to see African Americans who fought and fell in love; who chased the bad guys; who led complex lives themselves. When I hear the word blaxploitation I wonder whether they're saying we were exploited because they sold us heroes that didn't exist? Was

they tend to dismiss a lot of really good work that was done by some fine actors during that period.

The '70s represents a viable chapter in African American cinema history. There was such a broad spectrum of films. If you analyze it, there were even genres. There was the action genre, films like *Hell Up In Harlem* or *Black Caesar* with Fred Williamson. I'm into gangster pictures and I just loved that action and that world. Fred Williamson has always been a man's man, and in those films, *Black Caesar* and *Hell Up In Harlem*, he goes forward, speaks his mind, talks tough, fights bad. It's all

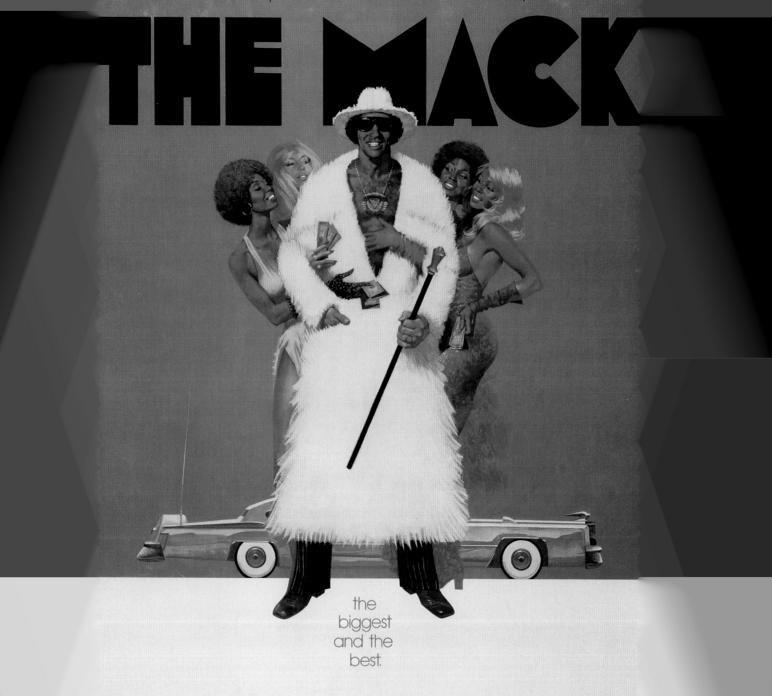

Mack and *Superfly* were character studies. *Cooley High* was, for African Americans, a slice of life in
age movie: Two friends growing up in the '60s and their bond of friendship, the Motown
them, and what happens to one friend. I loved *Claudine* because the film is like my life. My mot
on her own, having to date, and what happens, as she clung to her kids. It's just the story of my l
ways. Then you had Pam Grier, who was Foxy Brown—we had never seen an African American v
not just be a sex object, but be smart and take charge.

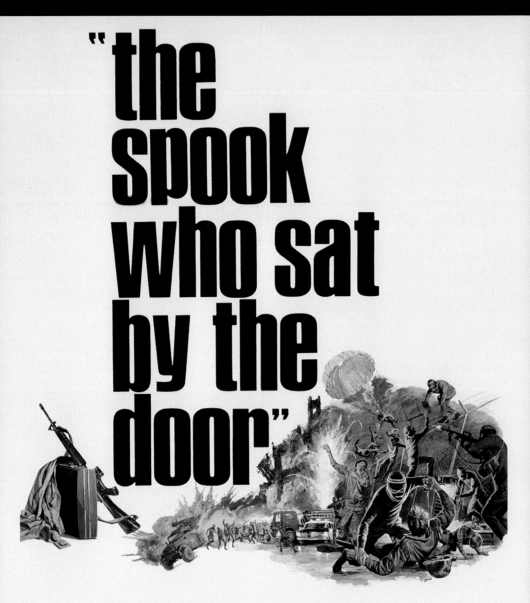

"the spook who sat by the door"

The controversial best selling novel
now becomes a shocking screen reality.

BOKARI LTD. presents "THE SPOOK WHO SAT BY THE DOOR"
with LAWRENCE COOK · PAULA KELLY · JANET LEAGUE · J.A. PRESTON
Screenplay by SAM GREENLEE and MELVIN CLAY Based on the novel "THE SPOOK WHO SAT BY THE DOOR" by SAM GREENLEE
Produced by IVAN DIXON and SAM GREENLEE Associate Producer THOMAS G. NEUSOM Directed by IVAN DIXON
Music by HERBIE HANCOCK

PG PARENTAL GUIDANCE SUGGESTED United Artists

Those movies could hold their own against any movie Hollywood made at the time, which is why they continued to get made. *Shaft* was number one at the box office and made incredible amounts of money. I think a lot of these films were cash cows for a lot of the studios, which helped keep the studios alive and funded other projects. The bottom line was not about black or white, it was green.

Fred Williamson will always be my hero because he said "Hey, I can produce movies. I can direct movies." It takes a whole lot of courage to just step out there and say "I'm going to make a movie." Like Rudy Ray Moore, I thank him all the time because he took his own money and acted, produced, directed some, wrote his own films. Now you might say he was just doing some crazy comedy, *Petey Wheatstraw* and *Dolomite,* and he was out there. But no, no, no, I understood what was really going on. There's Max Julien, The Mack, he did *Tomasine and Bushrod.* He did a lot of films that he wrote and directed.

They gave me the idea that it was possible to make movies. They were pioneers on a lot of levels for me. I mean, as I sit here, a writer, director, producer, actor, it's kind of like the *Wizard of Oz.* Getting to Oz and discovering that it's not all mystical-magical making movies isn't really that hard, it's just doing the work. I think that so many people have been programmed to believe that, "Oh my God, to write, produce, and direct a movie has got to whoa!" It's not really that. It's just getting together, and believing and doing the work.

The thing is, all my films are based on understanding. . . I'll put it like this. *Superfly* came out when I was a kid and we saw it on the weekend. That next Monday morning, all my friends had dyed their hair and had it processed to look like Ron O'Neal in *Superfly.* I knew Ron O'Neal was an actor in New York doing Shakespeare because I had been studying and reading about actors. He was just doing this role but he did it so well that people wanted to be like him. And that's when I understood the power of the medium. And so in all my work, I try to do something positive, or something that says something.

In *Meteor Man* I wanted to really hit home the message that the real courage comes from within. This one little kid came up to me, he had this little sparkle in his eye. He says, "Hey, Meteor Man. You got any of that Meteor left over?" I said, "No, it's all inside of me." The bottom line is that the real courage comes from within. It's like the scene when Meteor Man is being beaten by the bad guys in front of the community. The people just want to point the finger at the one bad guy. But when you really look at it, *what are you doing*? We had the screening in Oakland for the film and when that scene happened, you could hear people applauding and screaming out because it's so real. When you really think about it, and maybe that's the hopeless dreamer inside of me, I know that this world could change if we work together. If that one film planted that seed in a person's mind, maybe they will think about taking action and doing something with it in their community. I think that's the power of movies.

The bottom line for me is just continuing to make stories that I feel passionate about. If I do a comedy, the comedy has some substance to it, it's well structured, and it's well written. The jokes aren't predictable. For me as a filmmaker, I think it's creating stories that aren't the norm. I think that's what Fred Williamson, and all the guys and ladies that started this whole journey, were doing. I think I just continued the legacy.

WHAT IT WAS...

RUDY RAY MOORE

Rudy Ray Moore is not well known to general audiences but he is considered a cultural treasure among African Americans. His scatological standup comedy routine predated Richard Pryor and was bolder than Redd Foxx. His rhyming comedy structure influenced a whole generation of rappers. Moore's eighteen party albums, without the benefit of any radio play, have sold a million units. Rudy Ray Moore is the Godfather of Rap and the King of the Party Record. In 1975, Moore produced a movie based on his most famous character, Dolemite. It was a huge hit and launched Moore's film career. His blend of violence and comedy made his films unique among the movies of the era. With the demise of Black cinema in the early '80s, Moore went back to comedy, working clubs and concerts. He has worked with many of the top rappers, including 2 Live Crew, Easy E, and Snoop Doggy Dogg.

I have to go back to how I started doing what I became popular for. I was the world's first comedian to do four-letter words in records and comedy. I was lucky enough to get a character, a real tough character, Dolemite. He was real bad on the record. I did produce the record myself. I think it took me $253 to make this album. When I first put it out, I carried it to the distributors in a place we called record row, which was on Pico Boulevard in Los Angeles at that time. I wanted them to distribute my record around to the stores, mom-and-pop stores and so forth. I was made fun of, they listened to it and they just carried on terrible. One man said "Rudy, you've gone mad. What do you expect to do with this piece of shit? I'm sorry, I just can't handle anything like this." I knew that it was going to go because when I first started, I had put it on cassette tapes and carried it to the truck stops. The truckers listened to it and said, "Oh, I want a copy, I want a copy. As soon as you get some, give me a copy." I knew that it had the action. I hit the streets with it and handed out copies to fun-loving people and the record stores started buzzing for it. Everybody started calling for it.

The man that made fun of me called two days later and said, "Bring me a thousand copies right away." He was just so sorry about what he said he didn't know and didn't understand what I had. So the record hit. I started going on the road, doing concerts. Then I put out a second album, the *Rudy Ray Moore* album. On the cover, to signify my risqué type, I pointed at the two little cats lying on the floor that were the pussies that belonged to me. This record hit with a tale called the "Signifyin Monkey."

After we had back-to-back smash albums, I wanted to stretch my career more. I got Jerry Jones, who never did a screenplay before, to write me a story about Dolemite. But, I couldn't get a dime to finance the picture. The only person I got some money from was a man at Kent Records who had my recordings. He give me $25,000 to help finance Dolemite, and his assistants told him, "Don't give him a dime because Rudy Ray Moore is crazy. It'd be impossible for them to ever get this movie shot for that kind of money, you don't do it, don't do it." But the man let me have the money because he had eighteen of my albums on his label. I made up a contract, if he didn't get the money back

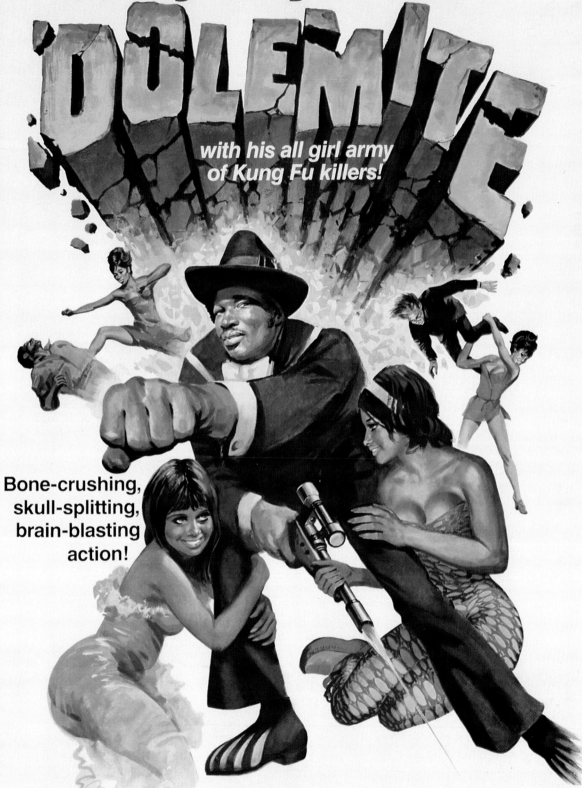

Rudy Ray Moore is

DOLEMITE

with his all girl army of Kung Fu killers!

Bone-crushing, skull-splitting, brain-blasting action!

STARRING **D'URVILLE MARTIN** · WITH **JERRY JONES** · INTRODUCING **LADY REED** as THE QUEEN BEE
Produced by RUDY RAY MOORE & T. TONEY · Directed by D'URVILLE MARTIN · Written by JERRY JONES
Martial Arts Champion HOWARD JACKSON · A DIMENSION PICTURES RELEASE · GENERATION INTERNATIONAL PICTURES

ORIGINAL MOTION PICTURE SOUNDTRACK AVAILABLE ON GENERATION INTERNATIONAL RECORDS · FEATURING SHINE AND THE GREAT TITANIC THE SIGNIFYING MONKEY · **R** RESTRICTED

©1975, By Dimension Pictures, Inc.

WHAT IT WAS...

from the picture, just take it out of my royalties, so I financed it myself. It took me thirteen months working concerts on the road, hard work, struggles, trials, and tribulations. I finally got enough money to get an editor to cut it for me and after I got it cut, they start making fun of me, not the film distributors, but people in general.

I carried the movie on the road: I four-walled one theater in Indiana. It's a hard job. But standing among the crowd, I knew then that I had the right product. I carried it to American International Pictures, which was the big company that had Pam Grier, Fred Williamson, and so forth. They had a Black fellow out to look at the picture. He told me, "Oh, I like this all right, but I don't think they'll like it over at American International Pictures." Dimensions Pictures picked it up. Dimension Pictures was a secondary company that picked up stuff nobody else wanted. The moment they saw mine, the late Larry Woolner had to have it. He took it and got a man to make a trailer on it. Oh, it was a trailer to end all trailers: "*Dolemite*, I've been Blackjacked, bootblacked, and still comin' back. I'm crown, renown . . ." and all that. It's just a trailer that was outta sight, and it set this picture aflame that was done by Dimension Pictures; I called it the master of trailers. *Dolemite* was a smash overnight. I think from what I understood that AIP fired the man who told them that they wouldn't like this picture.

The reason it worked is that the character, Dolemite, I had was so strong. People that went to see it said that *Dolemite* is a bad movie, better than the record, we're going to see it. And sure enough, for a $90,000 picture, it broke records in Chicago at the Woods Theater. It played against pictures like *Mandingo* doing greater business daily than that $6 million picture. Later, I found out that Dimension's finances were going down the drain. They filed bankruptcy, thus we wound up not getting our money. That was the end of that particular thing that we had going there. They shifted my pictures off to another company and twelve years later, I got my movies back. I have them now. I have suffered, not getting monies that I should have gotten. If it hadn't been for my record catalog, I would have been down the drain.

WHAT IT IS...

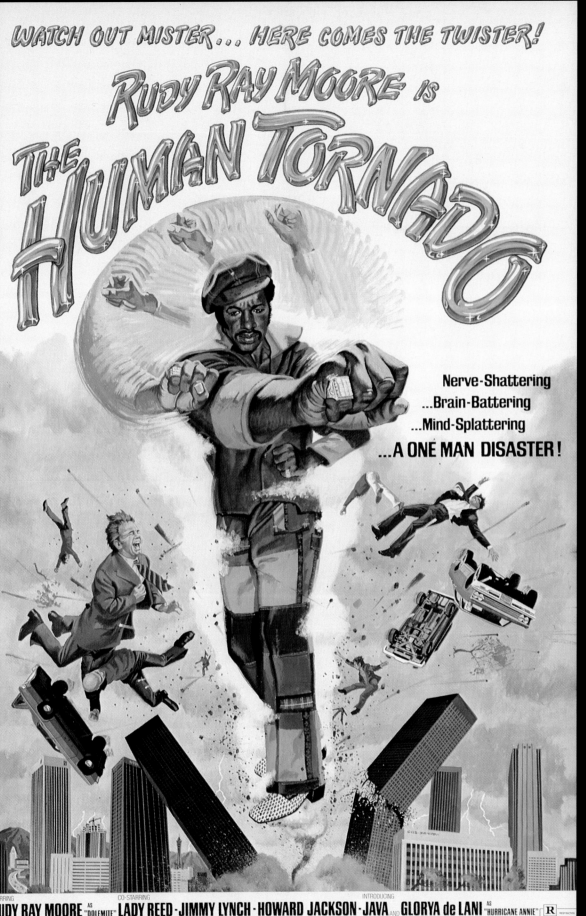

WATCH OUT MISTER... HERE COMES THE TWISTER!

RUDY RAY MOORE is

THE HUMAN TORNADO

Nerve-Shattering
...Brain-Battering
...Mind-Splattering
...A ONE MAN DISASTER!

STARRING
RUDY RAY MOORE AS "DOLEMITE" CO-STARRING LADY REED · JIMMY LYNCH · HOWARD JACKSON · JAVA AND GLORYA de LANI AS "HURRICANE ANNIE"

Screenplay by JERRY JONES · Directed by CLIFF ROQUEMORE · Produced by RUDY RAY MOORE in association with Theadore Toney A DIMENSION PICTURES RELEASE · A COMEDIAN INTERNATIONAL PICTURES
MAIN TITLE SONG BY RUDY RAY MOORE AVAILABLE ON KENT RECORDS

R RESTRICTED

131

WHAT IT WAS

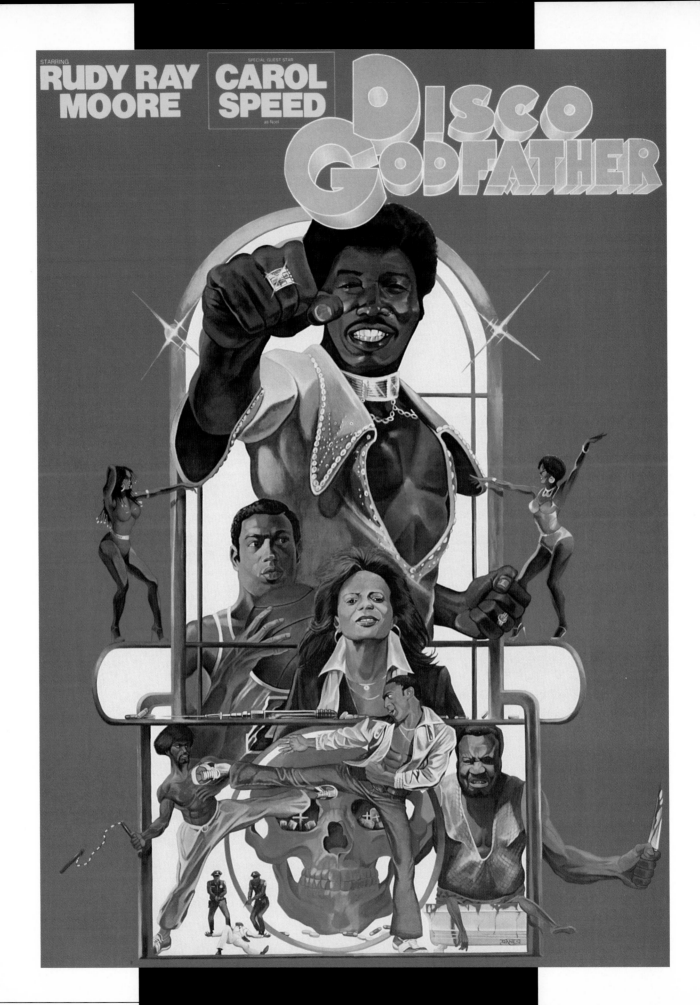

But right after *Dolemite* was released, American International Pictures president Sam Arkoff came and discussed with me about how I could make a picture with that kind of money. Then he said, "Would you do a film for me?" So then I did *The Monkey Hustle* for American International Pictures with Yaphet Kotto and the late Rosalind Cash as my co-stars. In fact, I starred over her but I was still with Yaphet Kotto in *Monkey Hustle*. That movie was a pleasure for me because Rosalind Cash was such a beautiful person. Her dressing room was right next door to mine and we would sit out in the streets, drunks would come by and she'd sign autographs for them, she was so nice. Yaphet Kotto, he was not leveled off as we were, but he was beautiful to work with too.

One thing about my movies is that they are different from the rest. In other words, I was always a comedian, a stand-up, with a story line. Even the violence, well it was comedy with violent overtones. In the Kung fu fights, I was great, but I had the wit and the ability to do things that would be appealing. I had this fellow, Howard Jackson, who had a karate school. He took me out there and drilled me with coordination for fight scenes. I did not have that personally myself. During the early days of my career, I was a modern dancer, so I had the coordination of movement in neck and hands. What I did is edit it into my martial arts fights. The lip shaking and finger movement that had become daring was just an original thing. I was trying to figure out ways to make stuff work and make it more exciting. One man who was working with me went into hysterics because I was doing fight scenes with my special head movement. He said, "Oh, no, don't do that, take that out." But the people on the set , they just loved it and we kept it in.

The movies that were made in the '70s just died quickly. The whites had drifted from the cities but the Black people filled these theaters, but eventually it all died. I guess, from the lack of good Black products, it could have got to the point of where it was boring, with all the movies having the same structure, everyone copying off of each other's movie, that could have been the case. I was alone with mine because I stood out, and being different from the rest of them, my pictures weren't the type that would die, but when the rest of them died, I had no place to play my pictures. The theaters closing put the actors of that period out of work, but not me.

I was a stand-up comedian, doing the same thing I did in that sad period when things weren't going for me. I went on the road and entertained and gained fans throughout the United States year after year. The reason for my successes being the world's first comedian to record four-letter words. I could get a step further, being the world's first comedian to record ghetto expressions. When I say ghetto expressions, I don't mean four-letter words, like the term motherfucker, and so forth. They never used that on records before I did. It wasn't Richard Pryor, it wasn't Redd Foxx. Those are two great comedians. Redd Foxx did risqué humor, where he said, "One horse was named Cold Tom and another was Gorilla and another was My Dick." That was as far as he went. He hit with his stuff in those days, but he wasn't as bold as I was.

Richard Pryor copied my structure four years later in 1974, but Richard had this going for him; Warner Brothers Records picked him up, a big label and he skyrocketed. Therefore, he could break

133

over me. When Richard had it, I did not have the crossover audience. I know Richard, we're not great friends, but we know each other well. I consider him as one of the great comedians of our time. I never figured that he was greater than me, but he has been given a lot of credit from white audiences because he was pushed over there. I have nothing against Richard, he is a great comedian, but I refused to go along with people who say that Richard Pryor opened the door for the comedians today. I am the one that opened the door for the hip-hop.

The reason for hip-hop artists to admire me is the structure of my work is timely and blends right along with the work of the now generation. I'm a comedian with rapping line comedy, like: "Some folks say that Willie Green/ Was the baddest muthafucka the world has ever seen." Or, "Way down in the jungle deep/ the lion stepped on the signifyin monkey's feet," I popularized that. With me doing those rap things in the early days, it caught on because it was a structure of humor that was unheard of. Everybody else did just one line of jokes, crack a joke and another joke and another joke. I did mine in satire, like people used to call "The Devil's Son-in-Law" a rap tale, all the way from the top to the bottom, six minutes long. The young rappers of today fell in love with the structure of the performance that I was doing at that time. They call me the Godfather of Rap, King of the Party Makers. I've been sampled seventy times by rap artists, taking little pieces from my records and making a rap record and including it in theirs, and different rappers have been inviting me to come and rap with

WHAT IT IS...

them, which I have. The late Easy E, the rapper, Snoop Doggy Dogg, Dr. Dre, all of them have put me on their records, I'm on a smash hit album, a million seller.

Things are happening for me. Capital picked up two of my albums and they were supposed to pick up five more, of which they cataloged four. They picked up one I put together called *Greatest Hits*, and it is doing well. They picked up the single *White Christmas*. I will be releasing and leasing more of my old albums.

I am going back into doing cameos. I did a cameo with Halle Berry and another called *Vacant Funk* with Pam Grier and Ernie Hudson. I gave Ernie Hudson his first film acting break in *Human Tornado*. So in my days, I gave a lot of people breaks. For Jerry Jones, my writer, it was the first film he had ever written, Nick Von Sternberg, his father was the director, Josef Von Sternberg, that his very first film as the director of photography. I had a lot of firsts in the early part of my career. We're coming back together to start *Dolemite 2000*. It is a little bit too premature for me to say what the whole story is going to be about, but there will be an all-girl army of Kung Fu fighters and the legendary Dolemite. We have *The Return of Petey Wheatstraw* on the drawing board. I've been to hell, lived in hell, and I finally escaped with a girl by the name of Naomi. I brought her to earth again, and we started over again to a rap pace that we had when we were on earth, *The Return of Petey Wheatstraw*. So that's where I'm going. I'm yours truly, Rudy Ray Moore, also known as Dolemite!

WHAT IT WAS...

Jack Hill is a veteran director of many independent films. During the '70s he directed such hits as **The Big Doll House, Coffy,** *and* **Foxy Brown.** *He is credited as the man who discovered the biggest star of the Black films of the '70s, Pam Grier.*

I was casting a movie called *The Big Doll House*, which was the first of the cycle of women-in-prison films. I just had a kind of a cattle call, because I wanted an ensemble of five young women who would be contrasting characters with one another. I must have interviewed eighty or a hundred girls. I had them read together in groups. Pam came in, she didn't have any hope of really getting much of a part, because she had never done anything before at all, except as a walk-on in a Russ Meyer movie. When I first saw Pam I was immediately struck by her presence and her authority. The character was not written for a Black person. It wasn't specified in the script at all. It was assumed that they'd all be white because at that time the idea of putting Black characters in a movie was kind of unusual. I gave her a reading, and I felt, "Well, you know, she's not a trained actress, but she just has such a natural talent that she'll carry it." She ended up practically stealing the movie, and even singing the title song. She was off and running.

When I was given the assignment to do *Coffy*, my heart sank. Larry Gordon, who was head of production at AIP at that time, wanted to do a Black woman's revenge story. I thought that I didn't know anything about that kind of lifestyle. But I needed the job, so I gave it a shot. As I got into it, I immediately thought of Pam Grier as the lead; I knew Pam and I knew her personality very well.

I definitely worked very closely with actors once I had a cast. In *Coffy*, I adapted dialogue with their help, but not to a really great extent. I had been a musician for most of my early years, when there was a really segregated society. I had been around Black people quite a lot more than most of the white folks were then. So, maybe I picked up something from there. I don't think that the so-called Black films that I did had really extreme funky dialogue. It's kind of in between. I felt it would be very dated if I got into that real kind of brother talk. Pam, in particular, was very, very helpful, and not just with the dialogue but in a couple of ideas in the movie. For example, the idea of putting razor blades in her Afro, knowing that she is going to be in a fight and somebody is going to grab her hair. The other one was using a bobby pin as a deadly weapon by sharpening it and bending it in a certain way. She had that kind of life experience in those things.

A lot of what I did in the movie was a little bit racist from the Black point of view, which I did deliberately. I felt, let's take a look at what it looks like from the other side. In fact, an actor that I very much wanted to cast in the movie, Charles Napier, refused to do it because he thought it was racist from the Black point of view. But I felt from

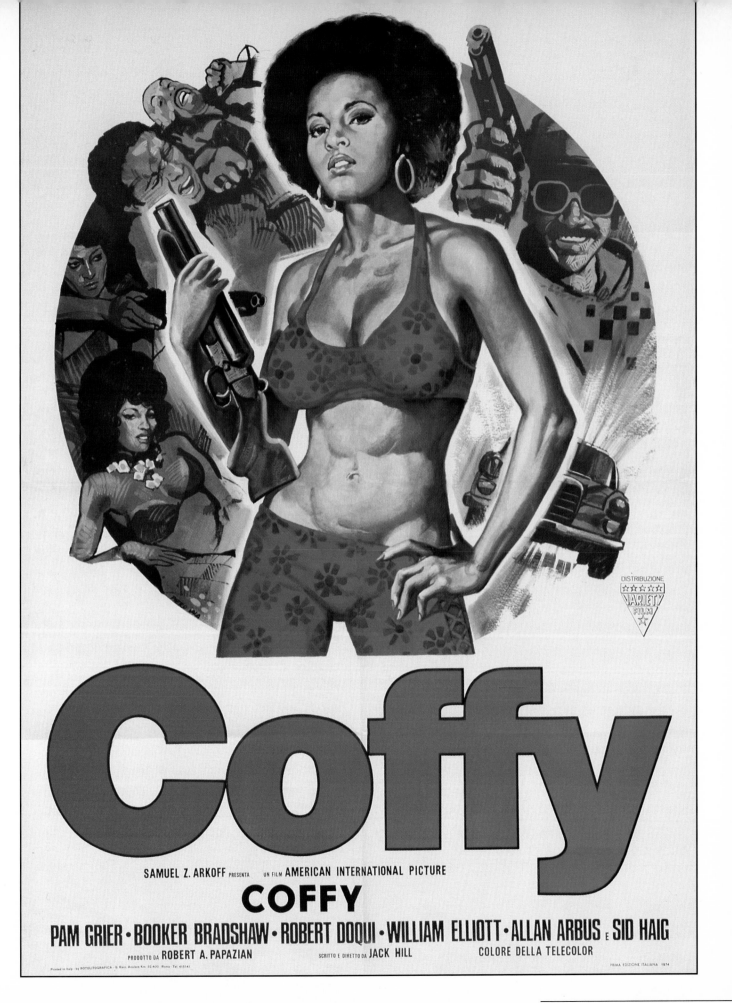

the very beginning that the story would only be possible with a Black woman in a Black situation. You could not translate that story into white characters and make it believable. In *Coffy*, a Black woman is in love with a Black guy who betrays her for this pretty blond woman. That is like a killing of friends. If you made Coffy and her boyfriend white and she discovered he had a Black girlfriend, it wouldn't have worked the same way. In a sense, there is a totally different standard. It is just built into our culture. I think maybe we're getting over that today, but at that time, it was certainly definitely strong. So, I felt that dramatically, that would be very, very powerful. One of the biggest thrills I had was sitting in the theater with a Black audience when the picture opened and seeing their reaction to it, to see how enthusiastic they were. People were on their feet, yelling back at the movie, and at one point in the final scene when Coffy is holding a gun on her lover, who is also the villain, they are screaming, "Kill him, kill him, don't listen to him." That was what the audience responded to. So, is it racism? I plead guilty if it is. So what? It's a good yarn.

An interesting thing about *Coffy* is that the whole reason for making the picture was *Cleopatra Jones*. A producer had brought *Cleopatra Jones* to AIP. Larry Gordon wanted to do it and they had a deal. They shook hands on it. All of a sudden, the producer got a better deal from Warners to make the picture with a bigger budget and, of course, a bigger fee for him. Larry was so pissed off about it, he hired me to come up with another project so they could scoop *Cleopatra Jones*. After *Coffy* was released, the grosses were nearly the same, except that Warner spent ten times as much on advertising and publicity, and more than twice as much making the movie. So, the bottom line for *Coffy* was much greater. We were happy, extremely happy about that. But I think Pam always envied Tamara Dobson, the actress who played Cleopatra Jones.

Pam wanted to be glamorous but I created a character who really was not glamorous. She was just really down to earth and funky. In the next one we did, *Foxy Brown*, Pam had much more control because now she was a major star. That is why she is wearing all these glamorous outfits and makeup and stuff, which I thought wasn't really right for the movie at all. In fact, *Foxy Brown* was supposed to be a sequel to *Coffy*. Originally, the title was *Burn, Coffy, Burn*, with exactly the same character. But at the last minute, the sales department of AIP, and there is no argument with them,

Big Dol

came down with the numbers and said, "Sequels are not making it." They had done a few sequels to some of their Black pictures that had flopped. "We don't want anymore sequels." They came up with the name *Foxy Brown*. We changed the character's name but everything else in the script was the same. At first, I hated the title. I thought it was a real racist title, I mean *Foxy Brown*. And yet, oddly enough, it's the title that's made that one the more popular cult film.

To me, *Foxy Brown* was kind of a desperation project that I really didn't have enough time to do. I just threw everything in. Some things I put into it just to spite the company. The people at AIP had nothing but contempt for the audience they were making movies for. Not just the Black audience but the whole audience that they made movies for. They didn't understand Black pictures. They didn't understand what made them work. I had to really fight to keep elements in the picture that I felt the audience would respond to. When the company was saying, "All they wanted was action, action, action." I'd say, "No, that's not it. You've got to have real humanity. That's what people respond to."

I'll give you an example. They wanted me to cut the scene with the prostitute, her ex-husband, and her child. They beat up the husband and the child wants his mother. They wanted me to take that out because it wasn't an action scene. It was one of the strongest moments in the movie, where you really suddenly get a feeling that she's not just a hooker, that there's really something going on there. You get tremendous sympathy for the character. Those are the kind of things I had to fight for, because they believed the audience just wanted violence. I had to make a bargain. I would give them something else if they would let me keep this.

House

WHAT IT WAS...

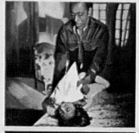

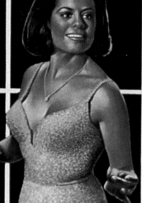

RAMENEZ-LE MORT OU VIF!

"IF HE HOLLERS, LET HIM GO!"

DANA WYNTER

RAYMOND ST. JACQUES

KEVIN McCARTHY

un film de
een film van
Charles Martin

àvec met
BARBARA McNAIR Lily
et en
ARTHUR O'CONNELL

Mus.: Harry Sukman

EASTMANCOLOR

MOORD ONDER DWANG!

FORWARD FILMS PRODUCTION CINERAMA INTERNATIONAL RELEASING ORGANISATION Century Pict.

IMPR. LICHTERT - Bruxelles 7

The notorious scene in *Foxy Brown*, where she presents the severed penis, was an idea that I never really thought they would go for. I was so annoyed by the attitude that AIP had toward the picture, the kind of stuff that they wanted, and the fighting that I was having to do to get any kind of humanity in the movie, that I suggested that one almost as a sarcastic thing. They loved it. They bought it and I was stuck with it. I must say, I've been ashamed of it ever since.

Coffy and *Foxy Brown* have been described as blaxploitation movies. The word blaxploitation was

invented by the trades like so many wonderful words in our language have been. It wasn't like exploiting Black people. "Exploitation movies" was a common phrase. They were considered exploitation movies in the sense that they dealt with a particular kind of subject matter that the major studios would not generally deal with. They exploited that subject matter to make a buck. Which is what the movies that I made were called at that time. Blaxploitation was just a word somebody in one of the trades came up with as kind of a shorthand. Blaxploitation never implied there was exploitation of Black people. No. It was just a cute combination of words somebody came up with. So, I wouldn't find anything objectionable about that. But your blaxploitation films basically dealt with characters like pimps, a

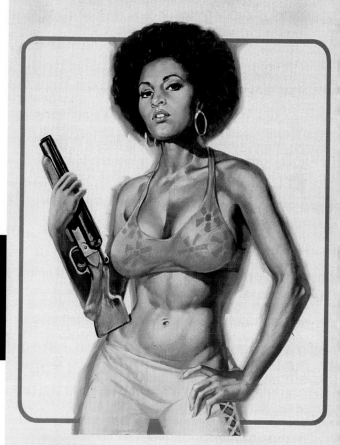

SAMUEL Z. ARKOFF PRESENTA UN FILM AMERICAN INTERNATIONAL PICTURE
COFFY
CON **PAM GRIER · BOOKER BRADSHAW · ROBERT DOQUI**
WILLIAM ELLIOTT · ALLAN ARBUS E **SID HAIG**
PRODOTTO DA ROBERT A. PAPAZIAN · SCRITTO E DIRETTO DA JACK HILL · COLORE DELLA TELECOLOR
Printed in Italy · By ROTOLITOGRAFICA · Rome PRIMA EDIZIONE ITALIANA 1974

WHAT IT WAS...

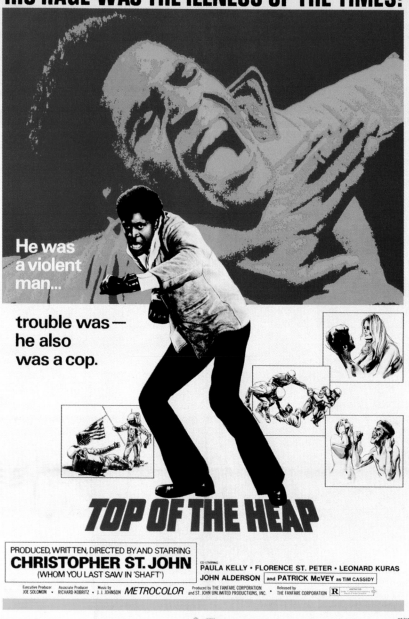

He was
a violent
man...

trouble was —
he also
was a cop.

TOP OF THE HEAP

PRODUCED, WRITTEN, DIRECTED BY AND STARRING
CHRISTOPHER ST. JOHN
(WHOM YOU LAST SAW IN 'SHAFT')

CO-STARRING: PAULA KELLY • FLORENCE ST. PETER • LEONARD KURAS
JOHN ALDERSON and PATRICK McVEY as TIM CASSIDY

Executive Producer Associate Producer Music by
JOE SOLOMON • RICHARD KOBRITZ • J. J. JOHNSON METROCOLOR Produced by THE FANFARE CORPORATION and ST. JOHN UNLIMITED PRODUCTIONS, INC. Released by THE FANFARE CORPORATION R

72/170

BILLY DEE WILLIAMS
IN
**UNA MEDAGLIA
PER IL
PIU' CORROTTO**

EDDIE FRANKIE SORRELL ALBERT
ALBERT·AVALON·BOOKE·SALMI
E **VIC MORROW** NELLA PARTE DI "MANSO"

lot of dope dealing, and things like that. I think that in general there was a kind of a feeling that those were the areas a Black character who was like a pimp or drug dealer would be somebody who was respected. They are going against the man, and making it, so there was a certain kind of glamour. That seems strange to say today, but in those days, I think it was definitely like that.

I was very, very conscious of portraying Black people as criminals, Black people as villains. If you notice in *Coffy*, I made the lead character basically a bad guy because he was selling out to the White Establishment. That's what makes him really bad. Now, that's very different from having a Black character who's a psychopathic killer or something like that. It was something I was very conscious of so I made the bad guy a Black who was selling out to the white

establishment or he's just a white guy exploiting the Black community.

The Black actors of those films, I run into them every so often, look back on that experience with great fondness. They really had a great time. Antonio Fargas, for example, just loved it. But the white actors look back on it as some terrible thing that they had to do. They just hated it. I ran into Peter Brown many years afterward. I said, "Peter Brown," and he looked at me kinda funny. "Don't you remember me? We worked at AIP—Pam Grier . . ." "Oh, yeah," he said, "that awful piece of shit." I didn't say who I was. I said, "Oh, yeah," and walked away. So that's an interesting difference.

The films have had a lasting popularity, both here and abroad. I know for a long time AIP just assumed there was no overseas market for these Black films. I think the overseas distributors and buyers felt that way too. They were dead wrong, and that fact is now clearly established.

For example, when *Coffy* opened for the first time in Japan, the Japanese wanted it so badly, they were willing to pay the cost of generating a new print, which is very expensive. The whole timing system twenty years ago was totally different from today. It cost $20,000 to generate that first new print and the Japanese were willing to pay for that. A film festival in Paris played *Coffy* and *Foxy Brown* in French dubbed versions. I wonder what the word for "motherfucker" is in French.

I think that the historical importance of the genre was that it demonstrated to the motion picture industry that there was a large crossover audience. By crossover, I'm talking about a white audience who was interested in Black subject matter and Black characters. The result was that it brought Black subject matter and Black characters into the mainstream of films, and now you see major films with Black leads, as well as white leads, and it's not even considered anything unusual. I think that put an end to the so-called blaxploitation genre, because it melted into the mainstream.

CHERYL DUNYE

Cheryl Dunye is the director and creator of the first African American lesbian feature film, **The Watermelon Woman**. It has received numerous honors and critical acclaim and was included in the 1997 Whitney Biennial in New York. The film also received best gay feature award at the Berlin Film Festival and best feature in the Los Angeles OutFest in 1996. In 1995 her short film **Greeting From Africa** was included in the Sundance Film Festival. Her other works have screened at film festivals in New York, London, Tokyo, Cape Town, and Sydney. In 1995 she was a recipient of a media grant from the National Endowment of the Arts.

Using documentary, fiction, and pseudo-documentary styles of filmmaking, Dunye creates what she calls the Dunyementary to explore race, sex, and class in the lives of Black women. A native of Philadelphia, Dunye currently teaches film classes at Pitzer College in Claremont, California, and at the University of California, Riverside.

I saw Pam Grier's films as a child with my mother, father, and brother at our neighborhood movie theater in Philadelphia. My family went to see all of the blaxploitation films. It was what we were going to do as a family on Friday nights. Pam had a nice big Afro. She was *really* bad. I think she just represented the kind of wildness that I had as a girl. Here was Pam Grier with the gun. I became the only girl playing with the boys playing with guns. I never necessarily said, "I want to be Pam Grier," it was always my fantasy to be Coffy.

I rediscovered her back in '93. I was getting my MFA at the time and was starting to format a class to teach, which I called African American Women in Film. In the class we studied women in front of the camera and behind the camera. Pam was right at the point when we had a plethora of images and stereotypes, but before women began picking up the camera themselves. Up until the '70s, there were many bad attempts to portray high-powered Black women in theater and film. It started with Hattie McDaniel's character, who is actually kind of an icon of the

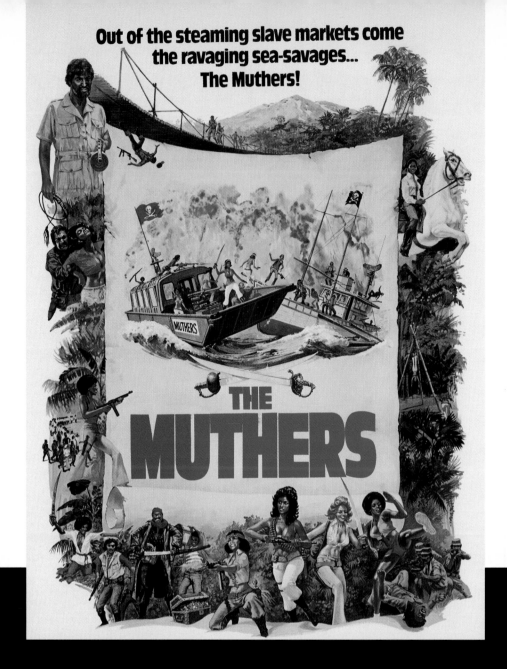

Out of the steaming slave markets come the ravaging sea-savages... The Muthers!

THE **MUTHERS**

mammy. With the '70s, you have the influence of the Black Power movement and the Black Panthers. The female characters that began to appear in film had to be super-empowered so that they could be the kind of commercial commodities who could create the kind of action films that made money. So you got this kind of mixed character who was both *really* bad *and* sensual—the vixen woman. That was something that people had never seen before. Here was this bad ass mama who, in my mind, did not fit any of the "mammy the maid" stereotypes.

I show *Coffy* to my film classes. Half the people say Pam Grier's character was empowered; she can kick ass. The other half say she's just another mammy who is ripping her shirt off, showing her breasts. She has to use her sexuality to empower herself, but she herself is not empowered. I let them make up their own minds.

But another way to look at this, which is a lot of stuff that I do in my own work and what other Black women performance artists do, is to show the body as a political thing, as a way to make change. Black women are stripped of power and the last thing that happens is that they still have control over their physical bodies. For example, in South Africa, people were living in shanties, women would rip off their clothes in protest, and the government trucks would go away because they didn't want to knock over those women. So, in that kind of sense,

the display of the body is a final act of resistance. Basically, that's the kind of characters that Pam played, stripping away the hoky narratives, she basically is left without anything but her own physical body and brain.

The term blaxploitation is a kitzy kind of pop term. It is like a marketing term to put on something. Black people weren't going to cinema. Working in urban areas, here's the kind of thing that could be marketed to them. It cut the Black audiences from just watching television.

Blaxploitation means to me basically from 1970 to 1979 low budget productions, standards, lots of Roger Corman stuff, and stuff that really was directed to the Black cinema. For a while it reminds me of Oscar Micheaux stuff in the '20s and early '30s. He was a pioneer Black filmmaker and started his cinema in response to *Birth of a Nation*. He started making silent films, and because of racism, he had to show them in Black theaters.

For the most part, Hollywood does not like to make films about women's issues or of color issues. It does not allow people to have free expression in their narrative. And if it changes, it changes the way this town wants it to change. To the extent that there were films that slipped through the cracks and are out, it is because of independents who aren't trying to become Hollywood. Because of that, you can still get stuff done.

I think my film *The Watermelon Woman*, which came from *Watermelon Man* in 1970, is part of that effort to put some spark back. It builds upon that tradition. Let there be more lesbian films. We need more cinema. We need more cinema of difference.

Tall, Lean and *Mean!*

VELVET SMOOTH

She's smooth as Velvet...

A Neshobe Films Production in association with Stygian Productions, Inc.

"Velvet Smooth" Starring **Johnnie Hill** Special Guest Star **Emerson Booze**

Also starring Owen Wat-son René Van Clief Elsie Roman Frank Ruiz Moses Iyllia Produced by Marvin Schild Michael Fink Joel Schild Directed by Michael Fink Original score by Media Counterpoint, Inc.

Distributed by Howard Mahler Films, Inc. in COLOR

R RESTRICTED
Under 17 requires accompanying Parent or Adult Guardian

Special guest NY Jets Star Emerson Boozer

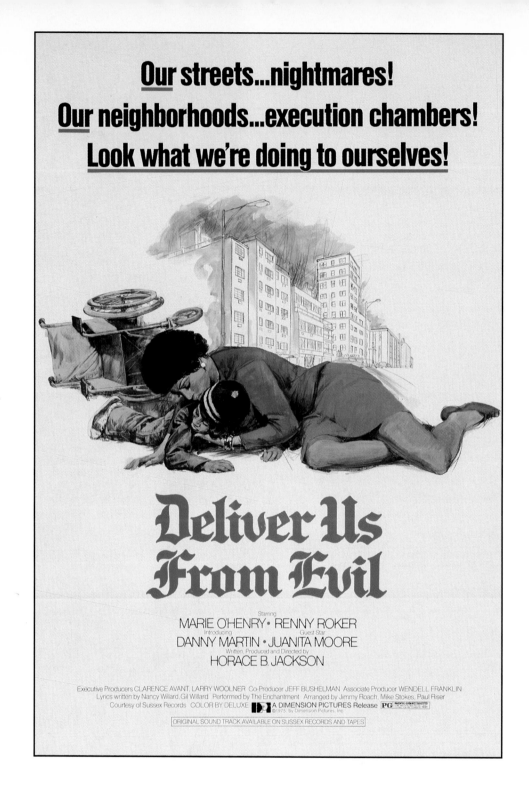

I do believe in Black women being able to be the protagonist in films, like Pam Grier was in the '70s. I also believe that action films need to change. We don't need to see another white man or a white man and a white woman or a mixed couple. We can actually have a Black woman kick ass. The positive thing I did get from blaxploitation films was a moment of hope, of being able to see myself, being able to fantasize about Blackness and about being Black. As a filmmaker, I want to offer that to young kids today.

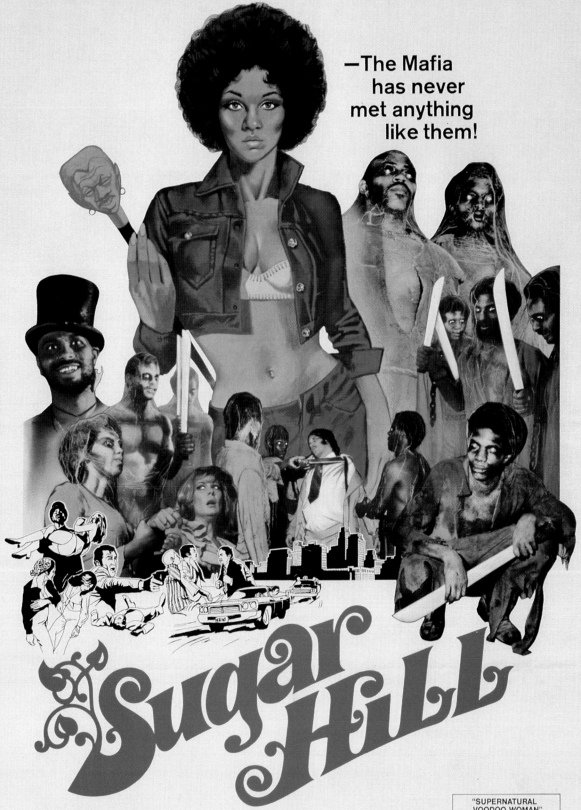

Meet SUGAR HILL and her ZOMBIE HIT MEN...

—The Mafia has never met anything like them!

Sugar Hill

"SUPERNATURAL VOODOO WOMAN"
Sung by "THE ORIGINALS"
Available on Motown Records

SAMUEL Z. ARKOFF Presents Color by Movielab **PG** PARENTAL GUIDANCE SUGGESTED

"SUGAR HILL" Starring MARKI BEY · ROBERT QUARRY · DON PEDRO COLLEY
Co-Starring BETTY ANNE REES · RICHARD LAWSON · ZARA CULLY · Written by TIM KELLY · Produced by ELLIOTT SCHICK
Directed by PAUL MASLANSKY Original Music Composed by NICK ZESSES and DINO FEKARIS · an American International Picture

74/59

ISAAC HAYES

THE BLACK MOSES OF SOUL

*Academy Award–winning composer Isaac Hayes began his legendary career as a session player for the Memphis-based Stax record label. He co-wrote such Sam & Dave hits as "Hold On, I'm Coming," "Soul Man," "I Thank You" and "You Don't Know Like I Know." He also wrote hits for Carla Thomas, "B-A-B-Y," and Lou Rawls, "Your Good Thing is About to End." As a solo performer, Hayes made some of the most powerfully potent music ever recorded. His 1969 album, **Hot Buttered Soul**, had a huge impact on the music scene and went platinum. His popularity crossed all racial and ethnic lines. In 1971, he wrote the musical score for **Shaft**, which not only revolutionized the way films are scored, it earned the highest honors. Hayes became the first African American to receive an Oscar for Best Musical Score, as well as a Golden Globe, two Grammys, the NAACP Image Award, and the Edison Award, Europe's highest award for music. While continuing his musical career, Hayes expanded into acting. He has done the drama **Truck Turner**, with Yaphet Kotto, and **Escape from New York** with Kurt Russell, and comedy with Keenan Ivory Wayans in **I'm Gonna Git You Sucker** and Mel Brooks's **Robin Hood: Men in Tights**. His television credits include both series and TV movies. He currently hosts a top-rated morning radio show on KISS-FM in New York City.*

Shaft was my first attempt to write a film score. I'd never had any prior experience scoring movies but I think they picked me because my album, *Hot Buttered Soul*, had gone platinum, which was unheard of at that time. My music was somewhat dramatic. I would take a tune and remake it and turn it all the way around. I did that with "By the Time I Get to Phoenix" and "Walk On By." I think they felt I had, musically speaking, a sense of the dramatic. Gordon Parks Sr., the director, and Joel Friedman, the producer, sent me a 16mm copy of three scenes. One was the opening scene of *Shaft*, where he came out of the subway and crossed the street. The next scene was a montage that showed Shaft in Harlem searching for a militant. The third was a love scene, when Shaft and his lady, Ellie, made love. They wanted me to write something for those scenes and to see what it would sound like. I knew I was being tested.

The first thing to do was the main theme. I knew the character was very relentless and he was always on the move. I had to come up with something that denoted continual movement. I decided to have the drummer play some sixteenth notes on the high hat. That was the idea of the opening theme. Then the bass line hit a note to try to denote some drama. The guitar was one of the main ingredients that I weaved throughout the song. It also denoted action, but it was very different. I used a wa-wa, which I first heard used by Jimi Hendrix in the '60s. I'd had a piece where I'd used a funky guitar but when I couldn't come up with anything to use with it, I just put it on the shelf. I thought about that piece immediately. We pulled it out, and I got the guitar player to listen to what he was playing. I told him to hook up a wa-wa, and I moved the wa-wa to give him an idea how I wanted him to do it. He caught on and took it a step further and that's how the wa-wa started the famous guitar lead. I played a few things, but it was just a rhythm. The rest of the song did not come until I had completed the score, because the music inside

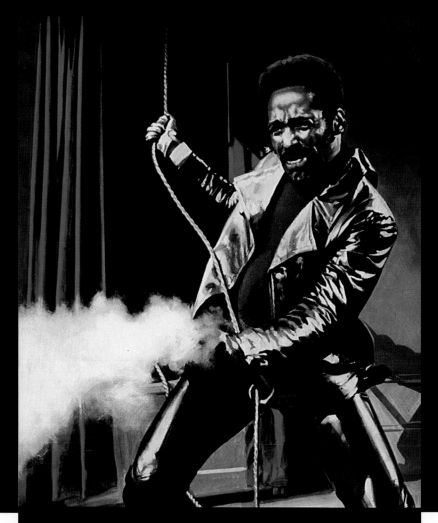

RICHARD ROUNDTREE

E CON MOSES GUNN

SHAFT
IL DETECTIVE

(SHAFT)

was an abstract of the entire score. I changed the rhythm down there when I started the vocals. The first verse was a rap, it was done in rhythm, although I didn't know rap would evolve into what it is today. That's how the main theme was started. The basic track, without any horns or anything, took me about two hours to compose. The film dictated how I would cut various sections of the main theme.

It took another couple of hours to put the sweetening on the horns and the strings. My head was wide open. It was very easy at that time to do that. The main love theme, "Ellie's Love Theme," with the vibe solo, took about an hour to do. The inspiration for "Soulsville," the montage through Harlem, was Aretha Franklin's "I Never Lived with a Man." That was it, so I took it to New York for Joel and Gordon to hear. We ran the film with it and they said, "Hey, this is great. Get on a plane and go to L.A. and get started."

And that's how it happened.

I was in the middle of a tour while I was working on the movie, so during the week I worked on the lot at MGM, and on weekends I would do a gig, or a couple of gigs. The guys that gigged with me were the same ones that worked with me on the film. It all worked out.

At that time, what I did was considered unorthodox but I didn't have my head on a block, the producer and director did. I had no written parts. As far as the rhythm was concerned, we had our own formula, which I worked out with my

WHAT IT WAS...

band and I worked it out with Carl, the head of arranging. We had two days to lay the rhythm down. We walked into the studio and the engineer said, "You guys got the charts?" We said, "We ain't got no charts. We got a few notes. Just roll the film." I saw terror on this man's face. But each time he rolled the film I'd come across and we'd hit the cue and bam, we did it! We had the clicks down and everything. So, at the end of the first day, we finished an hour and ten minutes ahead of time. The guy, a gentleman, came out and said, "I have never seen anything like this before." He said, "I thought it was going to be a disaster, because we had some guys in here a couple of weeks ago, and it was a disaster, and you guys walked right through it." They had to speed up the recording schedule and the dubbing. The next day, we did the suite, which was horns and strings, and that went without a hitch. The third day, we did vocals, and there I was—at the last minute, as we were pulling up in the parking lot, I was in the back of my limousine with my back-up singers writing down the last of the lyrics.

I scored the film in 1971 and a lot of what happened in the '60s, the civil rights struggle, the Vietnam issues, and so forth influenced me. Society was more liberal and having more fun at that time. I tried to make the tracks like that. There were a lot of musical influences that were in the score for the film. I had jazz influences, and there was some blues influences. Like "Buffy's Blues" and the jazz influence in "Cafe Reggio." "Soulsville" had some gospel influences. "Soulsville" was a social statement about the times, because it depicted the conditions in the inner city. Unfortunately, those conditions still exist. I just tapped a reservoir that I had during my formative years, my experience as a producer and a musician and matched it to the film. It was discovered that there was a market in Black moviegoers, and they wanted to know how to tap in to them. The whole thing was to get a Black film, with a Black leading man, a Black director, and a Black composer. So, it was like a briar patch to me. It wasn't as difficult as I thought it would be, once I had gotten down the methodology of how films are done. There was some discipline, and at the same

LA **PRODUCT** PRESENTA: **ISAAC HAYES** IN

È TEMPO DI UCCIDERE
DETECTIVE TRECK

CON **YAPHET KOTTO** · ALAN WEEKS · ANNEZETTE CHASE · REGIA DI JONATHAN KAPLAN · PRODOTTO DA FRED WEINTRAUB E PAUL HELLER

MUSICHE DELLA COLONNA SONORA COMPOSTE E DIRETTE DA **ISAAC HAYES** · TECHNICOLOR · UN FILM AMERICAN INTERNATIONAL · DISTRIBUZIONE PRODUCT CINEMATOGRAFICA

time, there was a lot of freedom. You were disciplined because you had to match a lot of dramatic cues on the film but you had creative freedom to interpret how you felt they should be played against the scene. That was great for me, because I was always going out of the box trying different things anyway.

Since I did not have formal training, I was not restricted, what I could hear, what I could imagine, I felt like these guys should be able to play it. That's why the sound is so unique. I did not know that it was setting a pace, and everything that followed for almost a decade had that same kind of sound, like *Shaft*. It revolutionized music in film and also in television. As a matter of fact, one day, I was on the soundstage and Dominic Frontier, whom I respected so much and looked up to for what he had done in films, walked in and fell on his knees and kissed the back of my hand. I said, "Wow! What's going on?" He said, "Thank you. Thank you for taking us out of the Dark Ages." That was one of the greatest compliments I ever got.

But we finished the whole deal. Gordon and Joel were thrilled. I said, "Thank goodness, I finished it and nobody killed me." We went to Memphis and did the album. I extended some tracks, like the "Love Theme" and "Soulsville" for the album. I sometimes

Laugh! Cry! Sing! Hear!
Feel! Dance! Shout!

A soulful expression
of the living word...

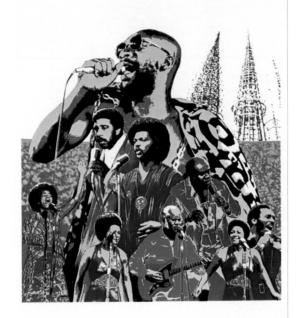

STAX FILMS/WOLPER PICTURES Presents **WATTSTAX** starring ISAAC HAYES
THE STAPLE SINGERS · LUTHER INGRAM · JOHNNIE TAYLOR · THE EMOTIONS
RUFUS THOMAS · CARLA THOMAS · ALBERT KING and OTHERS · Special Guest
Star RICHARD PRYOR · Produced by LARRY SHAW and MEL STUART · Executive
Producers AL BELL and DAVID L. WOLPER · Associate Producer FOREST HAMILTON
Directed by MEL STUART · From COLUMBIA PICTURES **R** RESTRICTED
Original Score is available on STAX RECORDS

take issue with today's soundtrack music. Nowadays, they'll just grasp some music and put it on a soundtrack, to say it's in there just to sell records. When we wrote music for a soundtrack, we scored the music and it had direct correlation with a scene. I think the music has so much validity, and so much relevance. The rappers sample a lot of classic soul music, they are intrigued by the music, hearing their parents talk about it and listening to their parents' record collections. That's why it's so endeared. It was real music.

Another thing that was real is that I was always attracted to acting. I never had any formal lessons. When I was in high school, I was vice president of the Speakers and Writers Club and all that kind of stuff, but that's a whole different ball game. I always wanted to act but I never had an opportunity. The first shot I had was because of my popularity as an entertainer, as a recording artist. I had huge successes with that, and I think that they felt this guy can draw box office. It wasn't an ego problem for me. Give me a chance, just get me in front of the camera. The first movie I acted in was *Three Tough Guys*. It was a learning experience. I worked with some talented actors: Lino Ventura, who was big in Europe, a nice guy; Fred

WHAT IT WAS...

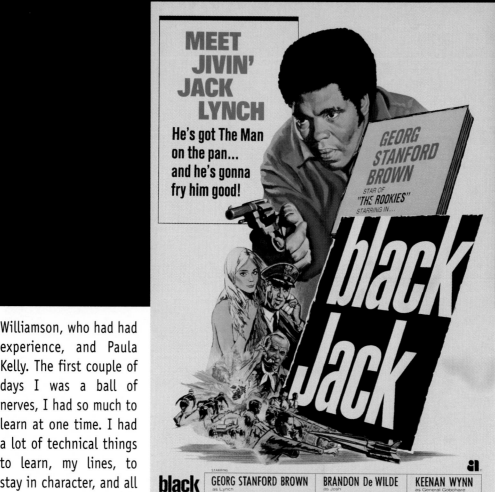

Williamson, who had had experience, and Paula Kelly. The first couple of days I was a ball of nerves, I had so much to learn at one time. I had a lot of technical things to learn, my lines, to stay in character, and all of that. The technical things were the things that gave me a problem. I'm not used to hitting my spot; you've got to walk over there, you've got to turn here, you've got to do your reversals, two shot and master, all the things I knew nothing about. I began to learn about it, how to conserve at some times and do more with your close-up. So, it became fun.

After *Three Tough Guys* came *Truck Turner*, the one that I starred in and I think it might be my most fun film. There was a lot of freedom. Jonathan Kaplan was a young director at the time and we just had a lot of fun on the set. He was generous as a director, to allow us to improvise a bit, because we knew what was really Black, and we did that. The only thing about *Truck Turner* is, you can't show it on TV, because there were a million "motherfuckers" in there.

Working with Nichelle Nichols, *Star Trek*'s Lieutenant Uhura, was great, and she was good at what she did. Each one of the actors that I've played opposite always threw a challenge at me. She was real tough, she resented Truck Turner. I had to be tough, and then play it off like she was nothing. When she called me a motherfucker, son-of-a-bitch, I had to just like, "Yeah, okay, uh-huh," and just play along, not react like I was offended. Truck Turner knew that he was a son-of-a-bitch, but he had to get the job done. It was a thrill working opposite Nichelle because she was sexy and to see her play a madam, to hear those profane things come out of her mouth, instead of, "Hailing frequencies open, Captain." You know?

Yaphet Kotto was so perfect for the villain because he was an intense actor. He was an experienced actor and a menacing bad guy. Every time I did a scene with him, I was watching him. Right before a scene, he would be by himself, and he would get very quiet. I would say, "Ah, he's getting into character. Look at him." He was looking

at me like he hates me. I said, "I'm not going to take it personally. I know he's pissed off at Truck Turner, right." I just watched all of that. Yaphet was good. He was a good villain, because the meaner the villain, the better the hero looks. It was a lot of fun during those times. I don't think deep down within we took ourselves that seriously, maybe some people did. It was fun to see, at last, the brother on the screen being a hero, being a sex symbol, having the upper hand, and winning for a change.

I use the term blaxploitation, but I don't speak of it with any kind of bitterness. It was a very important transition. It was an opportunity that we had never had in the history of filmmaking, as far as I know. We had the chance to finally have a Black hero on the screen. We, as actors, had a chance to work and not be in demeaning roles. They said that a lot of pimps and so forth were made heroes, which people were concerned about it influencing kids in the neighborhoods. My response to that was any time that there's a genre in its infancy, you're going to have some form of exploitation. I think the baby would have grown up, but they caught the baby just as it was crawling on its belly, on its knees and ready to stand up.

I think had certain groups not tagged it as blaxploitation, then Hollywood would not have withdrawn so quickly. I think it would have grown. But they destroyed that, so Hollywood backed up, but it opened the doors for a lot of composers, a lot of actors. A lot of people were working, and they made money. Hollywood made money. It got back on its feet, because it was floundering at the time. Blaxpliotation opened a whole new source of revenue.

If I had any kind of criticism it was that they should have taken off in various directions sooner than they did. The other thing was, as the saying goes, he who pays the piper calls the tune. You had white benefactors. There were Black businessmen who could have afforded to spend monies to produce films, but they didn't. So in order to work in the films, we had to, more or less, go along with what white people wanted. We didn't have a lot of creative control at that time. Jonathan Kaplan, in directing *Truck Turner*, was very, generous, we could alter some things to make it more realistic. But a lot of times you acted the way you did in the eyes of a white man and the way he perceived you to be. But I think we had films like *Sounder*, like *Cooley High*, they were fun things.

Another film I was involved with from that era was *WattStax*. It was a documentary about a music festival held in Los Angeles and about the Black community. Over 100,000 people attended. It was just a happening. We had the parade earlier that day. I enjoyed the privilege of being the Grand Marshal. The festival was held at the L.A. Coliseum. People packed lunches and everything. They sat there from 1:00 in the afternoon until 10:00 or 11:00 at night. Nothing

WHAT IT WAS...

Super Cool & Wild!! Smashing the Man and the Mob for his Women!

MEAN MOTHER

An AMHERST presentation starring
CLIFTON BROWN DENNIS SAFREN LUCIANA PALUZZI
LANG JEFFRIES TRACY KING
COLOR by DeLuxe
Released by
INDEPENDENT-INTERNATIONAL

went awry. There were no fights. A whole day of music and celebration. There was a spiritual love that was shared by everybody who was there. That's what was so exciting about it. It was featuring Stax artists. But you had people onstage like Melvin Van Peebles and Jesse Jackson. You had gospel music, you saw a young Ted Lange and Richard Pryor. Richard did some of his best stuff and it's what started Richard's resurgence. Why he grew up, maybe. I had to wait until everybody else had gone on. I was the last person to go onstage. I did, of course, "Shaft" and I think I did "Ellie's Love Theme," "Cafe Reggio," and we did some stuff in "Soulsville."

But it was like a documentary in the sense that people were talking about the conditions in the inner cities, about the Watts Riots and what might have caused it. You had the barbershop comments from the guys sitting on the corner. You were talking about religion, politics, and how it goes in the 'hood. That was some important stuff.

They are just now beginning to release *WattStax*. There was some footage taken out of the original release, all the stuff that's on the *Shaft* soundtrack. MGM took a hard stance on it and sued me, so they had to take it out. So although I did quite a few tunes, it doesn't show that much. I think one of Ted Turner's companies is going to release it and since he bought MGM's catalog, they should put that back in.

Currently, I managed to carve out a spot in the morning on WKRS radio in New York City. If you are not happenin,' the audience will let you know. But I have a good team supporting me. We have finally found our niche. We're also looking at syndication because I feel like we've got a show that's now ready.

Nationally, people know me but it's a mixed thing. The younger kids know me as an actor.

The older guys know me as a musician. Some of them know me as both. It's funny how when you're in a film, they call you by the character's name. Everybody was calling me Truck Turner, "Hey, you're Truck Turner." As a matter of fact, I went on a firing range and learned to shoot. I became an expert marksman because of *Truck Turner*. When I did John Carpenter's *Escape from New York*, they called me The Duke. It's just whatever you do and you have a reasonable amount of success, you become that to the viewing audience. So the kids recognize me. Some of them are just discovering *Truck Turner*. They get blown out by it. Just like the tune from *Hot Buttered Soul*, "Walk On By," which was used in the movie *Dead Presidents*. The kids rushed to the record store, "I want that new Isaac Hayes jam, 'Walk On By'." Yeah, the new Isaac Hayes. And it's old.

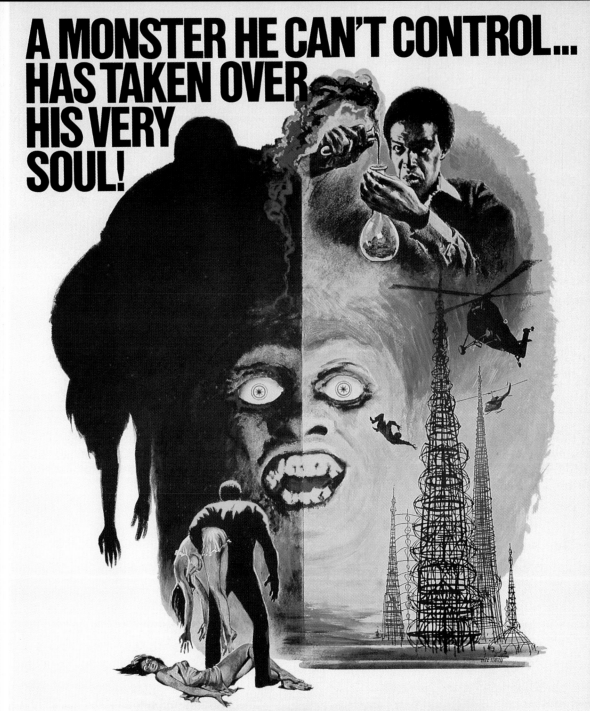

A MONSTER HE CAN'T CONTROL... HAS TAKEN OVER HIS VERY SOUL!

THE FEAR OF THE YEAR IS HERE!

DR. BLACK
MR. HYDE

DR. BLACK-MR. HYDE Starring BERNIE CASEY and ROSALIND CASH

Co-starring MARIE O'HENRY, JI-TU CUMBUKA, MILT KOGAN and STU GILLIAM As "SILKY"
Executive Producer MANFRED BERNHARD • Produced By CHARLES WALKER • Screenplay By LARRY LeBRON
Directed By WILLIAM CRAIN • Music By JOHNNY PATE ▶◀ A DIMENSION PICTURES RELEASE • METROCOLOR

©1976 by Dimension Pictures Inc.

R RESTRICTED
Under 17 requires accompanying Parent or Adult Guardian

ROBERT LOUIS STEVENSON

Emmy award–winning hairstylist Robert Stevenson began his career in 1969 at Universal Pictures. Over a seven-year period, he worked on every TV show Universal produced before working on feature films. His film credits include **Willie Dynamite, Car Wash, Flashdance, The Color Purple, Dangerous Minds, Waiting to Exhale, Jackie Brown** *and* **Amistad.** *He won the Emmy in 1985 for* **The Jesse Owens Story** *and was nominated two more times for* **The Jacksons: An American Dream** *and* **The Atlanta Child Murders.** *Stevenson is one of the most sought after hairstylists in films today.*

I had a salon in the Crenshaw area of Los Angeles. I heard on the radio about going down to the studio to sign up. At that time affirmative action was coming through. Fortunately there was a man named Charles Hack who was working at Universal who called me up and gave me an interview, and I interviewed with Bud Wessmore and Larry Germaine, who were the heads of Universal at the time in the makeup department. I was hired for three days' work and the rest is history. I've been there twenty-eight years now.

My first job was on the TV series *McMillan and Wife* with Rock Hudson and Susan St. James. Then I worked on *Ironside*. I worked on TV shows at Universal then I moved on to films. *Blue Collar* with Harvey Keitel, Richard Pryor, and Yaphet Kotto was one of the first movies that I worked on.

I was one of the last hair stylists to go through the apprenticeship program at Universal, and *Willie Dynamite* was the first Black movie that I did. I didn't do another Black movie until *Greased Lightning* with Richard Pryor and Pam Grier.

Another Black guy named Ron Smith came in about a year and half after me but there were very few. There were only two Black makeup artists at the time. It's better

today. There are quite a few Black hairstylists working in film, but there are no Black men doing makeup.

When I worked on *Greased Lightning*, we cut Richard Pryor's hair to make him look more like a country boy because he was portraying a guy from the South. It was a period piece so we had to cut his hair to make him look like the period. At that time, Richard was wearing a natural, so it was just keeping him shaped up. When the Jeri curl came in that was something different.

Melvin Van Peebles originally wrote *Greased Lightning* and started directing it, but I guess there were creative differences; They couldn't handle the way Melvin was shooting it so they brought in Michael Schultz to finish it. And the rest is known. Melvin also wrote another film, *Just an Old Sweet Song,* for TV that I worked on. It had Cicely Tyson and Kevin Hooks in it.

In *Willie Dynamite*, the wardrobe was designed by a guy in New York who was pretty popular at the time. It was rare to have a Black designer do it to catch that whole flavor. This guy knew the streets of New York and he knew the pimp scene so he designed all the clothes from what they were really wearing in New York, but he also went one step further with it. They went

Cleopatra Jones

She's 6 feet 2" of Dynamite... and the Hottest Super Agent Ever!

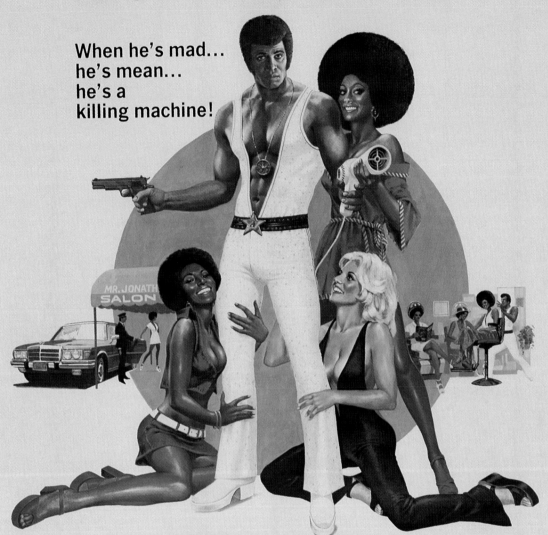

HE'S BAD...HE'S MEAN... HE'S A LOVIN' MACHINE!

When he's mad...
he's mean...
he's a
killing machine!

MR. JONATH
SALON

BLACK SHAMPOO

Starring
JOHN DANIELS · TANYA BOYD
Co-starring JOE ORTIZ · SKIP LOWE · GARY ALLEN WORLD AMUSEMENT COMPANY Presents A GREYDON CLARK Production
Written by ALVIN L. FAST and GREYDON CLARK · Music by GERALD LEE · Produced by ALVIN L. FAST · Directed by GREYDON CLARK · COLOR
A DIMENSION PICTURES Release
© 1976 Dimension Pictures Inc.

WHAT IT WAS...

with all New York actors and a lot of stage people. They were trying to make it bigger than *Superfly*. They had the cadillac with the fur hood and the diamond in the back. The costumes were unreal. They had fur coats and fur hats that were larger than life. The girls were international and all dressed to kill in elaborate dresses with way out hairdos. They would have updos, a lot of curls, really coifed, we used a lot of cascades. When the style for the pimp look was to have your natural flying out on the sides of your hat, we made the style for Joyce Walker to make her natural down to something small and pretty. It was fun for me to create. I looked in the hair magazines to find out what was way out **at the time and** took some ideas from there. They **gave me free rein but** we would do a lot of screen **tests, and Gilbert Moses** actually saw everything **before we ever put it on film.** If the costume was **way out, we'd fit the hair to the** costume. Universal **tried to invest in this film but I** think their timing was a little late because AIP had already caught the market and there wasn't too much new that they did except for the clothes and the cars, but that wasn't really enough to sell it.

I also worked on The Jacksons' *American Dream*. Those afros were all wigs and they were all huge. Early on, before anyone had naturals, we used wigs. If it was big hair most of what you saw were pieces and wigs.

Franklyn Ajaye in *Car Wash* had one of the biggest afros and that was a wig. In *Car Wash* what they wanted was this band of characters that were everyday types but were more comical. For Melanie Mayron, she looked nothing like she looks now. We blew her hair out and gave her a little overkill on the makeup and they stuck her in tight jeans and she looked like someone that worked in the car wash that the boss liked. For Antonio Fargas we

made him look like a gay guy who was on the fringe of trying to look like a woman but still a guy. For Richard, he played the preacher, so we made his hair like the old dyed conk, like the preachers used to straighten their hair, the preachers who were flamboyant, who were more pimp than actual preachers. I enjoyed it because people got to see your work. People would say, "Man did you see that!" They were conversation pieces. Most of the actors got into it. They wanted hair. They would come in and say, "I want it to be like this!" They didn't want to be just a normal person, they wanted to be seen. That made it easy, because you're not fighting someone who really didn't want to look like that, they wanted to go overboard. In fact they'd even give me ideas on how to go even further so it worked. The actors would talk to the director and say, "I know you want this but I'd really like this . . ." so we'd go even further. It was an exciting, fun time when people wanted to be seen. You always put your own spin on it.

Everybody was going "somewhere." Everyone would come over to the stage and visit. (When we were working on the films for Universal.) Black actors who weren't working would come over to the set and talk to those who were working, hoping that they could get on. It was exciting for the actors, people behind the scenes, and the director. It was pretty big for the director too. We had every actor in town stop by, anyone who was in the NAACP stopped by. They figured they were doing something. "They're doing this because of pressure," but you know what I think? They saw the money in it that they could probably make, but they waited a little too long so it was nothing new. After that things changed. *Sounder* broke that barrier toward the pimp movies and fast cars. This was before everyone got politically correct, no one really cared, because they were all working. So you held on to this as long as you could, because it was like all day sucka, we had to just hold it. Everyone was just really enjoying it and not really listening to the criticism, because who cared? We were working, we had a check coming.

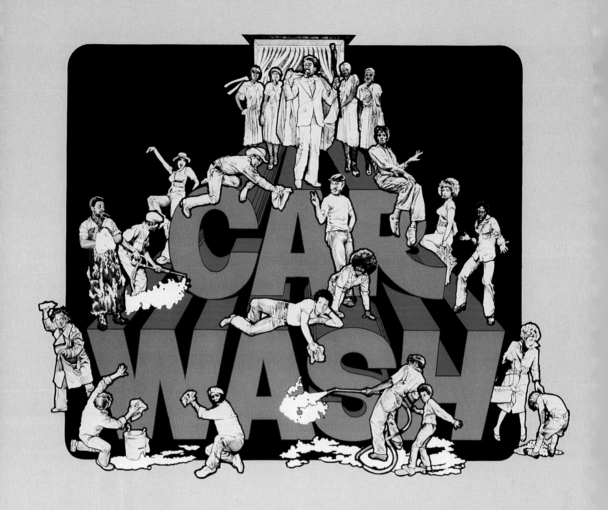

"CAR WASH" Guest Stars Franklyn Ajaye · George Carlin
Professor Irwin Corey · Ivan Dixon · Antonio Fargas
Jack Kehoe · Clarence Muse · Lorraine Gary
The Pointer Sisters · Richard Pryor

Written by JOEL SCHUMACHER · Music by NORMAN WHITFIELD · Directed by MICHAEL SCHULTZ
Produced by ART LINSON and GARY STROMBERG · AN ART LINSON PRODUCTION
A UNIVERSAL PICTURE · TECHNICOLOR® PG PARENTAL GUIDANCE SUGGESTED

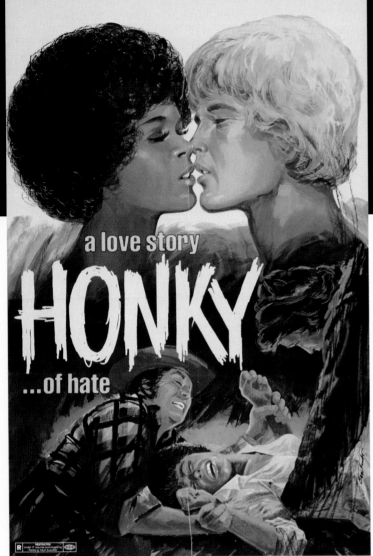

Fortunately, I've been working almost every day since I've been in the business. I did all films, not just Black films. I remember very well in the beginning when actors didn't want me to do their hair and didn't know whether I could do it. People like Joan Blondell were reluctant, but once I did it—it looked good, so that was it. (Hair represents the sign of our times.) The natural was rebellion, the DA was rebellion, the Jelly Roll was rebellion, the flattop was rebellion. The establishment has no control over it, but we do it. The bald look became a trend that actually helped bald men, popularized by professional athletes. I met Sam Jackson on *Just an old Sweet Song* standing in for Robert Hooks; the next time I met him was on *Coming to America* then we talked; and the next time I saw him he asked me if I would do the first movie he starred in, which was *The Great White Hype*, and I've been with him ever since. In *Pulp Fiction* he had a Jeri curl, in *Jackie Brown* he had red hair with a pony tail. (His hair in *Jackie Brown* comes from his love of Kung Fu movies.) Sam loves wearing wigs and changing himself because he can do anything. He reads the character and he sees the character a certain way. He'll tell me what he has in mind and we'll get together and we talk and we get with a wig maker and we design a wig. So we kind of work it like that. In *Red Violin* he's chrome dome, and bald on top and hair on the sides so I cut all his hair out of the center to make him look like a professor. Sam pays attention to detail and he's very good at seeing if it looks real, he doesn't want it to look like a wig. And I like that. That's where the challenge comes in for me. I think that's probably why I wound up with him.

If he had a great performance and he looked a certain way, then I feel that I contributed as much as he did; what we agreed on and what I made him look like. He made the character come alive and everyone says that looks good.

A lot of people like the '70s. A lot of younger people in the business ask me about what it was like. They didn't live the era but they like it. I think the appeal for them is the freedom of the styles. Everything was rough and new and exciting. Everyone was bold. We were bold. Where and when else would you have a girl walking around with her hair ten feet high or where else could you go with a girl with her hair parted down the middle, straight, straight hair in hip huggers with platform shoes twenty feet high. Big wide belts, collars that you could take off with in a heavy wind, way out colors on your suit with top stitching and embroidered flowers and it was *bold!* That was the period!

WHAT IT WAS...

CAROL SPEED

*Carol Speed portrayed the character Lulu in the film **The Mack***. *In addition to numerous television credits, she was in the films **Abby, Black Sampson, Savage!**, and **The Big Bird Cage**. Speed wrote the definitive book on Blacks in Hollywood, **Inside Black Hollywood**, and she has also written numerous songs.*

When I was growing up watching television in California's Santa Clara County, whether it was a beauty pageant or a musical, I was always fascinated by it. I didn't realize that they were white and I was Black, so it didn't stop me from having goals. I was probably the first Black person to attend the American Conservatory Theater in San Francisco on scholarship. I left there and headed to Los Angeles with all kinds of hopes and all kinds of dreams, not really realizing the labels and barriers that had been placed on Black and Brown people. But then I couldn't find filmwork anywhere until Sam Arkoff and Gene and Roger Corman came

along. Even though they weren't paying us a whole of lot of money; even though they were not making big budget films, we were making movies. We were working. That's when *The Mack* got made.

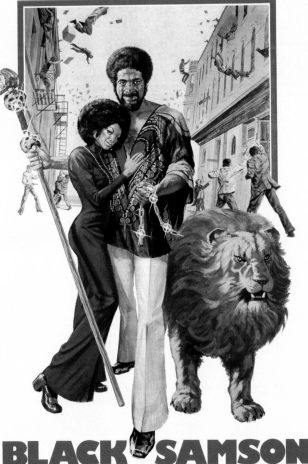

EVERY BROTHER'S FRIEND. EVERY MOTHER'S ENEMY.

BLACK SAMSON

STARRING
ROCKNE TARKINGTON · WILLIAM SMITH · CONNIE STRICKLAND · CAROL SPEED · MICHAEL PAYNE as Arthur

Co-starring JOE TORNATORE · TITOS VANDIS · NAPOLEON WHITING · JOHN ALDERMAN · Screenplay by WARREN HAMILTON, JR. · Story by DANIEL B. CADY · Produced by DANIEL B. CADY
Directed by CHARLES BAIL · Technicolor® · From Warner Bros. · A Warner Communications Company

The Mack represents the 1970s; it represents a slice of American life. Black people were living in their own segregated world, let's face it. That was part of American history of that time. The '70s was a transitional period. People were still trying to grasp Dr. King's dream; you had the Black Panthers who were so powerful. But you also cannot negate Woodstock or the flower children and the impact that they had. I think the America

Abby

...la storia di una donna posseduta!

CON
WILLIAM MARSHALL · TERRY CARTER · AUSTIN STOKER · CAROL SPEED E "ABBY" E CON **JUANITA MOORE**

SCENEGGIATURA DI
G. CORNELL LAYNE

STORIA DI
WILLIAM GIRDLER & G. CORNELL LAYNE

PRODOTTO DA
W. GIRDLER, M. HENRY & GORDON C. LAYNE

MUSICHE COMPOSTE E DIRETTE DA
ROBERT O. RAGLAND

WHAT IT WAS...

of the '70s was struggling to come to grips with a lot of things: women wanting their freedom; Black people wanting their freedom; the Latino community striving for political position. That's what the '70s represented, freedom. Everybody was looking for a way to express themselves.

There was a lot going on in Oakland, where the movie is focused, during the time we were making *The Mack*, especially with Huey Newton (founder of the Black Panthers) and the Panthers. That energy spilled over into the film. A lot of people used to come over to the movie set, which was in a nightclub, and hang out; people like Newton, Bobby Womack, and Sly Stone. Huey Newton used to tell us all about "Black power" and how we needed to put all of this together. He used to have a penthouse on Lake Merritt in Oakland, and he'd have the limousines bring everybody over. He wanted everybody to come by his penthouse. That energy, plus the powerful personas of Richard Pryor, Max Julien, Anazette Chase, Harvey Bernhard, and Michael Campos were all part of the whole mixture that created the power of this film. Harvey Bernhard and Michael Campos were very shrewd in selecting and getting what they wanted out of the cast and they let that flow. They encouraged the flow. The reality of Oakland, the '70s, and of filmmaking, all kind of blended together. It was a special moment and quite a ride.

I looked at *The Mack* as a slice of life, but I never thought that we were representing all of America. I looked at it as a role, just like I played a minister's wife possessed in the hugely successful film, *Abby*. It was a role. We were not creating something that did not exist. After all, there are no new stories since the Bible.

But a lot of Black people, after that (period of blaxploitation films) ended, were ashamed of us and the work we had done. It was as if they wanted to put us and those memories in the same place where they put the blues—disowned and forgotten. If it weren't for a handful of white people here in this country and the Europeans who took an interest in it, the blues would've been destroyed because Black people were moving away from it. The blues were too much like the red clay dirt of the South and Black people were more concerned with trying to take a shower than looking at the kinds of things that could grow in that soil. It lessens you when your own people spit on you like that. But I had the pleasure of being around the late blues great Big Mama Thornton, who was a powerful presence, who taught me not to have those kinds of inhibitions about my work or about who I was.

When I was doing those films, I was hoping that they would open another door. I just knew that I wanted to work; I knew I wanted to be in films. I knew that *Sounder* was good and so we were all striving to be like Cicely Tyson and

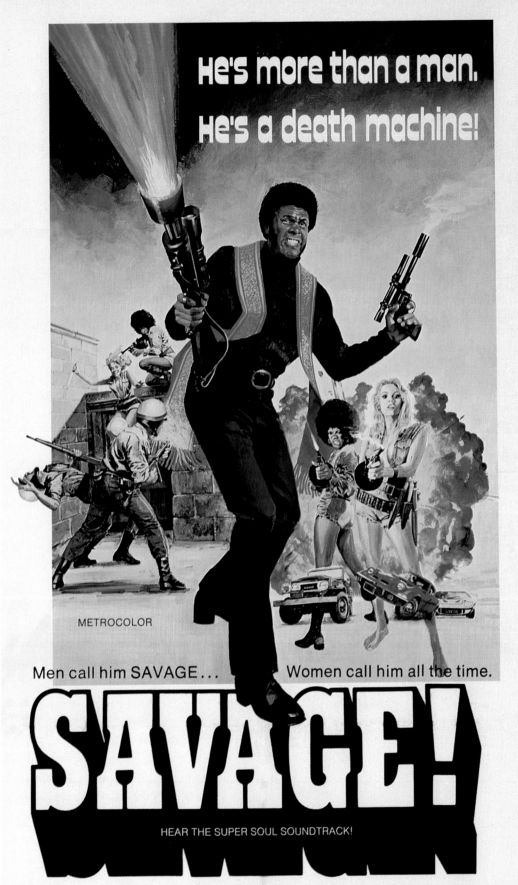

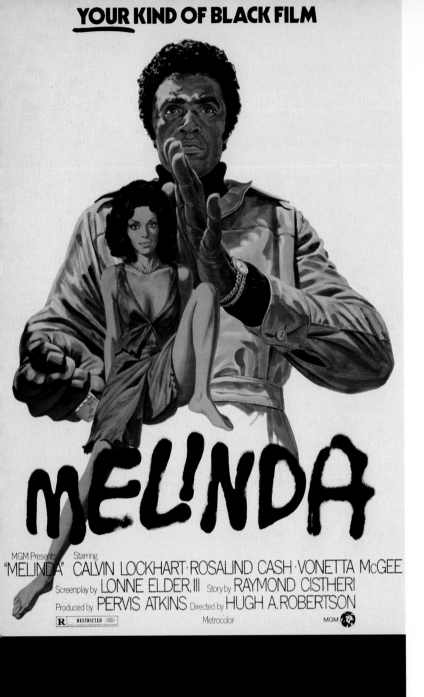

MGM Presents Starring
"MELINDA" CALVIN LOCKHART · ROSALIND CASH · VONETTA McGEE
Screenplay by LONNE ELDER, III Story by RAYMOND CISTHERI
Produced by PERVIS ATKINS Directed by HUGH A. ROBERTSON
R RESTRICTED Metrocolor MGM

Sidney Poitier, in that genre, instead of being the low-budget actors. But I didn't know that there was going to be this glass ceiling over me that we had to break through.

You have to remember, the last film that had the kind of impact of *The Mack* was *Guess Who's Coming to Dinner*, which was in 1968, with Poitier, Spencer Tracy, and Katharine Hepburn. That was a nice film with a nice Black man and a nice white girl and a nice Spencer Tracy and nice Katherine Hepburn. Then, all of a sudden, here comes this wild little Black chick talking about she's Lulu, in a slinky, red gown with my leg out. We were in *Newsweek* and *Time* magazines. The NAACP went into shock. They began to treat us the way they treated the old blues artists. They said, "You're ugly; I don't want to be a part of you." We went through a period where we were rejects because we had made these films.

That's heavy, I don't think anybody should have to carry that burden. We were not elected officials; I was not representing an organization, okay? What the NAACP did not realize is that it was not about their social cause. I was not representing any type of movement other than trying to eat and work through my craft. All we did was take a slice of society; a slice of American life and put it up on the screen. We cannot represent all of America's problems with Black people or Brown people or Red people or White people. Those are social issues that have to be dealt with. But it cannot always be done through art.

When I look back at that time, I can understand where Jesse Jackson was coming from, where Roy Innis of CORE was coming from; what Roger Wilkins of the NAACP and Ralph Abernathy of SCLC were saying. They felt that we should be role models. But what a heavy burden to put on an artist. I don't think anybody should carry that burden. So what they ended up doing was destroying and not replacing. You've got four organizations that never

came together to produce a film. Yet they came in and said, "Look at what you're doing to our people." But they never said anything to Clint Eastwood, with his big guns and his "make my day." Eastwood was making violent films that Black kids were going to see and nobody said a word to him about it.

We didn't really realize that America was still as racist as it was. You've got to remember, I bought into Dr. King's dream. We believed we were all going to get together and this was all going to happen. So when the guy at Columbia studio tells me you can't have the kind of money she's making; you can't do this, but she can, the reality hits you. It stuns you. If you don't have opportunity, what good is talent? I didn't get a reality check until afterward, when it was all over, and I realized that we were going to be cut off.

Only history can judge history. Nobody can stop right now and say what the future is going to be like; whether it's going to be good or bad. By the same token, I don't think you can judge a people by what's happening in the moment. It sometimes takes a hundred years or fifty years for us to reflect; or maybe twenty years before we can look back on how far we've come and really see it without being too emotional.

The Mack was a turning point in our history. It was the first film that actually showed a side of Black people—a certain segment of Black life—that had never been seen. Before that, you had Stepin Fetchit, Dorothy Dandridge aboard a slave ship, and *Anna La Lucasia* with Eartha Kitt and Sammy Davis Jr. You can still see the impact of *The Mack* in the music and art of the rappers. They all went into this "Mack thing," based on the film.

I survived because I could do other things; I found other means of creative expression. You can't let somebody press that hold button on you and you say, "My life is over because I'm not doing that." I say move on, always keep your union card together, and when they get ready to come back around, I'll be ready. But in the meantime, I still have a life to live.

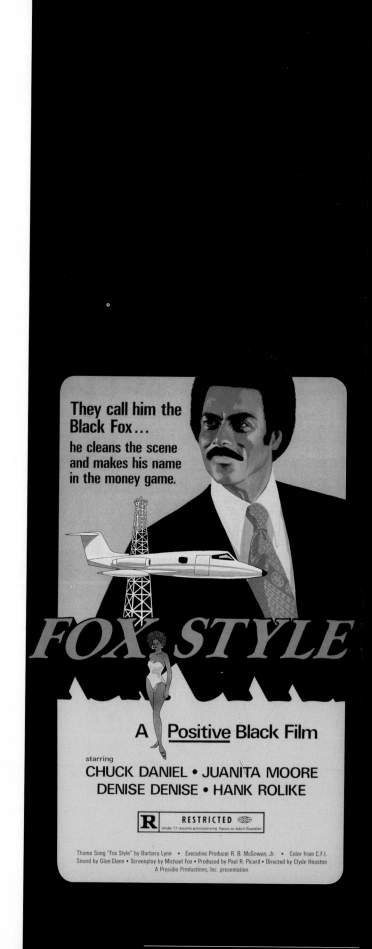

They call him the Black Fox... he cleans the scene and makes his name in the money game.

FOX STYLE

A Positive Black Film

starring
CHUCK DANIEL • JUANITA MOORE
DENISE DENISE • HANK ROLIKE

R RESTRICTED
Under 17 requires accompanying Parent or Adult Guardian

Theme Song "Fox Style" by Barbara Lynn • Executive Producer R. B. McGowen, Jr. • Color from C.F.I.
Sound by Glen Glenn • Screenplay by Michael Fox • Produced by Paul R. Picard • Directed by Clyde Houston
A Presidio Productions, Inc. presentation

WHAT IT WAS...

ICE T

Ice-T has been called the face of L.A. hip-hop. He has been credited with not only inventing Gangster Rap, but living it. He was involved in L.A. street gangs as a teenager. After spending two years in the army, he got his first break when he rapped in the movie **Breakin**. Ice-T began his recording career with a debut album for Warner, **Rhyme Pays** followed by successful albums like **Power**; **O.G. Original Gangster**, an account of life in South Central L.A.; and **Home Invasion**. His single, from the album **Body Count**, "Cop Killer" caused a national uproar, even President George Bush attacked it. Ice-T's work has stirred the First Amendment debate. His first album was the first to be stickered with a parental advisory for explicit lyrics. He has won a Grammy and was voted Best Male Rapper in 1992. Ice-T has an active film career with starring roles in **New Jack City, Ricochet, and Trespass**. He is the host of the British program **Ice-T's Baadasss TV**, his personal guide to blaxploitation movies and to Black culture. He also starred in the NBC drama series **Players**.

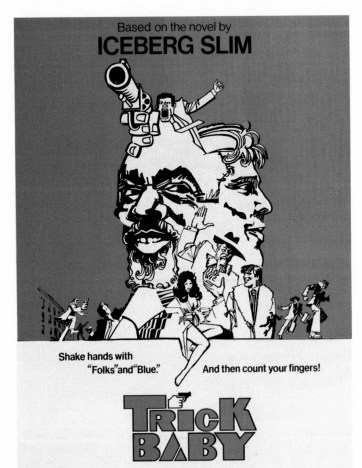

Based on the novel by
ICEBERG SLIM

Shake hands with
"Folks" and "Blue." And then count your fingers!

TRICK BABY

My real name is Tracey but I wouldn't let anyone call me that name because it was a girl's name to me, so my friends used to call me Tray. I got hold of Iceberg Slim's book when I was in the eighth grade in junior high school. By the time I got to high school, I could quote shit out of this book. So now you have a sixteen-year-old kid talking like a forty-year-old man. I would quote the way he would talk in the book at lunch and people would say, "Say some more of that Iceberg stuff, T!" So they started calling me, Iceberg after Iceberg Slim, then it started getting broken down from Iceberg to Iceberg-T to Ice-T.

I remember when I was young and those (blaxploitation) movies came out. It was the same time the rating system came out and I remember *Hit Man* and *Trick Baby* and all that stuff was rated "R" and I couldn't get into the theater. So what we would do is get one of our older hommies to go in and he'd get the side door and we would sneak in. I was about thirteen and it was on. In those days, that was also some of the first nudity in movies.

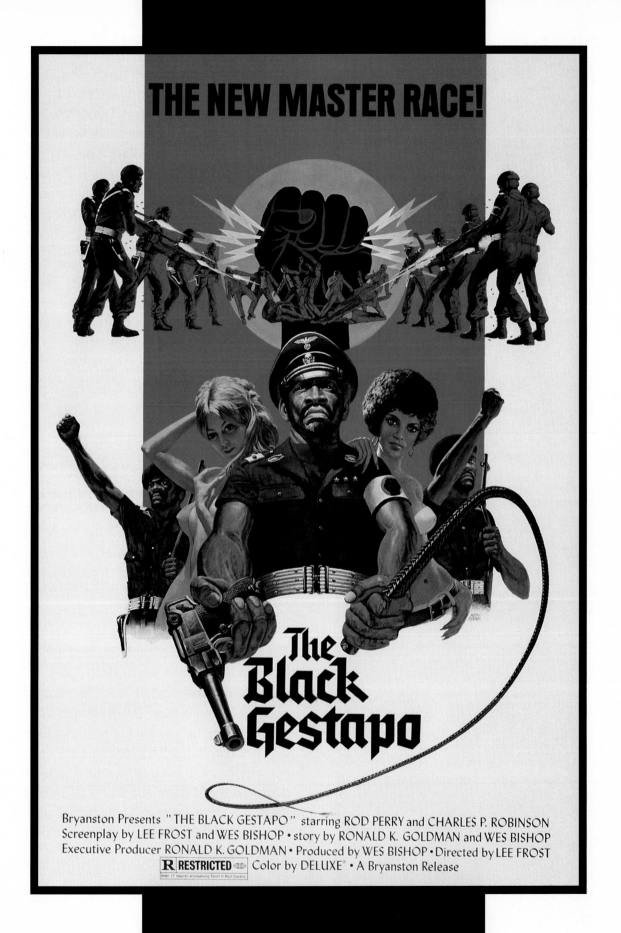

THE NEW MASTER RACE!

The Black Gestapo

Bryanston Presents "THE BLACK GESTAPO" starring ROD PERRY and CHARLES P. ROBINSON
Screenplay by LEE FROST and WES BISHOP • story by RONALD K. GOLDMAN and WES BISHOP
Executive Producer RONALD K. GOLDMAN • Produced by WES BISHOP • Directed by LEE FROST
R RESTRICTED Color by DELUXE® • A Bryanston Release
Under 17 requires accompanying Parent or Adult Guardian

MACK

Dolemite was in the bed and it was crazy. I think the game that was going on in the films at the time was a little over our heads. When I saw *Truck Turner* and *Willie Dynamite*, we were like, "Damn, look at these hats . . . and the cars." As a Black kid you could watch TV your whole life and never really see anyone that looked like you. So these movies put us in power, we were something and that was important.

I was one of the first people to use the heavy blaxploitation vibe in my records. I was deep off into them. To me the best one of all time is *The Mack*. *The Mack* had the dialogue that is the stuff that the kids still quote today. And it had Richard Pryor in there. It was such a deep movie. I have *The Mack* right now. I have a videotape recorder in my car and the only video I have in there is *The Mack*.

I think what the Black films show is that we were doing nothing new. I think that a lot of the heavy sexuality and the harsh language people heard on the first rap record made them ask, "Where on earth did this come from?" It just showed that it's nothing new for ghetto kids to speak in a certain lingo. They're drawing from the same source. I grew up around my father who had never heard of rap records and he talked more shit than me. I was like ten years old and this was my father talking to his son: "Fool, I take my dick, throw it down the street, and wrap it around that fuckin' mail box, and fuck." This is how my father talked. Now where did he learn to talk this shit? He and his boys would sit in the house, and I'd sit there and they would talk all kind of shit. They would bag on each other's heads, the same shit me and my hommies do. And my mother would come into the room, and they'd laugh and she'd talk shit, but they loved each other and that is how they got down.

If you want to see something today that looks close to a blaxploitation movie look at a rap video. Now that rap kids and cats like myself are selling millions

of records, we're getting ready to start making movies. I think you saw a lull in the period (right after the '70s) because those early movies were made by white people but this time it's going to come back with us behind it and were going to put the movies out whether they go to the theater or not. Check out the Master P video . . . that's the first one. And within the next ten years it's not going to be Spike Lee—it's going to be Tony Productions and Frankie and drug dealer crews coming out with their films, it's going to be some other shit. What it is . . . ten years ago

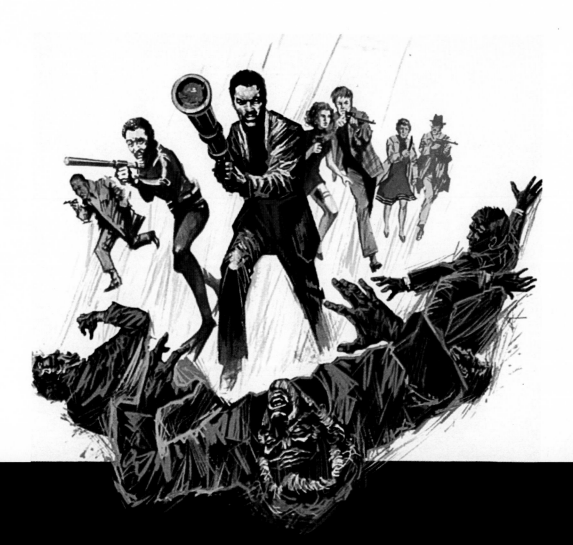

BILLY DEE WILLIAMS

EL SUPERGOLPE

WHAT IT WAS...

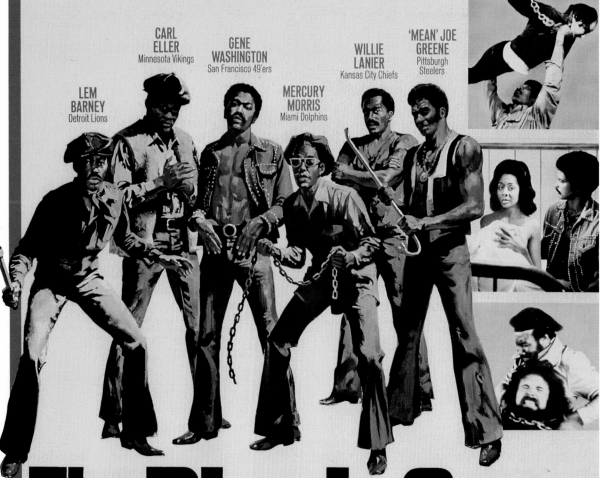

SIX TIMES TOUGHER THAN 'SHAFT'!
SIX TIMES ROUGHER THAN 'SUPERFLY'!
See the 6 biggest, baddest and best waste 150 motorcycle dudes!

LEM BARNEY
Detroit Lions

CARL ELLER
Minnesota Vikings

GENE WASHINGTON
San Francisco 49'ers

MERCURY MORRIS
Miami Dolphins

WILLIE LANIER
Kansas City Chiefs

'MEAN' JOE GREENE
Pittsburgh Steelers

The Black Six

JERRY GROSS Presents THE BLACK SIX · Produced and Directed by MATT CIMBER · Screenplay by GEORGE THEAKOS
Associate Producer RAFER JOHNSON · A MATT CIMBER PRODUCTION Distributed by CINEMATION INDUSTRIES **R** RESTRICTED

when I got into the music business, a Black kid could-
n't make a record because he didn't have the money,
so you had to get signed to a label. Now, we can make
our own records because you can own a studio,
for $20,000 'cause they have a DAT system so the
technology is catching up. Now none of the rappers are
signed to major labels anymore, they have their own
label. So if I sell a million records at a major label now
I don't make as much money. But if I do it as an indie,
I make five to eight million dollars. Now we say, fuck
it . . . let's make the movies . . . let's do the movies.
I'm giving you the inside, kids right now are planning
on making movies. They're out in the streets right now
with cameras. So you're going to see some real crazy
movies come out in a minute! I'm going to make my
movie, called *Marks,* which means a crime victim, a
love story and we go on this maneuver across the
country. It's an interesting movie, with a lot of vio-
lence. When you see it everybody will say that's like
Tarantino and I'll bite my finger and say, yes it is!

My definition of blaxploitation is a word somebody
gave it. I look at the films as Black movies. Black
movies are movies about Black people or about Black
things. Like, *Steel Magnolias* is a white movie, but
Black people go see it too—they go trip. *New Jack City*
was a Black movie. *The Godfather* was an Italian
movie.

I grew up watching *My Three Sons* and *Leave It to
Beaver.* I don't care if it was a white family or not. I
watched Eddie Haskel and I knew all those M.F.'s and
shit. Like my TV show isn't so much a Black show, it's
not really based on Blackness, it's just a show.
Different people talk different language—it's a Black
movie because it's dealing in Black dialogue and
dialect and expresses culture and how they deal with
shit . . . that's a Black film.

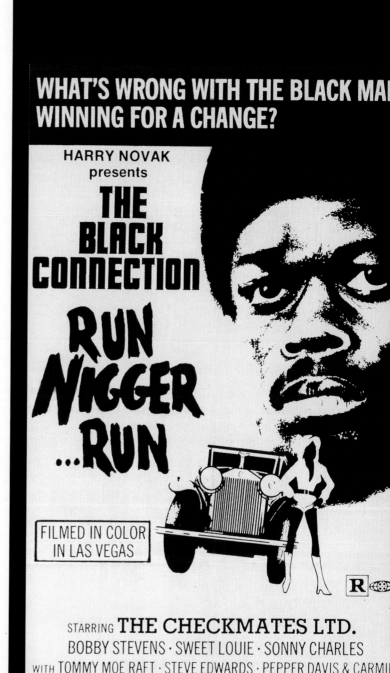

WHAT IT WAS...

SAMUEL L. JACKSON

Samuel L. Jackson is a very versatile actor with roles on stage, screen, and in television. He made his film debut while still a dramatic arts student at Morehouse College in Atlanta. After graduation, he originated roles in two of August Wilson's plays at Yale Rep and appeared in numerous plays on the New York stage. He made history when the judges in the Cannes Film Festival awarded him the first, and only, Best Supporting Performance award for his haunting performance as a crack addict in Jungle Fever. He won the British Academy of Film and Television award for Best Supporting Actor and received Golden Globe and Oscar nominations for Pulp Fiction. A partial list of his other film work includes Die Hard with a Vengeance, Eve's Bayou, and a cameo in the eagerly anticipated prequel to Star Wars.

I spent my life in the movies when I was a kid. I used to go to the movie theaters on Saturday morning about ten o'clock, and I didn't get home until ten that night. After all the cartoons and the serials and the monster movies and stuff were over, I'd meet my mom, and we'd go to the adult movies. She was a huge Jeff Chandler fan. If it was a Jeff Chandler movie, we'd watch Jeff Chandler.

One of the things I liked about living in Atlanta was that it was a testing ground for all the Black exploitation movies because Atlanta had a huge Black population. So I saw things that a lot of the rest of the country didn't get to see. They would just bring the movies for a test run for a day and a half or two days. For example, *Don't Play Us Cheap*, which was basically a filmed play that never got a wide national release, was a Black musical movie and it had this song, "If you see a devil, smash it." It was about roaches, people were playing roaches along the wall. It was a Melvin Van Peebles movie. Another was *The Candy Tangerine Man*. The fun thing about that movie was, you got this guy who was a pimp all week long and on weekends, he goes home and everybody thinks he's an insurance man. He's cutting the grass and the neighbors are there, "Hi John, how are you?" It's kind of funny. It was one of the first Black exploitation films with really graphic violence. Usually all the violence was off screen or implied in most of those movies and here you had a close-up, almost like a gore movie.

I was a big fan of Fred Williamson and the *Nigger Charley* movies. That was totally slanted Western action. I always went to see whatever Max Julien was doing. We always went to see Raymond St. Jacques and Godfrey Cambridge, the whole Coffin Ed Johnson and Gravedigger Jones movies. I really dug the *Shaft* series, basically to see Bundini Brown because he was just too funny to me. One of my favorite lines was "You

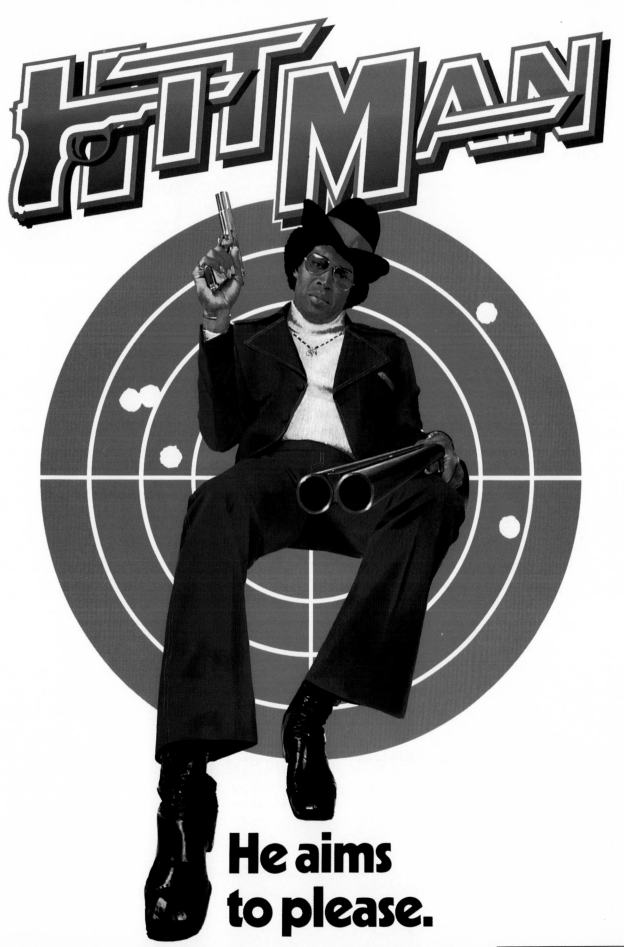

HITMAN

He aims to please.

WHAT IT WAS...

threw my man Willie out the goddamn window." I just love that, or, "Shaft, me and you are going to have to tangle." My favorite movie of all of them, even now, is *J.D.'s Revenge*. The acting itself was actually of a greater quality than you generally saw in those movies because you had Glynn Turman and Lou Gossett Jr. The story itself is really interesting, and there's the mysticism: J.D. coming back, possessing somebody's body. Glenn did a great job of going through those transitions. Glynn was the man, J.D. Walker, I loved that movie.

The important thing to remember about those films in the '70s is that it's our mythology. It's our kind of Hercules and Homer and all that stuff. *Superfly*, all those people that Pam Grier played, are mythological heroes, they're larger than life. They were heroes for us and we didn't have a lot of that then. That was a way to feel good about yourself, to go in, watch it and enjoy it. Nigger Charley was in the West, there were all these people against him all the time. But he always found a way to survive and make it happen and that was great for us.

The situations in those movies are kind of ludicrous in the same way myths are. Take The Odyssey: You travel the world, you live with a woman for twenty

years and get screwed. Then you get back on a boat and go find your wife. Those movies make just as much sense as all those things, or the movies that Tsau Hark makes in Hong Kong about people who can fly and do all the wonderful things they do. This is the stuff that we look at and it's our fairy tale. We can watch it, we can laugh at it, we can have fun with it, we can feel good about ourselves. They're all good versus evil stories. There's nothing there that says this is the way we should live or this is based in reality,

The first film I ever did was a pseudo-Black exploitation film, called *Together for Days*, with Clifton Davis and Lois Childs. Clifton was the leader of this little Black power movement and he fell in love with this white woman and the whole group starts to go to hell. It had to be 1971 or 1972. I hadn't developed what I do now at that point, I hadn't found ways of developing characters. It was being myself more than anything else: Make sure your Afro looked good, put a dashiki on, do that whole thing. But I actually got my SAG card doing that movie and I met a lot of people through that. I met Woodie King, Clifton, Melba Moore was down there, but she wasn't in it, Leonard Jackson, a lot of actors. As I was coming up in my acting career, even before I got to

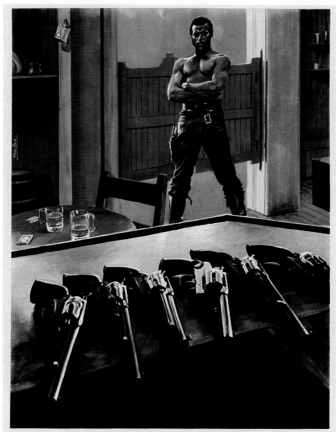

LIBERO DI CREPARE

CON

FRED WILLIAMSON - D'URVILLE MARTIN DON PEDRO COLLEY

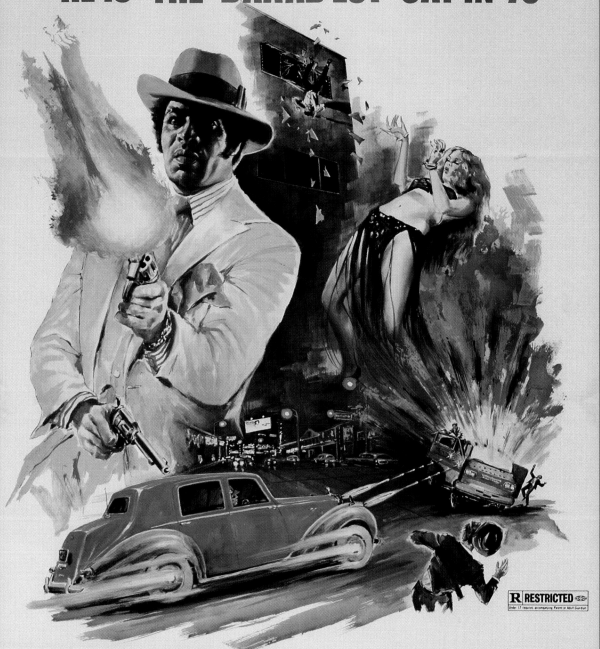

GIT BACK JACK—GIVE HIM NO JIVE...
HE IS THE BAAAD'EST CAT IN '75

A MATT CIMBER PRODUCTION

THE CANDY TANGERINE MAN

STARRING: TOM HANKERSON and Introducing: JOHN DANIELS as "THE BARON"
FEATURING: THE ACTUAL HOOKERS and BLADES of the SUNSET STRIP—HOLLYWOOD
WRITTEN BY: GEORGE THEAKOS MUSIC BY: SMOKE DIRECTED BY: MATT CIMBER

RELEASED BY:
MOONSTONE

WHAT IT WAS...

New York, I had met a lot of actors. Just to see them on screen, it was one of those things that let me know, okay, I am doing something right. I'm headed in the right direction. When I decided to make that choice, to be an actor, it was still not a viable career choice to the older people who knew me. They'd say, "What are you going to do for a living?" I'm a fucking actor. "I don't know, Sam, are you going to get some teaching credentials so you will have something to fall back on?" . . . Right.

When I first got to New York, I got an interview for *Ragtime*, which I actually ended up being in, but I got one of the rudest of awakenings that I've had. I'm sitting there waiting for my interview when James Earl Jones comes in. He was the preeminent Black actor in America at the time. He'd done *The Great White Hope*, all these other things. We're sitting there talking for a minute, and all of sudden, I realized he was there for an interview just like I was. Here's a man I would assume had scripts lined up on his door, but he did not, he was there being interviewed, and he didn't get the job. Moses Gunn got the job. He didn't even get the job. So from that point on, my whole outlook about what I was doing changed, and about where I was going and what would happen once I got there. Even though I'm here now, and I do have scripts around my door, I turn down a lot of stuff. I couldn't figure out why he wasn't at that time. Maybe times have changed in that way, but there's no reason he should have been in there being interviewed for a job. You either want James Earl Jones or you don't.

I'm sure there was a time in Hollywood that when scripts that had Black characters in them, they went to certain actors. They just didn't receive scripts that were about people. They weren't allowing those actors to be doctors, lawyers, or anything else, they were allowing them to be pimps, crooks, hustlers, or whatever they needed as a foil and not those other things in the films. While that was a whole different time, a smart actor would find a way to parlay success into something else. But at that time, people were parlaying their success to the next Black exploitation film not to the next film and that was just the way it kind of fell out for them. So not having agents that are creative or aggressive probably killed a lot of them in that way. A lot of them were great actors, like Dick Anthony Williams, fabulous actor. He did Pretty Tony, which is what most of the rappers know him as. He played Denzel Washington's Father in *Mo Better Blues*, but you don't see him that often. He's in L.A. and not in New York, so he's not like just working like most actors did when we were in New York, just kept acting.

The actors from that era got a lot of criticism for the roles they played, and organizations like the NAACP put pressure on the studios to stop making the movies. Is the NAACP going to come in and pay these people's rent if they can't work? What do you do? They always say, "We need to stop playing pimps and crooks and junkies and all this other stuff." I say where's the other job? Who in the NAACP is writing and producing movies so that we don't have to do those things? Help me with that?

We do need better roles and a wider range of material. One way stereotypical roles will stop is when there are some people of color green-lighting movies at studios. When there's more than one color of person sitting there saying,

Step 1 – Infiltrate enemy territory

Step 2 – Cut the supply line

Step 3 – Harass the hostiles

Step 4 – Search and destroy!

WHAT IT IS

"This is the movie we want to do." Who's the guy that sat there and said, "Arnold Schwarzenegger has a baby. We can do that, we've got to do that . . . we've got to do that!" Yet and still, you can go in there with some project that's about the first Black golfers, the things that Charlie Sifford and all those guys went through. That's drama, because things were happening to those guys. They were hitting their balls out in the fairway and people were stealing them. Not like now, where people move out of the way and say, "Hey, Tiger, here's your ball." No, they're taking these guys' balls, stomping them into the ground, then saying, "It didn't come over here." These guys were not able to sleep where all the other players slept, not being able to change in the dressing room and they were still winning. That's human drama, but you take that to somebody and they say, "Who are they? Who's the audience?" The same audience that went to see *Tin Cup*, asshole.

Even if the role, as written, is a stereotype, you do what I always did, I always took the job. You find a way to give that character dignity. You stop playing the bullshit part of it and you play what's real and makes sense about it. You take the job and you find a way to add dignity to that character, you give him a purpose when he shows up. You don't just walk in a room, wave a gun around, and say stick 'em up. You figure out in your mind that that character either needs to pay his rent, buy some food for his babies, get some heat in his house, or buy some drugs for himself. Something, so he has a purpose so when you see him, he's a compelling character. Then the audience says to itself, "Oh, I'd like to go with him when he leaves to see what he's going to do with that money," or "I know where he came from." You give him some sense of purpose that everybody sitting there looking at him can say, he really needs this money.

When my wife watched *Menace II Society*, she was so upset because she said this was a "how-to movie." These kids are cheering this movie for the wrong reasons. All I could say was, this is a good movie and it does show how senselessly they kill each other, and how ridiculously they react sometimes to certain situations, but the way they're reacting now is what this generation does. I did *Menace* because I liked the story, I liked the Hughes brothers. I thought they were going to do something that was going to mean something, and it did. That movie for the white audience that saw it, was a wake-up call. Look what you done, this is what's been created by the jobless situation out there, when you throw people together in these housing developments, when you create a sense of life where all

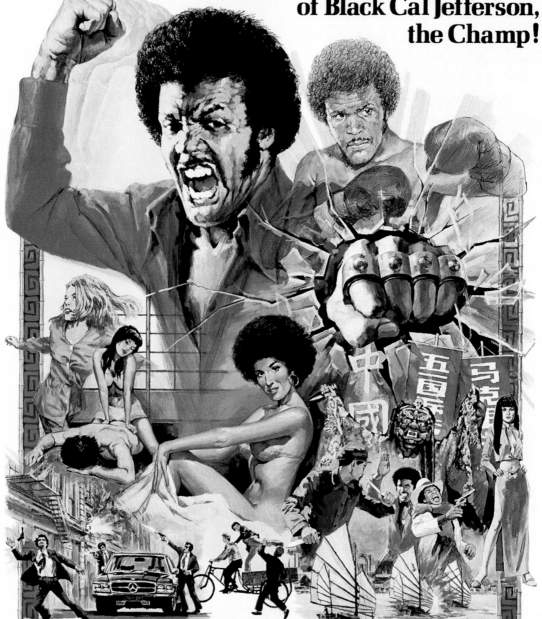

FROM HARLEM TO HONG KONG
they fear the name, the fame and the fury of Black Cal Jefferson, the Champ!

Bamboo Gods & Iron Men

An American International Release

starring
James Iglehart · Shirley Washington · Chiquito

R RESTRICTED
Under 17 Requires Accompanying
Parent or Adult Guardian

written by Kenneth Metcalfe and Joseph Zucherro · directed by Cesar Gallardo · COLOR prints by Movielab

COPYRIGHT · 1974 AMERICAN INTERNATIONAL PICTURES, INC.

74/63

they can do is sling and not have any hope for living past eighteen or nineteen years old. Then you create a whole society of gunslingers, and that movie spoke to that in a very real kind of way.

Those kids saw themselves on that screen. Nothing changed any lives, but it was effective to let some other people know this is what's out there, these are the people that you look at every day on the news that are the predators, and this is their attitude about it. Either you change society or you find a way to insulate yourself from it, and most of them do. I've had people come up to me and tell me that the character Gater changed their lives. They watched him and they saw themselves or they saw their sons, their husbands, their brothers, somebody, and they had a better understanding of them. Mainly because I didn't take the time to deal with the addiction, but more so the way people use their relationships to manipulate other people to get what they want, and that's what junkies do, they use up their relationships. And because of that, people could sit there and have a better understanding of who was coming to them, and could say no for a change and not always give them something or facilitate them or try and get them into a place where they could get some help.

Art should be able to stimulate and cause some kind of change. And that's what you want to do. Those Black movies of the '70s did that in a very subtle way. They added some pride to people who had money. They gave people a chance to walk into a theater and walk out and think they had a hero for a little while. No matter how poor they were or how depressed they were before they got there, they felt good when they left the theater and that's what it's about.

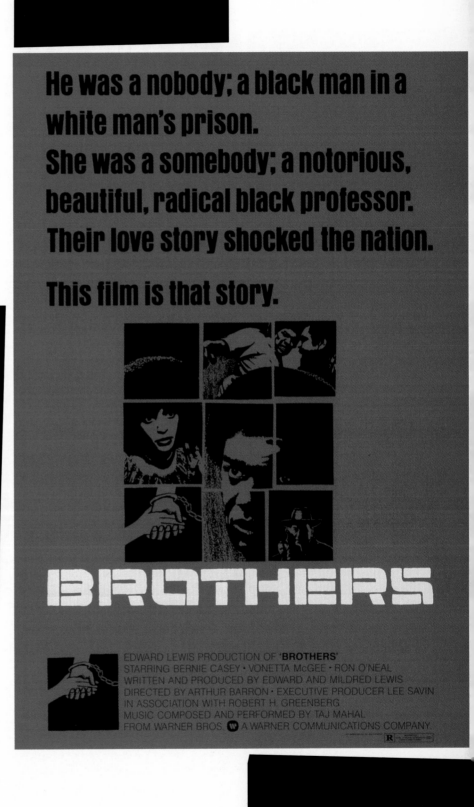

He was a nobody; a black man in a white man's prison.
She was a somebody; a notorious, beautiful, radical black professor.
Their love story shocked the nation.

This film is that story.

BROTHERS

EDWARD LEWIS PRODUCTION OF 'BROTHERS'
STARRING BERNIE CASEY · VONETTA McGEE · RON O'NEAL
WRITTEN AND PRODUCED BY EDWARD AND MILDRED LEWIS
DIRECTED BY ARTHUR BARRON · EXECUTIVE PRODUCER LEE SAVIN
IN ASSOCIATION WITH ROBERT H. GREENBERG
MUSIC COMPOSED AND PERFORMED BY TAJ MAHAL
FROM WARNER BROS. Ⓦ A WARNER COMMUNICATIONS COMPANY.
R

GLYNN TURMAN

Glynn Turman is one of the most highly respected actors to emerge from the Black cinema of the '70s. From his breakthrough role as the teenage writer in Cooley High to the grizzled veteran in The Buffalo Soldiers, Turman brings an intensity to his roles that is his special gift. He is best known for his role as Col. Clayton Taylor on the TV series A Different World. Turman lives in Los Angeles with his wife and children.

My background and my training were in the theater. My whole experience was based on having a great deal of respect for the images put out in the plays and productions that I had been a part of. So I brought that respect for the craft and for the theater and for the media with me to what I do in film. I look at motion pictures for all of us as propaganda. It's saying to the country, "Hey, this is where we are. This is what we're able to do. This is how far we've got to go." It's a very good gauge for society. That's how I look at it. And what I do is try to contribute to the progress by the roles that I pick and the roles that I hope to be part of. At least in that way, I can contribute to the progress of the big picture. Films are propaganda media. I'm an Aquarius and I'm a humanitarian, so I'm always looking to see what is bettering humanity. I was a revolutionary kind of guy back then, you know, the young hothead kind of actor: "He's not going to be a star, but he's a good actor and watch what you say around him." It didn't matter to me who the director was.

Every man falls into a trap or two. For me, the trap I encountered was in making the film *The Serpent's Egg* and the lure of working with a great director, Ingmar Bergman. I found myself in a precarious position in representing image. Had it not been for the insight of a director as fine as Mr. Bergman, I don't think I would have been able to get my point across. He handled this difficult situation for both of us. Production was stopped at one point because I refused to do a part of the scene. In the scene, I ended up buck naked, and Bergman wanted me to be at the foot of the bed while David Carradine and two prostitutes were in the same bed. I was anticipating a great big deal there, knowing how things are in the States, if you dare to stop production. I was petrified, but determined. He said, "Come into my dressing room." We began to talk. We hadn't had a chance to talk prior to shooting. I said, "I can't be at the foot of the bed like a dog." Bergman asked, "What do you mean?" I replied, "That's a negative image. Slaves slept with their masters on the floor at the foot of the bed. Mr. Bergman, I'm honored to work with you. You are one of the greatest directors in the world. I am the first Black person to work for you as an actor. I cannot have my people come to see me at the foot of the bed working for someone as great as you." He said "I never thought of it like that. It's out." We shot it the next day in a different way. I just remember how gracious he was in listening and understanding and trying to look at it from a point of view that was perhaps foreign to him. So it was a hell of an experience.

WHAT IT IS...

The REINCARNATION OF J. D. WALKER

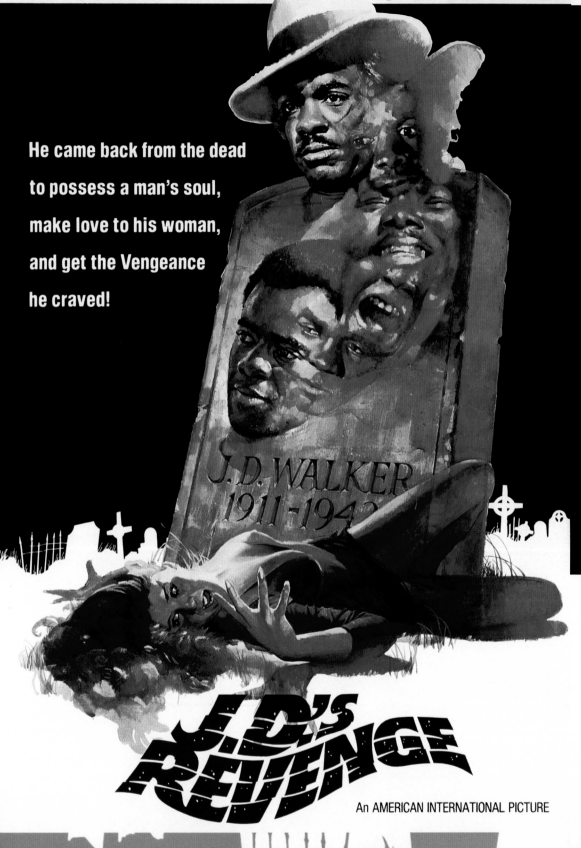

He came back from the dead
to possess a man's soul,
make love to his woman,
and get the Vengeance
he craved!

J.D. WALKER
1911-1942

J.D.'s REVENGE

An AMERICAN INTERNATIONAL PICTURE

WHAT IT IS...

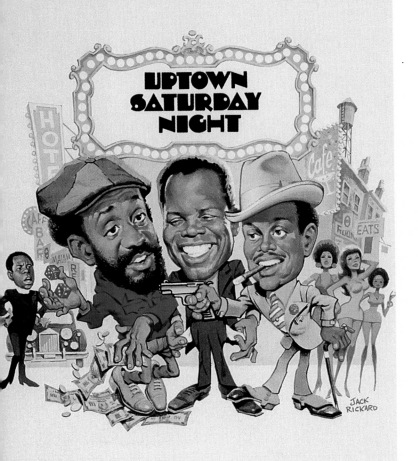

SIDNEY POITIER
BILL COSBY
And
HARRY BELAFONTE
As Geechie Dan

UPTOWN SATURDAY NIGHT

JACK RICKARD

They get funny when you mess with their money.

A First Artists Presentation

Another film where I had concerns was *J.D.'s Revenge*. That film has a following that is unbelievable. I liked doing it, but I didn't like the final cut, what was finally put on screen. I just thought it took shortcuts and it tried to be an exploitation film when it didn't have to be. It wasn't written as an exploitation film. But it was obviously gearing itself in the final cut toward sensationalism. I was sort of put at odds with the powers that be at American International Pictures because I wouldn't go on the press junket to promote the film. My managers, who were behind me in that decision after seeing it, said that there might be some repercussions. There may have been. However, it has survived to be a very, very popular film. So, in looking back at it, yeah, they flipped it a little bit, with the blood and the gore. But, hey, that's show business. I'm now able to overlook that. But it hasn't changed my opinion of what was done to the film.

On the other hand, we had a ball making *Cooley High*. That movie was so spontaneous, everyone was just excited about doing it, and we just had pure fun. We were allowed to be kids in that movie, which was great. The doing of it was so innocent and the innocence showed on screen. The message of loving life was unique to our story, especially considering the movies that were coming out at that time. It's what sets *Cooley* apart from the movies that have been theme copies of it to this day. But the thing that is always missing in those movies, that *Cooley* had, is how much those kids love life. They glorified life as opposed to glorifying the deaths so that when death came it was a true tragedy, even for the bad guys. It wasn't, "Look what I did!" It was, "Oh God, wow, I'm sorry." That's why it's a classic. Another thing that we were so proud of, as Black people, was to share with the rest of the world what our life was like. It was like a greeting card. This is how we are. And so many other people were able to say, "We're like that too." I think that's wonderful, just wonderful.

WHAT IT IS...

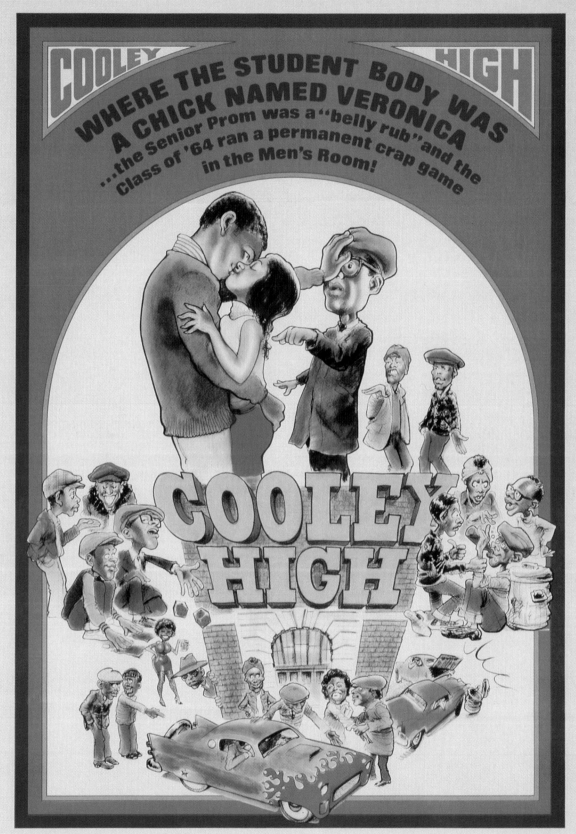

WHERE THE STUDENT BODY WAS
A CHICK NAMED VERONICA
...the Senior Prom was a "belly rub" and the
Class of '64 ran a permanent crap game
in the Men's Room!

COOLEY HIGH

SAMUEL Z. ARKOFF presents A STEVE KRANTZ PRODUCTION

An American International Release

"COOLEY HIGH" starring GLYNN TURMAN • LAWRENCE-HILTON JACOBS Co-Starring: GARRETT MORRIS
CYNTHIA DAVIS executive producer SAMUEL Z. ARKOFF written by ERIC MONTE produced by STEVE KRANTZ directed by MICHAEL SCHULTZ

A Cooley High Service Company Feature Original Soundtrack Album on Motown Records and Tapes COLOR by Movielab

PG PARENTAL GUIDANCE SUGGESTED
SOME MATERIAL MAY NOT BE
SUITABLE FOR PRE-TEENAGERS

COPYRIGHT ©1975 AMERICAN INTERNATIONAL PICTURES, INC.

WHAT IT WAS.

Five on the Black Hand Side was a very special movie to me because, once again, something had happened in that movie that was seldom done. It was produced by Brock Peters. That was a major step. It was a major movie, being produced by a dear friend, who was Black, who was an actor, and who had made the step into producership. That in itself made that a very special piece to be a part of, in my opinion, because it was taking control of your propaganda, taking control of your image. Having some say in what people thought about you around the world because you are seen around the world.

In general however, then as now, the studios made the movies. Back at that time, we were glad to get the movies. But it came with a certain stigma, whether it was called Black exploitation or whatever. It was a whole genre of get the man, get whitey. But that's what was the selling part or the hook. At that time, it was the era of Black Power and a certain assurance and assertion of one's ethnicity and pride, so that was fine. It's just that it was all one bag. The ones that stood out were the ones that tried to break the mold. I think probably what was good about it was that some did, indeed, break the mold. Some of these films are still very popular with the youth of today, or moviegoers of

today. *Superfly*, *Cooley High*, *The Mack*, these movies are what they call cult classics now. All of the films of the era had a lasting impact.

Those Black exploitation pictures of the '70s saved Hollywood: Financially saved their ass and that's all there is to it. In the early '70s, they weren't making any money with the films that they were doing and the stars that they had. This is a business. This is a factory town and it has to crank out product that makes money. The product that was cranked out were Black exploitation pictures. It would be a twenty-day shoot and in three months, the movie would be in the theaters, making money. They never lost a dime with any of these Black films. And they kept the lights on. We knew that. Everyone who was aware knew what was going on. Hollywood was able to survive a very depressed time, very depressed time. So if a Black film made $11 million, who got it? Ryan O'Neal in *Love Story*. That's what financed *Love Story* right? You're not going to put Glynn Turman in *Love Story*. And what happened was, they used us until they were able to get back on track. Then it was, "Thanks, boys, back to the fields." So that's the way that worked.

The Black films of the '70s were a great map for today's young filmmakers. I think had those films not been made, the springboard would have been much lower for filmmakers like Spike Lee and John Singleton. Even the idea that I don't have to be an actor, I don't have to star in the picture, but I can direct a picture or produce the picture. That level would not have been reached at this point had it not been for all the hell raised in making the Black movies of the '70s. The bar would have been there and Spike and all of them would have had to start at that level. There's that old saying, "I'm here only because of the shoulders that I stand on." I think it's very true and that all of these pictures are a map so we're able to say, "This is good, we want to do more of these, we don't want to do more of this, we don't need to do this again. Remember this one? That's a great map." I think that all those films, negative and positive, have contributed positively to the things that are happening now.

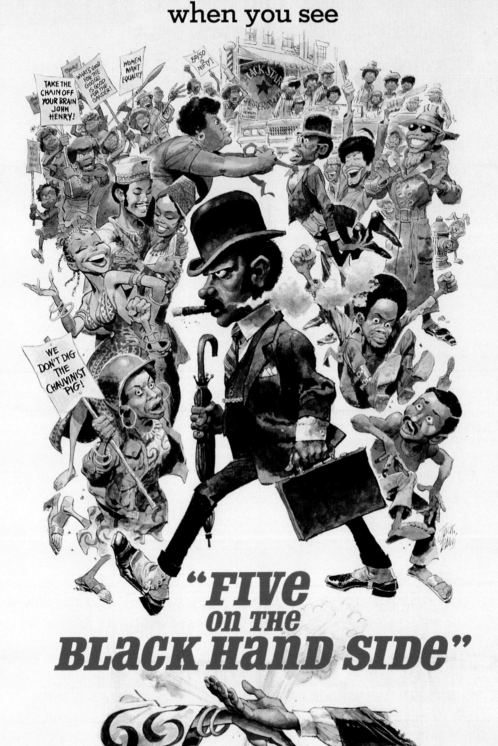

You've been coffy-tized, blacula-rized and super-flied – but now you're gonna be glorified, unified and filled-with-pride... when you see

"FIVE on the BLACK HAND SIDE"

MICHAEL TOLAN · BROCK PETERS present "FIVE ON THE BLACK HAND SIDE" starring CLARICE TAYLOR · LEONARD JACKSON · VIRGINIA CAPERS GLYNN TURMAN and D'URVILLE MARTIN as Booker T. · Produced by BROCK PETERS and MICHAEL TOLAN in association with THE PETERSEN COMPANY Associate Producer KAY KORWIN · Screenplay by CHARLIE L. RUSSELL Based on the play by CHARLIE L. RUSSELL · Music by H.B. BARNUM · Directed by OSCAR WILLIAMS

PG PARENTAL GUIDANCE SUGGESTED SOME MATERIAL MAY NOT BE SUITABLE FOR PRE-TEENAGERS

United Artists
Entertainment from Transamerica Corporation

73/340

QUENTIN TARANTINO

When director and screenwriter Quentin Tarantino produced Jackie Brown *and selected '70s icon Pam Grier to play the lead character, he called the film his tribute to the Black exploitation period. An Academy Award winner, Tarantino's cutting-edge work has set new standards for the movie industry. Tarantino wrote and directed the international sensation* Pulp Fiction, *for which he received an Academy Award for Best Original Screenplay and the Palme d'Or at the Cannes Film Festival. He wrote and directed* Reservoir Dogs, *wrote the screenplay for* True Romance, *and wrote and acted in* Four Rooms *and* From Dusk till Dawn. *Tarantino established Rolling Thunder Pictures in 1997.*

When I was growing up, exploitation movies in general really rang my bell. I really liked them. I saw everything from foreign art films to all the mainstream stuff too. But there was an element of rawness and outrageousness and naughtiness to exploitation films. Whether it be Black exploitation films, or the redneck movies, the good 'ol boy movies, or the pom-pom girl movies. The exploitation movies went a little further because that's what they had to sell. They didn't have Paul Newman, right? They had to offer something that the mainstream films couldn't offer. I think if you look at my work, it's not really taking that much from the mainstream cinema. What I've taken from exploitation films in general is that anything can happen. You don't see that much in movies anymore, that's the thing that kills movies, you've seen it all before.

I've actually looked at Black exploitation films in terms of fiction—as Black exploitation spaghetti Western.

People who grew up in the '70s are now looking back to what they grew up with. The '70s were looked down upon for so long. You never got any respect growing up in the '70s, you were basically always told how you missed the '60s. You were told how the music was happening and how you just missed it. In the '70s you had Elton John and that kind of thing. White pop music, after breaking new ground in the '60s became very bland in the '70s. There were no new Bob Dylans or Blonde on Blonde albums.

But for Black music, the '70s was the true explosion as a major provoking art form. It went from Chuck Berry and the Five Satins and that whole type of music in the '50s to the '60s with the explosion of Motown and R & B to the '70s where it became soul music. That was for my money, the greatest time in Black music history—the '70s. I never felt like I missed the '60s because I got the Black '70s and I would choose that over the hippie '60s any day of the week.

In soul music, there was Marvin Gaye's *What's Going On*, which was the Blonde on Blonde album for Soul music. It was one of the very first concept albums that came out.

I grew up in the South Bay area of Los Angeles listening to KDAY radio station. I grew up in a house where every

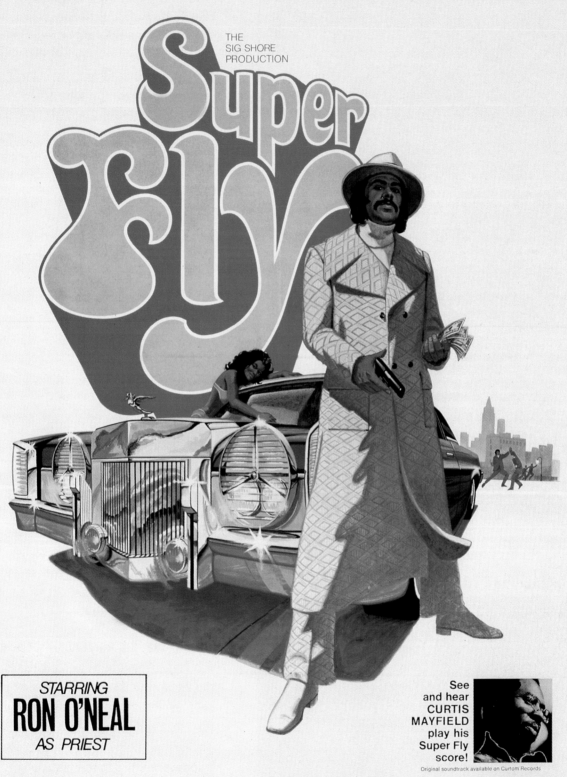

Never a dude like this one!
He's got a plan to stick it to The Man!

THE
SIG SHORE
PRODUCTION

Super Fly

STARRING
RON O'NEAL
AS PRIEST

See and hear **CURTIS MAYFIELD** play his Super Fly score!

Original soundtrack available on Curtom Records

The SIG SHORE Production "SUPER FLY" Starring RON O'NEAL · CARL LEE · JULIUS W. HARRIS · SHEILA FRAZIER
CHARLES McGREGOR · Music Composed and Arranged by CURTIS MAYFIELD · Screenplay by PHILLIP FENTY · Produced
by SIG SHORE · Directed by GORDON PARKS, JR. · from Warner Bros., a Warner Communications company

COPYRIGHT ©1972 WARNER BROS., INC.

72/319

MUHAMMAD ALI
io sono il più grande

Una presentazione Columbia/EMI

MUHAMMAD ALI in **IO SONO IL PIÙ GRANDE**

Saturday, *Soul Train* was on. I lived with my mom and her two roommates. My mom was about twenty-five and very beautiful and had a lot of friends. We lived with Jackie, a Black woman who was also beautiful, and a Mexican gal named Lillian. They were in their twenties and they were three young foxy ladies talking about their dates and getting ready as they watched *Soul Train*. As a little kid watching *Soul Train*, I always thought it was really cool. Nearly every commercial was an Afro Sheen commercial with Black actors in it. It was a Black world. You saw nothing but Black faces. Growing up watching the show, I always thought it would be the coolest thing to be the white person on *Soul Train*, that would be the highest honor. I thought maybe some day, I'll be the first white member of the *Soul Train* gang. I'll be out there locking up. Time went on, and I hadn't seen *Soul Train* again for about ten to fifteen years, who knows how long. But when I flipped it on, I just couldn't believe how short Don Cornelius's Afro was. I thought, what did he do? He's not Don Cornelius anymore. They had white people dancing on the show, and they sucked.

You look at Black exploitation films today and you see all the big Afros and the one-piece outfits with the zipper going down the middle, and the big platform shoes, and the big coats, with the big endangered species animal fur collar going down. I'm not saying everyone looked like that but it's about an embracing of a culture and an identity.

The film that just knocked my socks off the most was *Coffy*, from the moment she shot the guy in the head with the sawed off shotgun and his head exploded like a watermelon. I had never seen that before and then it just got better from there. Pam Grier was just like an incredible badass, she was just so great. *Coffy* is one of the greatest revenge movies ever made. Revenge movies were very big in the '70s. They worked. You watched revenge movies and you got caught

up in them. It's almost impossible to watch *Coffy* with an audience and not have them get caught up in the movie. When the film opened, people were standing on their seats screaming at the top of their lungs for her to blow away those guys. Revenge movies were the first movies I got completely caught up in that kind of way. *Coffy* just works. It's really nice when you have just a visceral response to a film at an early age. And, actually, I think I appreciate *Coffy* even more now. It still holds up. I remember when I was younger, people derided the movies and said they were cheap. I never looked at them that way. I always knew Kung fu movies were kind of slapped together and I knew Godzilla movies were kind of stupid. But the Black exploitation movies were great. They didn't look cheap to me at all. I didn't know what an exploitation movie was. I just knew they had more sex and violence then the other movies, which was a good thing for me.

In terms of what "exploitation" cinema is, it simply means there's an element in a film that you can exploit. That's what low budget movies had to offer. The way Hollywood movies have run and always will run is that they exist on a star system and that's why people all over the world like to see Hollywood movies. That keeps the machine running. When you make a Harrison Ford movie you are exploiting the hell out of Harrison Ford's image. You see *Air Force One* posters all over town, *big* giant pictures of a plane in Harrison Ford's face. In big studio films, they are exploiting the presence of a star, that's how they do it. Exploitation films don't have stars they can exploit like that and the things that they have to exploit are sex and violence and nudity and car chases or action in motorcycle movies, in Kung fu movies it's people fighting, that's what they have to exploit. That's why exploitation movie posters are far more interesting and fun to look at than mainstream movies, because a poster of a Paul Newman movies is going to have a picture of Paul Newman and that's the deal. A motorcycle movie is going to have all kinds of action and motorcycles and chicks in short pants and choppers and all that Hell's Angels memorabilia in your face. The term means we may not have the big budget and the stars but we do have action and we do have sex, and we do have a big gory monster. It's what they're selling.

When you talk about Jim Kelly, Pam Grier, Jim Brown, and Fred Williamson, you're actually talking about the same; they were major stars in that world. So they were exploiting the hell out of their images. Burt Reynolds was a redneck Fred Williamson for the Southern drive-in market. When he did his moonshining fast car movies, they were made just the way a Pam Grier movie was made for the Black market.

I like the term Black exploitation just like I like the term Kung fu films even if the movie is about karate or spaghetti Westerns. It doesn't fit everything. *Cornbread Earl and Me* is not exploitive in any way. It

CORNBREAD, EARL AND ME

195

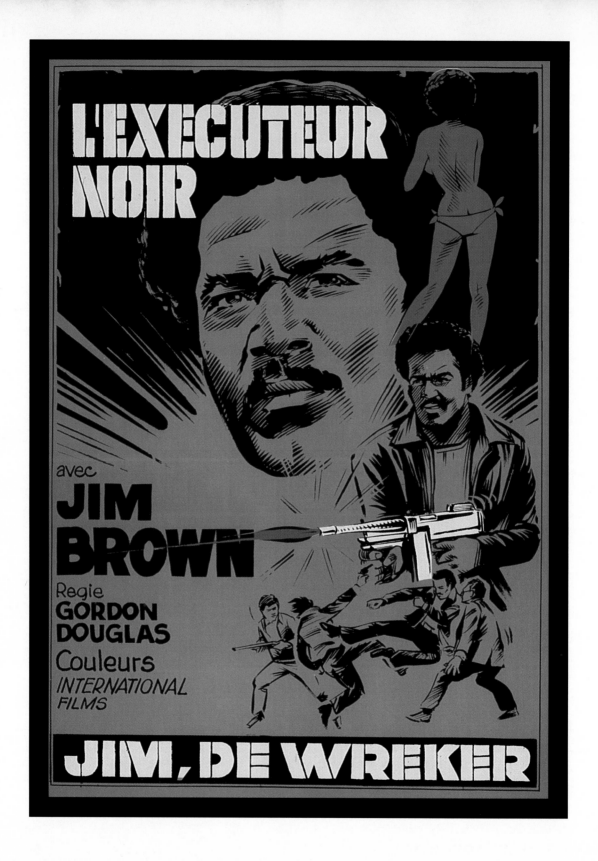

might be manipulative toward the audience, but it's not exploitive. The staple of Black exploitation movies is basically that they were Black crime films and they focused on detectives or gangsters, or crooks or criminals. The thing is that a lot of the Black films were basically just the same as white gangster films, redone James Cagney or Humphrey Bogart movies but set in Harlem. The basic plot is Howard Hawks's *Scarface*. It's *Black Caesar* and it's *The Mack*, it's the same thing down to the good mother who won't take the dirty money that her son brings her and she's played by of all people, Juanita Moore.

She played the god-fearing soul-suffering mother in *Imitation of Life*.

The sad thing about the genre was when it left, nothing ever replaced it again. The films were made for a Black audience. After *Shaft* there really wasn't that much of a thought toward crossover. It was very interesting, because I'm always interested in characters who can be who they are; that's something novels have always been able to do. It's one of the good fights that I've been fighting; characters don't always have to be perfect. In novels you can write about a person who is a fucking bastard, and he can be a fucking bastard—that's okay. He can still be the lead character in your book, he's just got to be an interesting character. Movies lost that pretty much in the '80s in a big way; we're getting it back in the '90s. People can be flawed and wrong and they can be scumbags and you can still watch the movie if it's interesting. What I find fascinating is there's still things that they did in Black exploitation movies that would be rather rough to do today. It would be tough.

If you look at *The Mack* and *Superfly* it's clear that these films are about nonconformity. The Mack, a pimp, and Superfly, a cocaine pusher, are involved in criminal endeavors but were never looked upon really as criminal endeavors. They are looked at as a fight against "whitey" . . . as empowerment. They never once say in *Superfly* that what he's doing is wrong, he's just not taking what "The Man" is dishing out. He's not going to play the game. Listen to the lyrics of the song.

"The aim of his load is to move a lot of blow, ask him of his dream, what does it mean, he wouldn't know, it can't be like the rest, it's the most he'll confess, but the time's running out, and there's no happiness, Oh Superfly, you're gonna make your fortune by and by . . ."

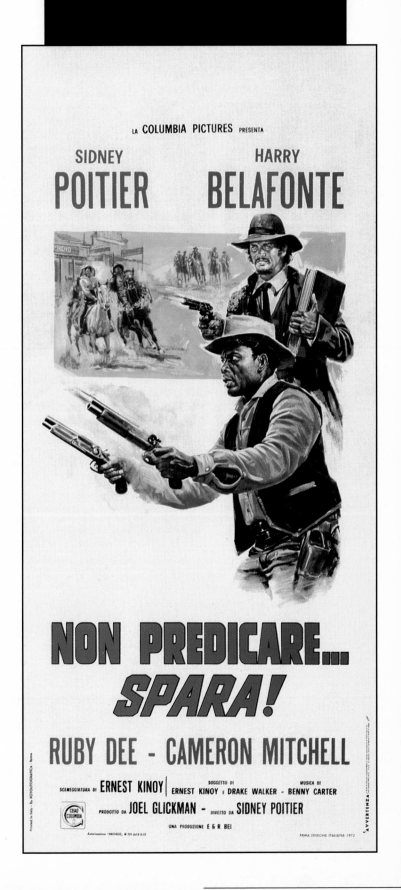

197

For that time in the '70s there was a very legitimate Black cinema going on. It got mired in all the talk about pimps and all that. Major studios jumped on the bandwagon as well as AIP in producing the films. Warner Brothers and MGM were right up there. MGM did *Hit Man*, United Artist did *Cool Breeze* and a ton of stuff. AIP were exploitation filmmakers who set up shop and were consistently cranking them out. The big studios had their own exploitation rings, because the B-movie market, the exploitation movie market, the grind house movie market, was very big in the '70s; a lot could be made.

The cinema hit all the genres. There were Westerns and horror films made specifically for a Black audience and it was fun! *The Legend of Nigger Charley* was a Black action film in a Western setting. A lot of the Black crime films literally were the old Warner Brothers movies just redone with Black casts. *Cool Breeze* is a Black remake of *The Asphalt Jungle*. *Hit Man* is a remake of the Michael Caine London crime film, *Get Carter*. There was *Buck and the Preacher* which had a very Black exploitation feel to it and also had a big budget and starred Sidney Poitier and Harry Belafonte. There was the crazy Italian production, *Take a Hard Ride* with Jim Brown, Fred Williamson, Jim Kelly and Lee Van Cleef with a little spaghetti Western thrown in there.

Then consider *Mandingo*, which is a Black exploitation movie in every way, shape, and form if ever a description deserved to be applied to a film. *Mandingo* was produced by a big studio and was very successful with Black audiences. *Mandingo* is a big studio exploitation masterpiece. It has the same aesthetic as a women-in-prison movie, except far more horrible. It's probably one of the most violent and disgusting films you'll ever see. It's based on a very famous book that showed the real truth about the old South. There is so much wimpiness in major studio's films. To think that *Mandingo* was made by a major studio and they spent so much money on it, and it looks like they did, I'm still flabbergasted, which is one of the reasons why I love that movie so much. I'll never forget it. It exists so much on its own in 1977.

It's very interesting because for so many years people have been putting these films down. It was the rise of hip-hop and rap artists talking about how much they loved Black exploitation films and how much they loved Max Julien and *The Mack* and *Superfly* and

LE VAMPIRE NOIR

"BLACULA"

WB RELEASED BY WARNER BROS.

"BLACULA" ··· WILLIAM MARSHALL · DENISE NICHOLAS · VONETTA McGEE
GORDON PINSENT ··· THALMUS RASULALA ··· EMILY YANCY · LANCE TAYLOR, Sr. · CHARLES MACAULAY ··· COLOR
PRODUCED BY JOSEPH T. NAAR · DIRECTED BY WILLIAM CRAIN · WRITTEN BY JOAN TORRES AND RAYMOND KOENIG · MUSIC COMPOSED BY GENE PAGE · An American International Picture

DE ZWARTE VAMPIER

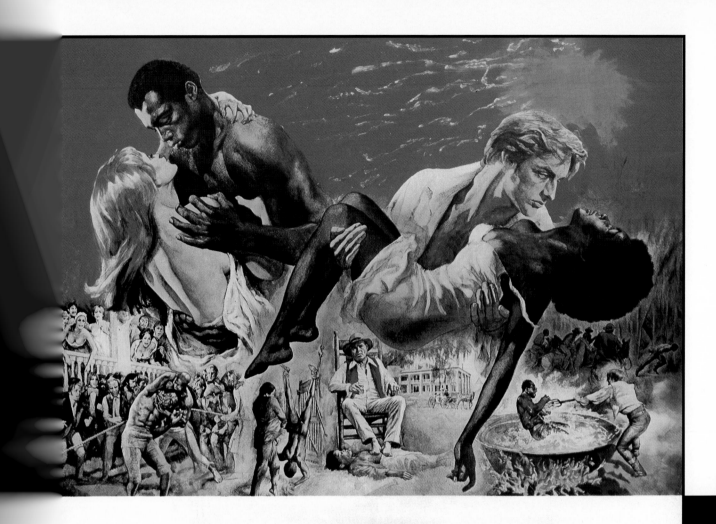

MANDINGO

DINO DE LAURENTIIS
présente

avec

JAMES MASON · SUSAN GEORGE · PERRY KING

RICHARD WARD · BRENDA SYKES et pour la première **KEN NORTON** dans le rôle de **MEDE**

avec **LILLIAN HAYMAN** D'après le roman de **KYLE ONSTOTT** (Editions Robert Laffont) et la pièce de **JACK KIRKLAND**

Scénario de **NORMAN WEXLER** Musique de **MAURICE JARRE** Producteur exécutif **RALPH SERPE** Produit par **DINO DE LAURENTIIS**

Réalisé par **RICHARD FLEISCHER** - TECHNICOLOR

UN FILM PARAMOUNT DISTRIBUE PAR CINEMA INTERNATIONAL CORPORATION

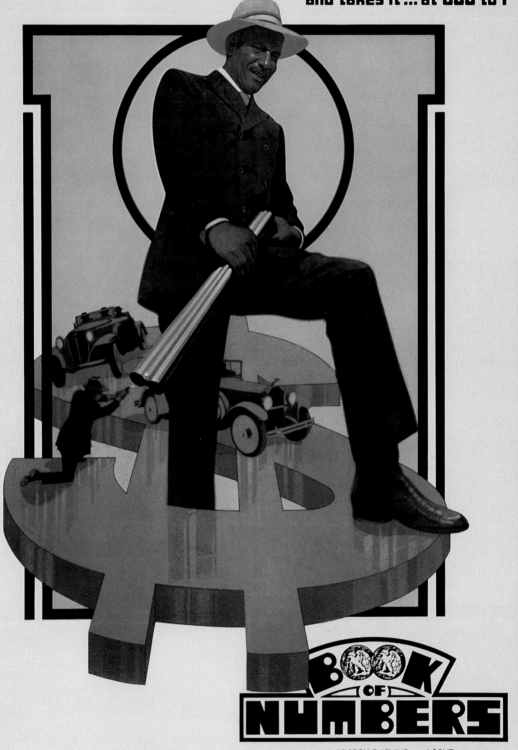

Willie Dynamite, and using Rudy Ray Moore and sound bites from both Black exploitation films and Kung fu movies in their records. On the song for Public Enemy where the guys start talking and going, "What's playing? *Driving Ms. Daisy*, ah, man, fuck that shit, man, let's go home and watch *Black Caesar*!" A lot of the Black stars of the time were embarrassed about being in the '70s movies and a standard thing that was said was, "Well at least it's giving some good Black actors a chance to work, that weren't given a chance. Bernie Casey got a chance to work, Rosalind Cash got a chance to work . . ." It's just so submissive and degrading to the genre. Rap artists twenty years later were the first people, the first Black "celebrities" to embrace the films. I grew up with the films and I loved them. I didn't need anyone else to tell me. I talked about them with anyone who would listen even before I became known.

A lot of the films are just fun. Of course, there's some really ridiculous ones. There are some that you end up laughing at quite a bit because you know they just didn't date that well. But that's the same thing for a lot of the hippie movies of the '60s. They don't date that well. That doesn't mean that they're bad movies, it just means that they look dated; it looks like the times have changed. But there are so many that just stand as wonderful documents of their time.

When I put Pam Grier as the lead of *Jackie Brown*, people said, "Oh, you're doing for Pam Grier what you did for John Travolta." Well, I don't think like that. I cast a good actress in a role that's perfect for her. I'm not thinking about launching or rediscovering, it's not about that. That's a nice thing to write about but it really has nothing to do with the actual work or process involved. It was going to be brought up so much that I thought I had to bring it up to Pam very early on. That's all media machine press work bullshit that really has nothing to do with the work. When I talked to Pam about it she said, "Oh Quentin, don't even think about that, I'm not thinking about that, because I'm not a white male!"

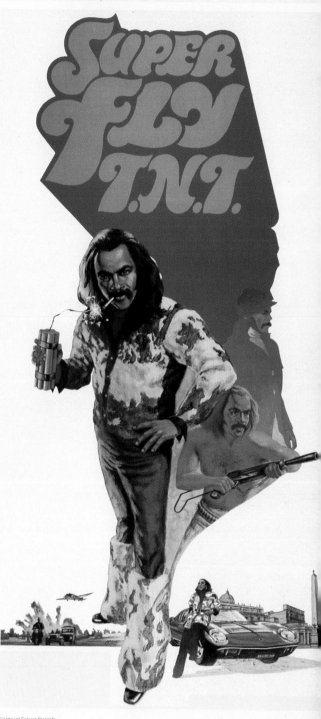

WHAT IT WAS...

The Black Street Fighter

While the movie doesn't take place in the '70s, the characters all came of age in the '70s. So now, everyone is older. Sam Jackson plays an older guy who comes from the knowledge of the '70s. He's an arms dealer. He has a lot of money in Cabo San Lucas and he has Jackie (Pam Grier) bring over a little bit of the money at a time. Robert De Niro plays an ex-con whose a little fried from the experience, he's in his fifties. Robert Forster , who plays a bail bondsman, is about fifty-nine. Pam Grier plays a forty-four-year-old who, when she gets busted by the ATF, is able to get through everything because she's smart. She manages to keep cool and think on her feet. That's Jackie's main attribute. She's not a function for the male characters, she's not a superhero but she's the smartest person in the piece. In the original book, Jackie, the main character, is white. The number one characteristic Jackie has is no matter how intense the situation gets, she appears cool. In thinking about this, her age is an important element for me. Most people who would have adapted it would have made her younger but I thought I have to find a forty-four-year-old woman who legitimately looks thirty-five, who has all of her beauty and who looks like she can handle anything. That sounds like Pam Grier to me! So without really changing anything, it did change because Jackie Brown is a Black woman and had different life experiences. The aspect that ties it with Black exploitation films, it's just an old school movie, it's old school characters. When Pam Grier was doing her work in *Foxy Brown*, Robert De Niro was doing his work in *Mean Streets*. Here they are. But she's not *Coffy*, she's not *Foxy Brown*, she's not a femme fatale, she's very human and it's what Pam Grier has; she gets through it with her coolness.

I brought a lot of the feeling of Black exploitation films that I like to *Jackie Brown*. It's like the debt that *Pulp Fiction* owes to spaghetti Westerns, *Jackie Brown* owes to Black exploitation films. And, the relationship that surf music had to *Pulp Fiction*, old school '70s soul music has to *Jackie Brown*; that's the rhythm and the pulse of the movie.

60,000 Volts of Black Power

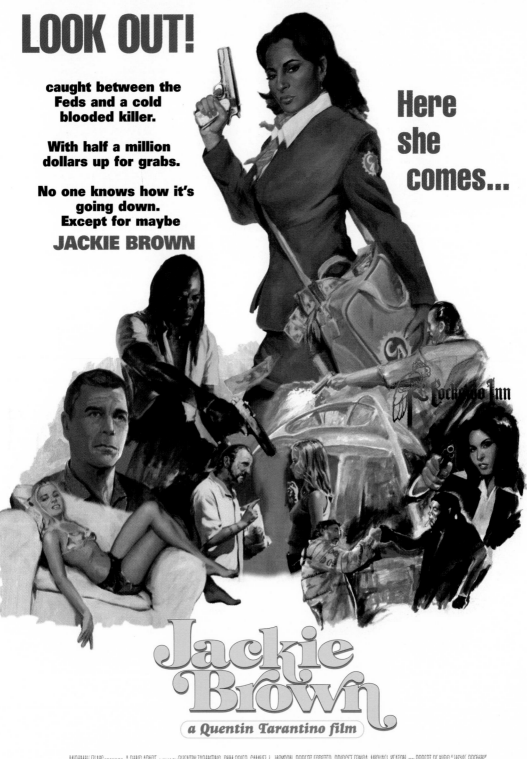

POSTER FILMOGRAPHY

AARON LOVES ANGELA Columbia 1975
Cast: Kevin Hooks, Irene Cara, Moses Gunn, Robert Hooks
Director: Gordon Parks Jr.
Plot: A re-telling of *Romeo and Juliet* with Black 16-year-old Aaron in love with 14-year-old Puerto Rican Angela in the harsh world of New York's ghetto.

ABBY American International Pictures (AIP) 1974
Cast: Carol Speed, William Marshall, Terry Carter, Austin Stoker
Director: William Girdler
Plot: Eshu, the Nigerian god of sexuality, possesses a minister's wife, turning her into a wanton, sexually ravenous creature. An AIP knockoff of *The Exorcist*.

ACROSS 110TH STREET United Artists 1972
Cast: Yaphet Kotto, Anthony Quinn, Anthony Franciosa
Director: Barry Shear
Plot: Three Black men, disguised as cops, rob $300,000 from a Harlem numbers bank, killing five mafiosos and two real policemen during the robbery. They hide from both the cops and the mob. The theme of the uptown Black ghetto vs. downtown Italian mob was the prototype for the Black gangster movies that followed.

ADIOS AMIGO Atlas Films 1975
Cast: Fred Williamson, Richard Pryor, Thalmus Rasulala
Director: Fred Williamson
Plot: Big Ben (Williamson) is arrested after shooting up the house of the man who drove him off his land. He is freed when the group is robbed by Sam Spade (Pryor). The two become partners with Sam always getting the pair into trouble with his constant schemes. A very uneven comedy.

AMAZING GRACE United Artists 1974
Cast: "Moms" Mabley, Moses Gunn, Slappy White, Rosalind Cash, Butterfly McQueen
Director: Stan Lathan
Plot: "Moms" Mabley wages war against corrupt Baltimore politics in this light hearted comedy.

THE ARENA New World Pictures 1973
aka NAKED WARRIORS
Cast: Pam Grier, Margaret Markov, Lucretia Love, Paul Muller
Director: Steve Carver
Plot: A voluptuous Nubian slave and a Druid high princess lead a gladiator's revolt against their Roman oppressors.

BAMBOO GODS AND IRON MEN AIP 1974
Cast: James Iglehart, Shirley Washington
Director: Cesare Gallardo
Plot: A boxing and Kung fu epic shot in the Philippines.

BARE KNUCKLES TWE 1977
Cast: Gloria Hendry, Sherry Jackson, John Daniels
Director: Don Edmonds
Plot: Extremely violent action film about a bounty hunter in pursuit of a Kung fu killer.

BIG DOLL HOUSE New World 1971
Cast: Sid Haig, Judy Brown, Pam Grier
Director: Jack Hill
Plot: A group of women prisoners are subjected to torture and sexual abuse. Finally, with help from sympathizers, they escape. This film started a cycle of women-in-prison films. It also launched Pam Grier's career.

BLACK BELT JONES Warner Bros. 1974
Cast: Jim Kelly, Gloria Hendry, Scatman Crothers
Director: Robert Clouse
Plot: In order to repay a debt to a Mafia chieftain, a Black hood tries to force an old man to sell his karate school to the mob. The

school is in the middle of an urban renewal area in Watts that the Mafia wants to control. When the old man is killed, his daughter and students join forces with federal agent Black Belt Jones to destroy the mob. Clouse directed Kelly in *Enter the Dragon* and in this film Kelly does his best Bruce Lee imitation.

BLACK CAESAR AIP 1973
Cast: Fred Williamson, Art Lund, Val Avery, Julius W. Harris, Gloria Hendry
Director: Larry Cohen
Plot: The saga of Tommy Gibbs's rise to power, from shoeshine boy to number one crime boss. Very much in the tradition of the '30s gangster films like *Little Caeser* and *Scarface*, Black Caesar contains many fine cinematic moments. The scenes between Gibbs and his father show first rate acting and emotional truth. One of Williamson's best performances.

THE BLACK GESTAPO Bryanston 1975
aka GHETTO WARRIORS
Cast: Rod Perry, Charles P. Robinson, Phil Hoover, Angela Brent
Director: Lee Frost
Plot: A former Vietnam general forms a militia to clean up the Watts ghetto. A bloodbath follows and the group initiates a reign of terror. Finally, the people of Watts rise against them.

BLACK GIRL Cinerama 1972
Cast: Brock Peters, Leslie Uggams, Claudia McNeil, Lousie Stubbs, Ruby Dee, Gloria Edwards
Director: Ossie Davis
Plot: The story of an aspiring dancer and the conflict between her two half-sister and a girl who was raised by her family.

BLACK GUNN Columbia 1972
Cast: Jim Brown, Brenda Sykes, Bernie Casey, Martin Landau
Director: Robert Hartford-Davis
Plot: Jim Brown is an L.A. nightclub owner seeking revenge on the mob who killed his brother.

BLACK JACK AIP 1972
aka WILD IN THE SKIES
Cast: George Stanford Brown, Brandon de Wilde, Keenan Wynn
Director: William T. Naud
Plot: All kinds of complications occur when three anti-war activists hijack a B-52 bomber. This comic adventure ends with Fort Knox getting nuked.

BLACK JESUS Plaza Pictures 1968
Cast: Woody Strode, Jean Servais
Director: Valerio Zurlini
Plot: An African leader is determined to save his people through passive resistance to a dictatorial regime that is being propped up by European colonialists. In the end, he is imprisoned and tortured. Loosely based on the life of Patrice Lamumba.

BLACK MAMA, WHITE MAMA AIP 1972
Cast: Pam Grier, Sid Haig, Margaret Markov, Lynn Borden
Director: Eddie Romero
Plot: Two female inmates from a Latin American prison, one a Black prostitute and the other an idealistic white guerrilla fighter, are chained together and transferred to another prison. Enroute, their bus is ambushed by revolutionaries and they escape. Using nun's habits, they flee from the police, the revolutionaries, and a criminal gang. A remake of *The Defiant Ones*.

BLACK SAMSON Warner Bros. 1974
Cast: Rockne Tarkington, William Smith, Connie Strickland, Carol Speed
Director: Charles Bail
Plot: Samson, known for his gentle nature, social

conscience, and the cane he carries, owns a nightclub in South Central Los Angeles. When he refuses to cooperate with a gangster who wants to take over the neighborhood, the gangster kidnaps Samson's girlfriend. In the final confrontation, Samson uses Kendo (Japanese stick fighting) and the people from the 'hood to overcome evil. The director would later make *Cleopatra Jones and the Casino of Gold*.

BLACK SAMURAI BJLJ International 1977
Cast: Jim Kelly, Bill Roy, Roberto Contreras, Essie Lin Chia
Director: Al Adamson
Plot: Warlock, the head of a cult of voodoo worshippers, kidnaps the daughter of the Minister of the Samurai Code. Her boyfriend, a top government agent, takes offense and destroys Warlock and his bloody cult.

BLACK SHAMPOO Dimension 1976
Cast: John Daniels, Tanya Boyd, Joe Ortiz, Skip Lowe
Director: Greydon Clark
Plot: A stud hairdresser makes his saloon popular by blow-drying more than his female customer's hair. When thugs destroy his salon and beat up his employees, the hairdresser shows he can dye more than hair.

THE BLACK SIX Cinemation 1974
Cast: Gene Washington, Carl Eller, Lem Barney, Mercury Morris, Mean Joe Green, Willie Lanier
Director: Matt Cimber
Plot: A Vietnam vet and his five friends avenge his brother's death at the hands of a white biker gang.

THE BLACK STREET FIGHTER New Line 1976
aka BLACK FIST; BOGARDS
Cast: Richard Lawson, Philip Michael Thomas, Dabney Coleman, Annazette Chase
Director: Timothy Galfas
Plot: A young Black man is lured into becoming a street fighter for a crooked promoter. When his pregnant wife and brother-in-law are killed, he takes revenge on all those who have abused and used him. Dabney Coleman stands out as the crooked cop.

BLACULA AIP 1972
Cast: William Marshall, Denise Nicholas, Vonetta McGee, Thalmus Rasulala
Director: William Crain
Plot: An African prince is bitten by Dracula and becomes a vampire. Two hundred years later, his coffin is brought to Los Angeles and he begins searching the night for victims.

BLAST New World 1972
Cast: Billy Dee Williams, Raymond St. Jacques, D'Urville Martin
Director: Frank Arthur Wilson
Plot: This is a re-edited version of *The Final Comedown*, with producer, director, and writer credits given to Frank Arthur Wilson when in fact Oscar Williams performed all three functions. A group of Black militants are in a shootout with the police. The charismatic leader of the militants has been critically wounded. As the battle rages, he relives key moments of his life leading up to the present situation.

BLIND RAGE MGM 1978
Cast: D'Urville Martin, Leo Fong, Tony Ferrer, Dick Adair
Director: Efren C. Pinon
Plot: Five blind Kung fu masters plan a robbery worth fifteen million dollars.

BOOK OF NUMBERS Avco Embassy 1978
Cast: Raymond St. Jacques, Philip Michael Thomas, Freda Payne, Hope Clark, D'Urville Martin
Director: Raymond St. Jacques
Plot: Two slick waiters setup a numbers game

in a small Arkansas town. The local criminal chieftain is not amused and sends two henchmen to set thing aright. St. Jacques's directorial debut.

BOSS NIGGER Dimension 1975
Cast: Fred Williamson, D'Urville Martin, William Smith, R.G. Armstrong, Barbara Leigh
Director: Jack Arnold
Plot: A pair of bounty hunters take on local bad guys in order to save a small town in the 1870s.

BROTHER ON THE RUN Harnell Independent 1973
aka SOUL BROTHERS DIE HARD
Cast: Terry Carter, Kyle Johnson, Gwenn Mitchell, James Sikking
Director: Herbert L. Strock
Plot: A Black teenager is hunted by the police for a crime he didn't commit.

BROTHERS Warner Bros. 1977
Cast: Vonetta McGee, Bernie Casey, Ron O'Neal, Renny Roker
Director: Arthur Barron
Plot: A radical, beautiful college professor falls in love with a convict. A fictionalized account of the romance between Angela Davis and George Jackson. Powerful and subtle performances by O'Neal, McGee, and Casey are the highlights of this powerful film.

BUCK AND THE PREACHER Columbia 1972
Cast: Sidney Poitier, Harry Belafonte, Ruby Dee, Cameron Mitchell
Director: Sidney Poitier
Plot: A Black former Union cavalryman leads wagon trains of former slaves to freedom in Western lands. They are attacked by bounty hunters who want to keep cheap Black labor in the South. A series of clashes lead to a final confrontation and the Black settlers receive help from the Indians.

BUCKTOWN AIP 1975
Cast: Fred Williamson, Pam Grier, Bernie Hamilton, Thalmus Rasulala
Director: Arthur Marks
Plot: A man comes to a small, highly corrupt southern town to bury his brother, who's been killed by the local police. After reopening his brother's gambling joint, the police try leaning on him. He calls in his Philly friends to help him and discovers he's just replaced one set of hoods for another. He takes them on himself.

CANDY TANGERINE MAN Moonstone 1975
Cast: John Daniels, Angel (Tracy) King, Pat Wright
Director: Matt Cimber
Plot: A man leads a double life: Respectable upscale suburbanite with a wife and two kids; and a high-living Sunset Boulevard pimp with a yellow and red Rolls-Royce and a stable of nubile girls. After battling corrupt police and defeating the Mafia in a bloody war, he tires of the life and retires to the suburbs.

CAR WASH MCA 1976
Cast: Richard Pryor, George Carlin, Antonio Fargas, Ivan Dixon, Franklyn Ajaye
Director: Michael A. Schultz
Plot: A hit theme song by Rose Royce and numerous guest appearances make up for the thin plot line. Memorable are Richard Pryor as a phony preacher and Antonio Fargas as a militant gay.

CHANGE OF MIND Cinerama 1969
Cast: Raymond St. Jacques, Susan Oliver, Janet MacLachlan, Leslie Nielsen
Director: Robert Stevens
Plot: The brain of a white DA is transplanted into the body of a Black man. He tries to go back to his former life but is rejected by his

friends and family. He returns to the woman who was married to the dead man. He wins a court case against a bigoted sheriff.

CLEOPATRA JONES Warner Bros. 1973
Cast: Tamara Dobson, Bernie Casey, Brenda Sykes, Antonio Fargas, Shelley Winters, Esther Rolle
Director: Jack Starrett
Plot: 6'2" CIA agent Cleopatra Jones destroys a poppy field worth $30 million. Mommy, queen of the L.A. underworld, vows to destroy Jones and the battle is joined. After fighting corrupt cops and Mommy's henchmen, Cleo and Mommy have their final confrontation in a junkyard. Cleo wins.

CLEOPATRA JONES AND THE CASINO OF GOLD
Warner Bros. 1975
Cast: Tamara Dobson, Stella Stevens, Albert Popwell
Director: Chuck Bail
Plot: Cleo arrives in Hong Kong to rescue two fellow agents from the clutches of the the Dragon Lady. Refusing help from the HK Police, Cleo teams up with a female private eye and her motorcycle riding helpers. They trace the Dragon Lady to her lair, a casino in Macao. In hand to-hand-combat, Cleo kills the Dragon Lady and rescues her fellow agents.

COFFY AIP 1973
Cast: Pam Grier, Booker Bradshaw, Robert DoQui, Allan Arbus
Director: Jack Hill
Plot: When her 11-year-old sister is turned into a hopeless addict, a nurse goes on a rampage of revenge and death. This extremely violent film firmly established Grier as the queen of the genre.

COME BACK, CHARLESTON BLUE
Warner Bros. 1972
Cast: Raymond St. Jacques, Godfrey Cambridge, Jonelle Allen, Adam Wade
Director: Mark Warren
Plot: Coffin Ed Johnson and Gravedigger Jones return in this sequel to Cotton Comes to Harlem. A man is found dead on a meat hook in the freezer of a Harlem club, with a folding blue steel razor next to him. The razor is the trademark of Charleston Blue, a legendary gangster last seen in Harlem in 1932. Gravedigger and Coffin Ed's investigation finds links between a Vietnam vet turned photographer, a beautiful debutante, an old psychic, and a power struggle to control the drug trade in Harlem. Based on the Chester Himes novel, The Heat Is On.

COOL BREEZE MGM 1972
Cast: Thalmus Rasulala, Judy Pace, Lincoln Kilpatrick, Raymond St. Jacques
Director: Barry Pollack
Plot: A Black man, just released from San Quentin, is under surveillance by a white L.A. police station. Along with a Vietnam vet and his half brother, a bookie, a part-time safe cracker who's a minster the rest of time, and a respectable businessman, the man plans a $3 million diamond heist to establish a Black people's bank. But greed undoes the plan and they end up dead, in jail, or on the run. This is the third remake of The Asphalt Jungle. It had been done once as a Western, The Badlanders, and as an international adventure, Cairo.

COOLEY HIGH AIP 1975
Cast: Glynn Turman, Lawrence Hilton-Jacobs, Garrett Morris
Director: Michael Schultz
Plot: This movie, most often compared to American Graffiti, follows the adventures of high schoolers in Chicago in 1964. Events range from comic to the tragic with a musical score of Motown hits from the mid '60s. A first-rate film that effectively captures a slice of Black urban life.

COONSKIN Bryanston Distributors 1975
aka STREETFIGHT
Cast: Voices of: Barry White, Charles Gordone, Scatman Crothers, Philip Michael Thomas
Director: Ralph Bakshi
Plot: One of the earliest examples of the mixture of live action and animation. In the live action framing sequences, while waiting for the car that will enable them to escape from a Southern prison, an older con tells the younger one a modern version of the Uncle Remus tales. A slick rabbit, a confused bear and a not so slick fox go to Harlem and take over, doing in the police and the Mafia along the way. Although roundly denounced by CORE as racist and insulting, many critics found that the film had heart and artistic integrity.

COTTON COMES TO HARLEM UA 1970
Cast: Godfrey Cambridge, Raymond St. Jacques, Calvin Lockhart, Judy Pace, Redd Foxx
Director: Ossie Davis
Plot: A slick conman of a Reverend fleeces his flock of $87,000 for his "Back to Africa" boat. Armed men take off with the money. They hide the money in a bale of cotton, which falls off the getaway truck. The two policemen investigating the robbery, Coffin Ed Johnson and Gravedigger Jones, suspect the reverend is behind the whole thing. But it takes a series of mishaps, twist and turns before the money is found and the bad guys are in jail. Based on the novel by Chester Himes. This was Ossie Davis's directorial debut.

DARKTOWN STRUTTERS New World 1975
aka GET DOWN AND BOOGIE
Cast: Trina Parks, Roger E. Molsey, Shirley Washington
Director: William Witney
Plot: When the mother of the leader of motorcycle riding singing group is kidnapped, the group swings into action to rescue mom.

DEATH JOURNEY Po' Boy/Atlas 1976
Cast: Fred Williamson, D'Urville Martin, Bernie Kuby, Heidi Dobbs
Director: Fred Williamson
Plot: A Los Angeles PI must deliver a witness to the New York DA in 48 hours. The mob has other plans for the witness. Generally considered the best of the Jesse Crowder movies.

DELIVER US FROM EVIL Dimension 1975
Cast: Marie O'Henry, Renny Roker, Danny Martin
Director: Horace Jackson
Plot: Pushers and street thugs terrorize a kid in a wheelchair. Ghetto residents, including a bitter ex-con and a playground supervisor, work to make the streets safe.

DETROIT 9000 General Film Corp 1973
aka POLICE CALL 9000; DETROIT HEAT
Cast: Alex Rocco, Hari Rhodes, Scatman Crothers, Vonetta McGee
Director: Arthur Marks
Plot: A group of robbers steal $400,000 worth of jewels and other valuables from people attending a Black congressman's gubernatorial campaign fund raiser. Two cops, one white, the other black, are assigned to the case. Conflict between the cops, a dead American Indian with no legs, a madam and her call girl, a murderous group of thugs, and an unknown fence for the stolen goods are all part of the mix in this police procedural crime drama. The title is police code for "Officer needs assistance."

DEVIL'S EXPRESS Howard Mahler Films 1974
aka GANG WARS
Cast: Warhawk Tanzania, Larry Fleischman, Sam DeFazio
Director: Barry Rosen
Plot: A Chinese demon comes to New York looking for trouble, meanwhile two gangs are fighting a turf war. If this sounds confusing, wait until you see the movie.

DISCO GODFATHER
Generation International Pictures 1979
aka AVENGING DISCO GODFATHER
Cast: Rudy Ray Moore, James H. Hawthorne, Pucci Jones, Jimmy Lynch, Lady Reed, Carol Speed
Director: J. Robert Wagoner
Plot: A retired cop becomes a celebrity DJ at the Blueberry Hill disco . . . he's the DISCO GODFATHER. All is well until his nephew flips out on PCP, which is flooding the streets. Disco Godfather vows "to personally come down on the suckers that's producing this shit!" From that point on, he alternates between cleaning up the streets and performing at Blueberry Hill, where he exhorts the crowds to "Put a little slide in yo' glide!" Moore claims this film ended his movie career.

DOLEMITE Dimension 1975
Cast: Rudy Ray Moore, D'Urville Martin, Lady Reed
Director: D'Urville Martin
Plot: Dolemite, the infamous character from Moore's nightclub routine who only speaks in rhymes, is a pimp, martial arts master, and a sexual dynamo. After being released from prison, Dolemite sets out to clear his name.

DR. BLACK, MR. HYDE Dimension 1976
aka THE WATTS MONSTER
Cast: Bernie Casey, Rosalind Cash, Stu Gilliam, Marie O'Henry
Director: William Crain
Plot: In this version of Robert Louis Stevenson's classic tale, Dr. Pride is a wealthy Black doctor working on a cure for cirrhosis of the liver. He begins to use his patients at the Watts free clinic, where he volunteers his time, as subjects in his experiments. He uses the drug on himself, which turns him into a murderous white man. The film ends with a violent confrontation with the police at the Watts Towers.

DRUM United Artists 1976
Cast: Ken Norton, Pam Grier, Fiona Lewis, Warren Oates, Isela Vega
Director: Steve Carver
Plot: Twenty years after the events in Mandingo finds bordello owner Isela Vega selling Norton to Oates. Mistreated by his new master, Norton is hung upside and naked and (along with Yaphet Kotto) is whipped. Filled with anger and humiliation, they revolt. Nudity, whipping, and castration gave the original version an X rating but heavy editing reduced it to R.

DYNAMITE BROTHERS
aka STUD BROWN Cinemation Industries 1974
Cast: James Hong, Aldo Ray, Alan Tang, Timothy Brown
Director: Al Adamson
Plot: A Black man on the run and a Hong Kong martial arts expert looking for his sister join forces to find the sister and fight drug dealers in Watts.

EBONY IVORY & JADE Dimension 1976
aka FOX FORCE; SHE-DEVILS IN CHAINS
Cast: Roseanne Katon, Colleen Camp, Sylvia Anderson
Director: Cirio Santiago
Plot: Three American women in Hong Kong for the Olympics are kidnapped and held for ransom.

FIVE ON THE BLACK HAND SIDE UA 1973
Cast: Clarice Taylor, Leonard Jackson, Virginia Capers, D'Urville Martin, Glynn Turman, Godfrey Cambridge
Director: Oscar Williams
Plot: The comic adventures and misadventures of a Black barber who tries to cope with his family and running his business.

FOR LOVE OF IVY Cinerama 1968
Cast: Sidney Poitier, Abbey Lincoln, Beau Bridges, Carroll O'Connor

Director: Daniel Mann
Plot: A trucking executive, with a gambling operation on the side, wants to marry the Black maid of a rich white family.

FOX STYLE Presidio Productions 1973
Cast: Chuck Daniel, Juanita Moore, Richard Lawson, John Taylor, Jovita Bush, Denise Denise
Director: Clyde Houston
Plot: A wealthy nightclub owner struggles to reconcile his country roots with his newfound city sophistication.

FOXY BROWN AIP 1974
Cast: Pam Grier, Peter Brown, Terry Carter, Kathryn Loder
Director: Jack Hill
Plot: Grier, in one of her classic roles, poses as a hooker to trap the mobsters who killed her cop lover. This is the last of the four films she did with director Hill.

FRIDAY FOSTER AIP 1975
Cast: Pam Grier, Yaphet Kotto, Godfrey Cambridge, Thalmus Rasulala, Eartha Kitt, Jim Backus, Scatman Crothers
Director: Arthur Marks
Plot: Based on the comic strip, Friday saves a group of Black leaders from an assassination plot by white racists.

GORDON'S WAR 20th Century Fox 1973
Cast: Paul Winfield, Carl Lee, David Downing, Grace Jones
Director: Ossie Davis
Plot: A Vietnam vet returns to Harlem to find his wife dead from a drug overdose. Declaring war on the pushers, he organizes his Green Beret buddies into a strike team and they clean up the 'hood.

THE GRASSHOPPER National General Pictures 1970
Cast: Jaqueline Bisset, Jim Brown, Joseph Cotton, Ed Flanders
Director: Jerry Paris
Plot: A beautiful teenager flees Canada for fame and fortune in L.A. but ends up a jaded call girl.

THE GREATEST Columbia 1977
Cast: Muhammed Ali, Ernest Borgnine, Robert Duvall, James Earl Jones, Roger E. Mosley
Director: Tom Gries
Plot: Based on his autobiography, this is the story of Muhammed Ali. The film opens with Cassius Clay's return from Rome after winning the Olympic Gold Metal in the Light Heavy Weight division. The key events in his life are chronicled: turning professional, defeating Sonny Liston, his conversion to Islam, his refusal to serve in Vietnam and winning his case before the Supreme Court, and his great victory over George Foreman.

THE HARDER THEY COME New World Pictures 1973
Cast: Jimmy Cliff, Janet Bartley, Carl Bradshaw
Director: Perry Henzell
Plot: The rise and fall of a would be music star. Most notable for a sensational soundtrack, which captures reggae music of the era. The actors speak the Jamaican patios so completely that the film is often subtitled.

HELL UP IN HARLEM AIP 1973
Cast: Fred Williamson, Julius W. Harris, Gerald Gordon, Gloria Hendry, D'Urville Martin, Margaret Avery
Director: Larry Cohen
Plot: This sequel to Black Caesar finds Tommy Gibbs fighting both his father and the Mafia for control of Harlem. The Mafia kidnaps his two children and later murders his wife. After numerous killings and a double cross, Tommy leads a group of frogmen against the mob compound in the Florida Keys where he kills the Mafia Don and rescues his children.

WHAT IT WAS...

A HERO AIN'T NOTHIN' BUT A SANDWICH
New World Pictures 1978
Cast: Cicely Tyson, Paul Winfield, Larry B. Scott, Helen Martin, Glynn Turman
Director: Ralph Nelson
Plot: A boy must learn to cope with the pressures of school and the new man in his mother's life.

HIT! Paramount 1973
Cast: Billy Dee Williams, Paul Hampton, Richard Pryor, Gwenn Welles
Director: Sidney J. Furie
Plot: After his teenage daughter dies from a drug overdose, a federal agent recruits his own commando team to kill the members of the Marseilles drug gang that supplied the heroin. After undergoing special training, the commandos make their way individually to Marseilles and kill the nine members of the drug syndicate. Then they escape.

HIT MAN MGM 1972
Cast: Bernie Casey, Pam Grier, Lisa Moore, Don Diamond
Director: George Amitage
Plot: A small-time hood comes to L.A. to bury his brother. When he learns his brother was murdered, he stays to solve the murder. A remake of the British film Get Carter. A first rate performance by Casey.

HONKY Jack H. Harris Enterp 1971
Cast: Brenda Sykes, John Neilson, William Marshall
Director: William A. Graham
Plot: A white, suburban teenage boy falls in love with an upscale Black girl in a midwestern town. They learn about bigotry people have toward them. Considered a daring film when it was released. Features a score by Quincy Jones.

HOT POTATO Warner Bros. 1976
Cast: Jim Kelly, George Memmoli, Geoffrey Binney, Irene Tsu
Director: Oscar Williams
Plot: Martial arts experts try to rescue an ambassador's daughter in Thailand.

THE HOUSE ON SKULL MOUNTAIN
20th Century Fox 1974
Cast: Victor French, Janee Michelle, Mike Evans, Jean Durand
Director: Ron Honthaner
Plot: On a dark and stormy night, four relatives gather to hear the will of the mistress of the House on Skull Mountain. The voodoo practicing butler watches over the proceedings.

THE HUMAN TORNADO Dimension 1976
aka DolemiteII
Cast: Rudy Ray Moore, Lady Reed
Director: Cliff Roquemore
Plot: We follow the further adventures of the irrepressible Dolemite. After being caught in bed with the sheriff's wife in a small Alabama town, Dolemite escapes to California. They fight the hoodlum trying to take over the nightclub owned by an old friend.

I ESCAPED FROM DEVIL'S ISLAND UA 1973
Cast: Jim Brown, Christopher George, Rick Ely
Director: William Witney
Plot: Two prisoners in 1918 revolt against the inhumane treatment of the French prison and escape. It features alligators, a shark attack, hostile Amazon natives, and a leper colony.

IF HE HOLLERS, LET HIM GO Cinerama 1968
Cast: Dana Wynter, Raymond St. Jacques
Director: Charles Martin
Plot: A falsely accused man escapes from prison. With the help of a lovely nightclub singer, he restores his good name.

I'M GONNA GIT YOU SUCKA 1988
Cast: Keenen Ivory Wayans, Bernie Casey, Isaac Hayes, Chris Rock, Jim Brown
Director: Keenen Ivory Wayans
Plot: A spoof of the clichés of the '70s Black-action movies. Vietnam vet Jack Spade enlists the aid of Black heroes to save Any Ghetto, USA from the bad guys.

J. D.'S REVENGE AIP 1976
Cast: Glynn Turman, Joan Pringle, Lou Gossett
Director: Arthur Marks
Plot: A hard working college student is possessed by the spirit of a gangster killed in the '40s. The spirit wants revenge on the man who killed him and his sister. Fine acting, especially by Turman and Gossett, an intriguing plot, and the moody New Orleans setting made this an above average film.

LEGEND OF NIGGER CHARLEY Paramount 1972
Cast: Fred Williamson, D'Urville Martin
Director: Martin Goldman
Plot: Charley is given his freedom by his dying owner but the evil overseer tries to keep him a slave. He kills the overseer and flees with two other slaves to the West with a bounty hunter on their trail. The bounty hunter catches-up with them in a frontier town but he and his men are killed in a shootout with the Blacks.

LET'S DO IT AGAIN Warner Bros. 1975
Cast: Sidney Poitier, Bill Cosby, Jimmie Walker
Director: Sidney Poitier
Plot: When their lodge loses its lease, two Atlanta friends decide to raise the $50,000 it will take to build a new home for their lodge. Their scheme involves New Orleans bookies and a skinny boxer who wins when hypnotized. A sequel to Uptown Saturday Night.

THE LIBERATION OF L. B. JONES Columbia 1970
Cast: Lee J. Cobb, Anthony Zerbe, Yaphet Kotto, Rosco Lee Brown
Director: William Wyler
Plot: A Black man returns to the Southern town where he was born to seek vengeance against the white cop who beat him when he was a child. He gets caught up in web of intrigue involving the white cop who is having an affair with the wife of a wealthy Black businessman.

THE MACK Cinerama 1973
Cast: Max Julien, Don Gordon, Richard Pryor, Carol Speed
Director: Michael Campus
Plot: After being released from jail, a pimp battles corrupt cops and the Mafia on his way to the top of the hooker trade. But after a series of clashes, his mother and best friend are killed by the corrupt cops. He and his politicized brother kill the cops and the pimp leaves penniless for Alabama. One of the most highly respected films of the '70s Black cinema, The Mack was a huge box office success.

MANDINGO Paramount/Dino De Laurentis 1975
Cast: James Mason, Susan George, Ken Norton, Brenda Sykes
Director: Richard Fleischer
Plot: The daughter of a Southern plantation owner takes a prized fighting slave as a lover. This violent, big budget movie was less than the sum of its parts. However, it was successful enough to have spawned a sequel, Drum.

MAN FRIDAY Avco Embassy 1976
Cast: Peter O'Toole, Richard Roundtree
Director: Jack Gold
Plot: In this retelling of Defoe's Robinson Crusoe, Friday revolts against his white master and eventually drives him crazy.

MEAN JOHNNY BARROWS Atlas Films 1976
Cast: Fred Williamson, Roddy McDowall, Jenny Sherman, Elliott Gould
Director: Fred Williamson
Plot: Vietnam vet becomes involved with the Mafia after he is unable to get honest work. The movie attempts to deal with issue of returning Black vets facing discrimination. Williamson's directorial debut.

MEAN MOTHER Independent International 1973
Cast: Clifton Brown, Dennis Safren
Director: Al Adamson
Plot: Two Vietnam deserters go their separate ways. They become criminals and are finally reunited. This movie was made by taking footage from an older film, edited together with newer scenes.

MELINDA MGM 1972
Cast: Calvin Lockhart, Rosalind Cash, Vonetta McGee, Jim Kelly
Director: Huge A. Robertson
Plot: A self centered DJ tosses out his business executive girlfriend for an alluring and mysterious woman. When she is found dead in his apartment, he is in trouble with the police and the mob. A forgotten classic.

MONKEY HUSTLE AIP 1977
Cast: Yaphet Kotto, Rosalind Cash, Rudy Ray Moore
Director: Arthur Marks
Plot: A Black neighborhood in Chicago is going to be torn down for a new freeway. A big block party is organized to save the 'hood but the people spend too much time hustling each other.

THE MUTHERS Dimension 1976
Cast: Jeanne Bell, Rosanne Katon, Jayne Kennedy
Director: Cirio H. Santiago
Plot: Two American women head a pirate crew called the Muthers. When the sister of one of the Americans is captured and sent to plantation prison camp, the muthers swing into action to save her.

NO WAY BACK Atlas 1976
Cast: Fred Williamson, Charles Woolf, Tracy Reed
Director: Fred Williamson
Plot: Tough L.A. private investigator Jesse Crowder goes to San Francisco to find a bank embezzler. He traces the man to San Diego but discovers the mob and the man's wife have plans of their own for the missing money. The final confrontation takes place in the country where Jesse rides in on a horse to save the day.

NORMAN... IS THAT YOU?
Warner Bros. 1976
Cast: Redd Foxx, Pearl Bailey, Tamara Dobson
Director: George Schlatter
Plot: This film version of the Broadway play was intended as a star vehicle for Redd Foxx. A perturbed father feels compelled to straighten out his gay son.

NOTHING BUT A MAN
A Cinema V Presentation 1964
Cast: Ivan Dixon, Abbey Lincoln, Yaphet Kotto
Director: Michael Roemer
Plot: Fired and labeled a troublemaker, Dixon portrays a Black laborer trying to maintain a relationship and dignity in a small Southern racist town.

ONE DOWN TWO TO GO Media 1983
Cast: Fred Williamson, Jim Brown, Jim Kelly, Richard Roundtree
Director: Fred Williamson
Plot: A New Jersey martial arts promoter is cheated out of his tournament money by a gangster. The promoter's three tough-guy friends come to his aid.

PASSION PLANTATION
Howard Mahler Release 1977
Cast: Louisa Longo
Director: Mario Pinzauti
Plot: A white slave owner plants more than cotton with his slaves. Originally a soft porn flick called, Black Emmannuelle, White Emmannuelle, it was recut and retitled to cash in on the success of Mandingo and Drum.

PETEY WHEATSTRAW
Generation International Pictures 1977
aka DEVILS' SON-IN-LAW
Cast: Rudy Ray Moore, Ebony Wryte, Sy Richardson
Director: Cliff Roquemore
Plot: A legendary comedian and club owner makes a pact with the devil after rivals kill his friends at a funeral. This fantasy comedy features a rhyming opening (an early example of rap), Petey having sex with a room full of women, fighting devils in red tights, Kung fu fighting, and numerous other delights.

A PIECE OF THE ACTION Warner Bros. 1977
Cast: Sidney Poitier, Bill Cosby, James Earl Jones
Director: Sidney Poitier
Plot: Two slick con men are blackmailed by a cop into helping out a community center and reforming wayward teenagers.

POP GOES THE WEASEL Moonstone 1975
aka LADY COCOA
Cast: Lola Falana, Gene Washington, Alex Dreier
Director: Matt Cimber
Plot: In a plot that must have been inspired by the real life exploits of actress Liz Renay, Lady Cocoa is in prison for refusing to testify against her gangster boyfriend. She's allowed out in Lake Tahoe under the protective custody of two detectives because she promises to talk. Gangsters try to kill her.

RUN NIGGER RUN Box Office Int. 1973
aka THE BLACK CONNECTION
Cast: The Checkmates Ltd., Bobby Stevens, Sweet Louie, Sonny Charles
Director: Michael J. Finn
Plot: A man, caught between warring mobsters, runs for his life. Shot in Las Vagas, there's lots of music by The Checkmates Ltd.

SAVAGE! New World 1973
Cast: James Iglehardt, Lada Edmund, Carol Speed
Director: Cirio Santiago
Plot: After ambushing a rebel leader in a Latin American country, a soldier is charged with the leader's murder by the government he served. Feeling betrayed, he escapes and goes over to the rebel side. With the help of all female commando squad, he rescues a girlfriend and kills the bad guys.

SAVAGE SISTERS AIP 1974
Cast: Gloria Hendry, Rosanna Ortiz, Cheri Caffaro
Director: Eddie Romero
Plot: Gloria Hendry is an interrogation officer at an island prison camp who saves two female thieves. They eventually take revenge on the prison officals who were mean to them.

SCREAM, BLACULA, SCREAM AIP 1973
Cast: William Marshall, Pam Grier, Don Mitchell
Director: Bob Kelljan
Plot: A voodoo ceremony reincarnates Blacula. William Marshall returns as Mamuwalde, the vampire he made famous, leaving a bloody trail until he meets his match in Pam Grier.

SERGEANT RUTLEDGE Warner Bros. 1960
Cast: Woody Strode, Jeffrey Hunter, Constance Towers
Director: John Ford
Plot: Sgt. Rutledge, a Buffalo Soldier—a Black cavalry soldier—is accused of raping a white woman. During his court martial, in a series of flashbacks, his bravery and innocence is revealed. One of Strode's biggest roles.

SHAFT MGM, 1971
Cast: Richard Roundtree, Moses Gunn, Charles Cioffi
Director: Gordon Parks Sr.
Plot: Hired by a Black gangster to find his daughter, Shaft encounters militants and mafiosi before the case is solved. The prototype for films that were later called "blaxploitation." The Isaac Hayes score won an Oscar.

SHAFT IN AFRICA MGM 1973
Cast: Richard Roundtree, Frank Finlay, Vonetta McGee
Director: John Guillermin
Plot: Shaft goes undercover to find the killer of an Emir's son and who is behind a modern slave trade. The action takes place in Paris and Africa. The last of the Shaft movies.

SHAFT'S BIG SCORE MGM 1972
Cast: Richard Roundtree, Moses Gunn, Drew Bundini Brown, Joseph Mascola
Director: Gordon Parks Sr.
Plot: A Black numbers man stashes $250,000 of the mob's money in a coffin but he is killed by his partner. The mob wants the money and control of the numbers racket throughout New York, which displeases the Harlem hoods. Shaft, at the police's request, steps in to solve the problem.

THE SLAMS MGM 1973
Cast: Jim Brown, Judy Pace, Roland Harris
Director: Jonathan Kaplan
Plot: After stealing $1.5 million dollars from the mob and destroying a suitcase full of heroin destined for the ghetto, Curtis Hook is double-crossed and shot by his partner. He ends up in prison where he has to avoid warring Black and white gangs, the FBI who wants information about the mob, the mob who has a contract on his life, and the prison guards who want the money.

SLAUGHTER AIP 1972
Cast: Jim Brown, Stella Stevens, Rip Torn, Don Gordon
Director: Jack Starrett
Plot: After his father and mother are murdered by the Mafia, ex-Green Beret Slaughter goes after the killers. The trail leads him to Mexico where, using Green Beret tactics, he slaughters the bad guys.

SLAUGHTER'S BIG RIPOFF AIP 1973
Cast: Jim Brown, Ed McMahon, Brock Peters, Gloria Hendry
Director: Gordon Douglas
Plot: The mob kills one of Slaughter's friends and he wants revenge! Slaughter steals a list of people on the mob's payroll but he and his girlfriend are captured. The girlfriend is killed and the list taken but Slaughter survives. With machine gun in hand, Slaughter raids the mob compound, kills everybody who needs killing, and retrieves the list. He then leaves for Paris and a life of quiet relaxation.

SLAVES Galleon Release 1969
Cast: Ossie Davis, Stephen Boyd, Dionne Warwick
Director: Herbert J. Biberman
Plot: A rather eclectic cast tries its hand at this peculiar revisionist look at the life of an independent slave in Kentucky. Boyd is effectively evil as the abusive "massa," and Ossie does a nice turn as the slave standing up for his rights.

THE SOUL OF NIGGER CHARLEY
Paramount 1973
Cast: Fred Williamson, D'Urville Martin, Denise Nicholas
Director: Larry Spangler
Plot: In the post–Civil War West, free Blacks are being kidnapped by vicious ex-Confederates who still think slavery is good. They are being held in a compound in Mexico. Charley and the indestructible Toby ride to the rescue.

SOUL PATROL Madison World Film 1980
aka BLACK TRASH
Cast: Nigel Davenport, Ken Gampu, Peter Dyneley
Director: Christopher Rowley
Plot: A black newspaper reporter and a white cop join forces to investigate the mysterious deaths of some drug dealers.

SOUL SOLDIER Fanfare Film Productions 1972
aka RED, WHITE AND BLACK
Cast: Rafer Johnson, Robert DoQui, Lincoln Kilpatrick, Cesar Romero
Director: John Cardos
Plot: The first of the Black Westerns of the '70s, the one that started the craze. The men of the 10th Cavalry, the Buffalo soldiers, fight Indians in Texas. Despite their battles, they feel empathy for another oppressed minority, the Indians.

THE SPOOK WHO SAT BY THE DOOR UA 1973
Cast: Lawrence Cook, Paula Kelly, Janet League
Director: Ivan Dixon
Plot: In order to avoid charges of discrimination, the CIA hires its first Black agent, Dan Freeman. But after five years of guiding tours and suffering discrimination, Freeman quits and goes home to Chicago to work in a social service agency. Recruiting from the streets, he trains a cadre of revolutionaries and begins fighting an urban war of liberation.

SUGAR HILL AIP 1974
aka VOODOO GIRL
Cast: Marki Bey, Robert Quarry, Don Pedro Colley
Director: Paul Maslansky
Plot: After a night club owner is killed for refusing to sell his club to gangsters, his girlfriend seeks revenge. Using voodoo, she calls upon an army of zombies to get the killers.

SUPER DUDE Dimension 1974
aka HANGUP
Cast: William Elliot, Marki Bey, Cliff Potts
Director: Henry Hathaway
Plot: An LAPD detective works to bring down the drug dealer who hooked his childhood sweetheart.

SUPERFLY Warner Bros. 1972
Cast: Ron O'Neal, Carl Lee, Sheila Frazier
Director: Gordon Parks Jr.
Plot: A super cool, super tough coke dealer decides to "stick it to the man" with one last big score and then retire. With a great musical score by Curtis Mayfield and a strong performance by the charismatic Ron O'Neal, this is one of the defining films of the '70s Black cinema. Roundly denounced by some for glamorizing drug dealers, others saw a tale of the limited options open to bright young men in the ghetto.

SUPERFLY TNT Paramount 1973
Cast: Ron O'Neal, Roscoe Lee Browne, Sheila Frazier
Director: Ron O' Neal
Plot: A pale sequel to the original finds Priest living in Rome with nothing to do. He becomes involved with African revolutionaries fighting colonialism.

SWEET JESUS PREACHER MAN MGM 1973
aka SWEET JAMES PREACHER MAN
Cast: Roger E. Mosley, William Smith, Michael Pataki, Marla Gibbs
Director: Henning Schellerup
Plot: A Black hit man poses as a Baptist preacher in a ghetto church. He decides to take over the local rackets.

SWEET SWEETBACK'S BAADASSSSS SONG
Cinamation 1971
Cast: Melvin Van Peebles, Simon Chuckster, Hubert Scales
Director: Melvin Van Peebles
Plot: The police raid a brothel and take sweet-back in for questioning. Along the way, they stop and beat a young Black. Much to his own surprise, Sweetback saves the youth and kills the cop. With the police in hot pursuit, Sweetback makes a successful run to the border and escapes. This film's impact was immediate and long lasting. While Shaft is the progenitor of the "blaxploitation" era, without Sweetback, Shaft would have been a white detective story as was originally written. Many current African American filmmakers, like Spike Lee, cite the influence of Sweetback.

TAKE A HARD RIDE 20th Century Fox 1975
Cast: Jim Brown, Lee Van Cleef, Fred Williamson
Director: Anthony Dawson
Story: A cowboy and a gambler team up to deliver a big bankroll to their dying boss's wife. They are pursued by a ruthless bounty hunter.

THAT MAN BOLT MCA/Universal 1973
Cast: David Lowell Rich, Fred Williamson, Byron Webster
Director: Henry Levin
Plot: Bolt is hired to deliver a million dollars from Hong Kong to Mexico City with a stop in L.A. But the money turns out to be criminal loot and after his girlfriend is killed, Bolt returns to Hong Kong to extract revenge.

THE THING WITH TWO HEADS AIP 1972
Cast: Ray Milland, Rosie Grier, Don Marshall
Director: Lee Frost
Plot: A bigot, dying of cancer, has his head added to the body of a condemned killer. The bigot plans to remove the other head but it decides to run away and prove his innocence.

THREE THE HARD WAY UA 1975
Cast: Jim Brown, Fred Williamson, Jim Kelly
Director: Gordon Parks Jr.
Plot: A trio of Black heroes swing into action when they discover a plot by white supremacists to pollute the water supply with a poison that kills only Blacks.

THREE TOUGH GUYS Paramount 1974
aka TOUGH GUYS
Cast: Lino Ventura, Fred Williamson, Issac Hayes, Paula Kelly
Director: Duccio Tessari
Plot: An ex-con priest and an ex-cop cook join forces to get the man who framed the cop and cost him his badge. One of the few times Williamson plays a bad guy.

...tick...tick...tick... MGM 1970
Cast: Jim Brown, George Kennedy, Fredric March, Janet McMacLauchlin
Director: Ralph Nelson
Plot: The arrest of a wealthy young white man sets the stage for a violent confrontation between bigoted citizens and the Southern town's first elected Black sheriff.

TNT JACKSON New World 1974
Cast: Jeanne Bell, Pat Anderson
Director: Cirio H. Santiago
Plot: In order to find her missing brother, TNT goes undercover as a hooker in Hong Kong. She battles the Chinese mob to save the day. There is a topless Kung fu fight.

TOP OF THE HEAP Fanfare 1972
Cast: Christopher St. John Paula Kelly, Alan Garfield
Director: Christopher St. John
Plot: Sick of being a cop, and trying to juggle family life and a mistress, George Latimer (St. John) escapes into a rich fantasy life (a la Slaughter House-Five).

TRICK BABY Universal 1973
aka DOUBLE CON
Cast: Kiel Martin, Mel Stewart, Dallas Edward Hayes
Director: Larry Yust
Plot: Two Black con men run afoul of the Mafia when one of their cons causes a man connected to the mob to have a heart attack.

TROUBLE MAN 20th Century-Fox 1972
Cast: Robert Hooks, Paul Winfield, Ralph Waite, Paula Kelly
Director: Ivan Dixon
Plot: When floating crap games are held up, rival syndicates begin a turf war. Mr. T is called in to solve the dispute.

TRUCK TURNER AIP 1974
Cast: Issac Hayes, Yaphet Kotto, Alan Weeks, Dick Miller
Director: Jonathan Kaplan
Plot: Truck's a bounty hunter who kills a madam's boyfriend when he jumps bail. She puts out a contract on him and big crime bosses takes it. But in the end, they are both run over by the Truck.

UPTOWN SATURDAY NIGHT Warner Bros. 1974
Cast: Sidney Poitier, Bill Cosby, Harry Belafonte, Richard Pryor
Director: Sidney Poitier
Plot: Two factory workers are robbed of a lottery ticket worth $50,000 during the heist of an exclusive club. They decide to retrieve the wallet themselves and are plunged into a world of sleazy criminals. A satire of the "blaxploitation" genre, this uneven comedy features some fine performances, especially Belafonte's send up of Brando's Godfather.

VELVET SMOOTH Howard Mahler Films 1976
Cast: Johnnie Hill, Owen Wat-son, Emerson Boozer, Elise Roman
Director: Michael Fink
Plot: Velvet is a tough woman who runs a female detective agency. She is hired by a local crime lord to find out who is taking his action. This involves crooked cops, disloyal co-workers, and an unexpected surprise ending. A very low budget film.

WATERMELON MAN Columbia 1970
Cast: Godfrey Cambridge, Estelle Parsons, D'Urville Martin
Director: Melvin Van Peebles
Plot: A bigoted, big-city insurance salesman wakes up one morning and finds that he's turned into a Black man. A provocative, for the time, comedy. Van Peebles used the money he made from this film to finance Sweet Sweetback's BaadAsssss Song.

WATTSTAX: THE LIVING WORD
Columbia 1973
Cast: Issac Hayes, The Staple Singers. Luther Ingram, Rev. Jess Jackson
Director: Mel Stuart
Plot: A concert film shot over several shows at the L.A. coliseum. The shows, staged by Melvin Van Peebles, were a celebration of Black life and music and were sponsored by Schlitz Beer. The film was a collaboration between Stax Records and Wolper Productions. Richard Pryor was the MC.

WILLIE DYNAMITE Universal 1974
Cast: Roscoe Orman, Diana Sands, Thalmus Rasulala
Director: Gilbert Moses III
Plot: A new hooker joins the stable of Willie Dynamite. A social worker thinks she can still be saved. A moral tug of war follows and in the end the girl is saved and Dynamite is also reformed.

ZEBRA KILLER General Film Corp. 1973
aka COMBAT COP
Cast: Austin Stoker, James Pickett, Huge Smith, D'Urville Martin
Director: William Girdler
Plot: Stoker plays detective tracking down serial killer. Sensational plot twist makes this a memorable finale to Girdler's career cut short by helicopter accident.

WHAT IT WAS...